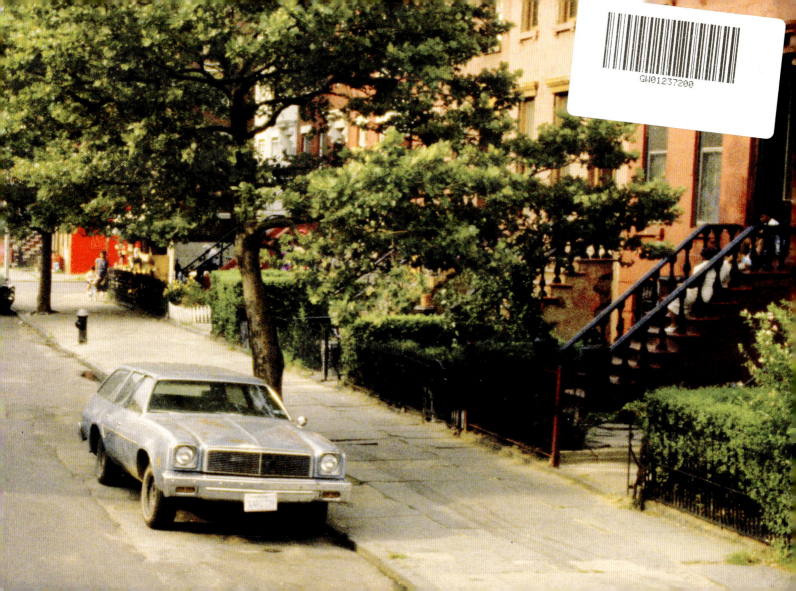

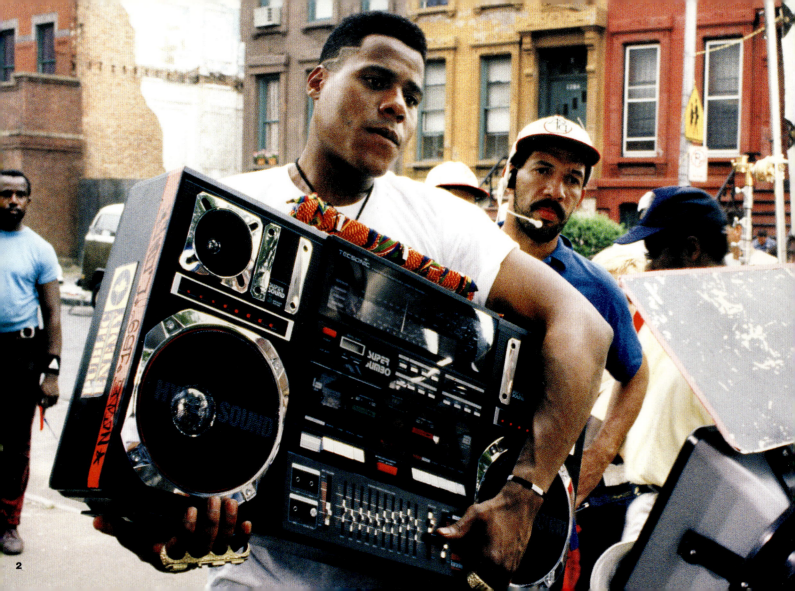

SPIKE LEE DO THE RIGHT THING

BY SPIKE LEE AND JASON MATLOFF

EDITED BY STEVE CRIST

Setting up for Radio Raheem's "Third World Briefcase" shot.

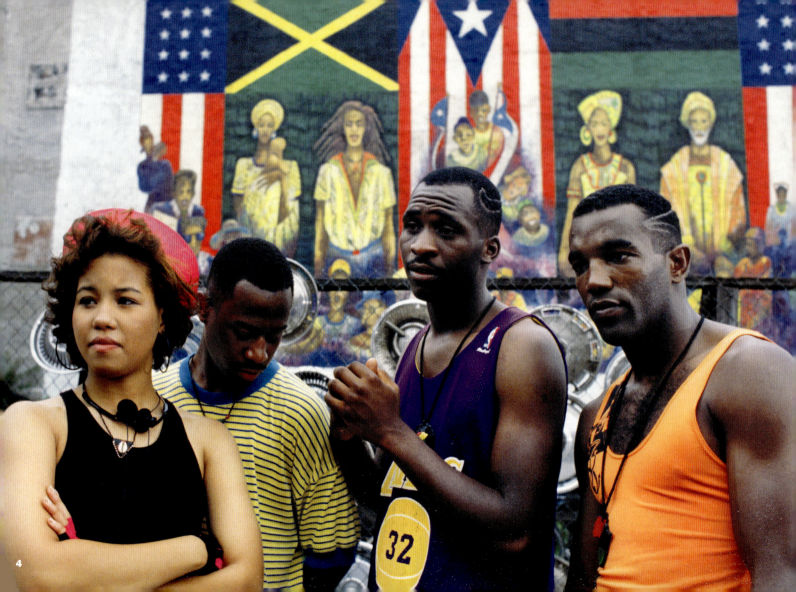

TABLE OF CONTENTS

Introduction by Spike Lee	6
An Oral History by Jason Matloff	8
The Movie	40
Photographs by David Lee	104
The Script	178
Film Credits, Cast and Crew	352
Colophon	358

We painted the mural on that wall.

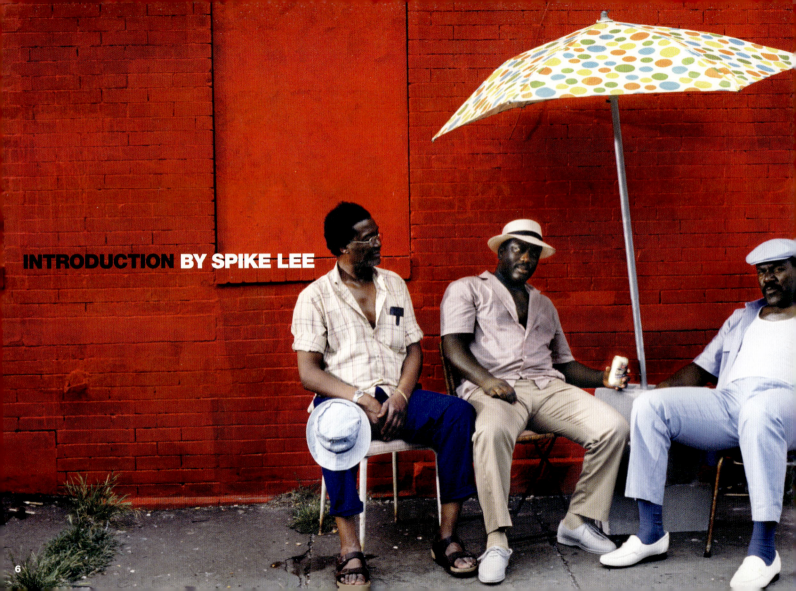

INTRODUCTION BY SPIKE LEE

I'm often asked what my favorite film is that I've directed. I don't have one specifically, but *Do The Right Thing* is on the list.

After *She's Gotta Have It* (1986) and *School Daze* (1988), I knew the title of my third film. I didn't find it strange that I knew it would be titled *Do The Right Thing* but had no sense of what the story would be. Start with that and build.

Since the August 1989 release of the film, if I had a dollar for every time somebody came up to me and yelled, "Hey Spike, do the right thing," I would have been able to finance several of my films.

Working on this book, reading the fine oral history has been a joy. I remember things I had forgotten and learned things I didn't know. *Do The Right Thing* grows in stature every year. Colleges and universities have a course on it, which, to me, is maybe its greatest achievement. The film is being taught to new generations of people every semester—young students who were not even born when the film came out. And it's not just confined to film schools.

It is our hope that you will continue to enjoy *Do The Right Thing*, which still holds up strong after all these years. The reason for that is the hardworking, talented and dedicated people in front of and behind the camera. Our mission was to make a bold film, not just with the subject matter, but also in how it looked, how it sounded, and the quality that one puts into this art form/craft we call cinema. We set out with what we intended to do, and did it. That's what I call a winner.

SPIKE LEE
Brooklyn, NY
August 28, 2010

AN ORAL HISTORY BY JASON MATLOFF

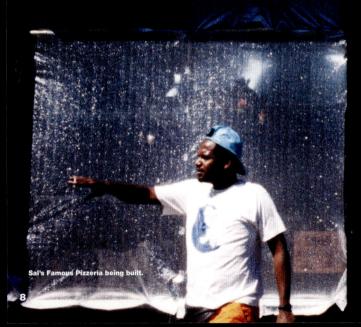

Sal's Famous Pizzeria being built.

CAST OF CHARACTERS

SPIKE LEE [Mookie], Writer, Producer, And Director
DANNY AIELLO [Sal]
RUBY DEE [Mother Sister]
RICHARD EDSON [Vito]
GIANCARLO ESPOSITO [Buggin' Out]
BILL NUNN [Radio Raheem]
JOHN TURTURRO [Pino]
PAUL BENJAMIN [ML]
FRANKIE FAISON [Coconut Sid]
JOIE LEE [Jade]
MIGUEL SANDOVAL [Officer Ponte]
RICK AIELLO [Officer Long]
JOHN SAVAGE [Clifton]
SAMUEL L. JACKSON [Mister Señor Love Daddy]
ROSIE PEREZ [Tina]
ROGER GUENVEUR SMITH [Smiley]
STEVE WHITE [Ahmad]
MARTIN LAWRENCE [Cee]
FRANK VINCENT [Charlie]
LUIS ANTONIO RAMOS [Stevie]
STEPHEN PARK [Sonny]
MONTY ROSS, Co-Producer
JON KILIK, Line Producer
ERNEST DICKERSON, Cinematographer
BARRY ALEXANDER BROWN, Editor
WYNN THOMAS, Production Design
ROBI REED, Casting
RUTH CARTER, Costume Design
PRESTON HOLMES, Production Supervisor
RANDY FLETCHER, 1st Assistant Director
DARNELL MARTIN, 2nd Assistant Camera
DAVID LEE, Still Photography
KEVIN LADSON, 3rd Assistant Props
ART SIMS, CEO of 11:24 Design Advertising [Poster and Logo Design]
CHUCK D [of Public Enemy]
TOM POLLOCK, Chairman, Universal Pictures (1986–1995)
SEAN DANIEL, President of Production, Universal Pictures (1984–1989)

"Those that'll tell don't know," says Da Mayor in *Do the Right Thing*. "And those that know won't tell." That may have been true for the characters who lived in the Bedford-Stuyvesant neighborhood of Brooklyn on the hottest day of the summer, but for those who starred in and worked on Spike Lee's masterpiece, knowing and telling weren't mutually exclusive.

In the oral history that follows—an unprecedented insider's look at *Do the Right Thing* and the lasting effect it still has on our culture—you will discover from firsthand accounts how Lee cast the film, shot key scenes (such as the race riot), dealt with critics' warnings of violence in theaters, and even helped to bring our President and First Lady together.

'IT'S GONNA BE A SCORCHER TODAY'

SPIKE LEE [Mookie], Writer, Producer, And Director: New York City at that time was a very racially polarized environment, which I still feel was fueled by Mayor Ed Koch. The Howard Beach incident [in which a group of white youths, many of whom were Italian-American, attacked three black men, including one who ended up being killed by a car] had recently happened, and I wanted to explore the love-hate relationship between African-Americans and Italian-Americans. I'd always been intrigued by that because we were the first black family to move into Cobble Hill, a neighborhood in Brooklyn that was primarily Italian-American at that time. I got called a nigger for, like, the first week, but once they came to realize that there were not, like, 20 million more black families coming behind us, it was okay. For this film, I also wanted to do something that took place on the hottest day of the summer. I'd never read any study or anything, but I knew things just got crazy in New York once it hit 95 degrees.

MONTY ROSS, Co-Producer: Spike would usually stop at this little bodega on his way to the 40 Acres and a Mule office and pick up a cheese Danish and the *Daily News*. Sometimes he would get the *Post*, but mainly it was the *Daily News*. I would hear things coming from his office: "Eleanor Bumpurs!" He was livid about that. "Oh, man, Howard Beach!" By the time he had gotten through the articles, he had gone ballistic. Spike didn't know yet exactly what the story was going to be, but it was starting to take shape in his mind. And when you saw that he had gotten a big stack of index cards and yellow legal pads, then you knew he was ready to really start writing.

ERNEST DICKERSON, Cinematographer: Spike and I were sitting together on a plane to Los Angeles, because we had something to do out there for *School Daze*, and he was writing a script on a legal pad. The title at that point was *Heat Wave*. He then asked me, "How do you portray heat on film? How do you get the audience to really feel it?" I remember we talked about having car radiators boiling over, hot asphalt, and steam.

JON KILIK, Line Producer: Spike had just finished *School Daze* and needed a producing partner to help set up his new film. So he and Monty came to my place to talk, and either at that meeting or the next, Spike said, "Let's do the movie for $10 million, let's get Robert De Niro to star in it, let's get Paramount to finance it, and let's start shooting on July 18." Well, we *did* start shooting on July 18.

LEE: Paramount was on track to make the film. Then at the last moment, out of nowhere, they didn't like the ending. They wanted Mookie and Sal to hug, all happy and upbeat. I wasn't doing that.

SEAN DANIEL, President of Production, Universal Pictures (1984–1989): I had really wanted to be in business with Spike, so when I read the script for *Do the Right Thing*, I felt that it was a movie we had to make. It was going to be very provocative and yet accessible to a wide audience. So I gave Tom Pollock the script.

TOM POLLOCK, Chairman, Universal Pictures (1986–1995): I liked *She's Gotta Have It*, and I thought, wow, this guy's really talented. When I read *Do the Right Thing*, I felt it had the potential of being great. I also had never before seen a movie that dealt explicitly with race—and what was then called a race riot—from a black director, and I'm always interested in something new. I thought it could be a little dangerous, not in that it would inspire riots but that the agenda would be misperceived. Our job at the studio was not to change the social fabric of America but to make entertaining movies on interesting subjects. But provocativeness is also a good thing, so I thought if it could be made inexpensively enough, then we ought to do it. I originally put the budget at $6 million and Spike wanted $7 million, so we compromised. I said, "If you bring it in for $6.5, then I won't touch it. You can make the movie you want to make." We told Spike what he needed to hear: that we'd back him, market it, sell it, and take the heat. Because we all knew there was going to be some heat. We had just made *The Last Temptation of Christ* [for which Pollock, director Martin Scorsese, and others received death threats], so we weren't naive.

DANIEL: Let's just say that we hadn't lost our nerve. We knew what we were getting into. We could read. There was nothing that was hidden.

POLLOCK: The only scene I discussed with Spike before we made the movie was where Mookie throws the trash can through Sal's window. I was worried about it because we spent a lot of the film setting up both Sal and Mookie as relatively good guys. We didn't ask him to change it, but I did want to know what he was thinking. Spike explained that that's what can happen when resentment boils over, especially with the oppressive summer heat, and how, after Radio Raheem is killed, at that moment, whatever has come before doesn't matter. It didn't make me less nervous, but I certainly understood what he meant.

'MY PEOPLE, MY PEOPLE'

LEE: I definitely wanted Robert De Niro to play Sal. He is one of my favorite actors, and what young filmmaker wouldn't want him to star in his or her film? I gave him the script, and he liked it but said it wasn't for him. He told me that he knew an actor named Clem Caserta [who was said to have once owned a pizzeria on Mulberry Street in New York's Little Italy] who would be great for the part. So out of respect for Bob I met with him, but I knew it wouldn't work. And casting De Niro would have thrown everything out of kilter, because the film is such an ensemble piece. I've learned in my career that people who are meant to get a certain part get that part. And Danny gave the best performance of his career.

DANNY AIELLO [Sal]: I was in New York at a party for Madonna, and as I was leaving, this little guy runs after me and says, "I have this script." So we started a dialogue, which led to meeting in restaurants, going to a Yankees game, going to a Knicks game, getting cheesecake at Junior's in Brooklyn. We became relatively close. But not politically—I'm a conservative, and Spike sits on the left side of the court. Well, I was off to Toronto to do a movie, and he sent me the script. I'll never forget that shit, because there wasn't enough postage on the package, so it didn't make it through customs. I got it about four or five days later, and in the first few pages, Sal was essentially described as a pizza man, which to me was tantamount to being a watermelon man if I were black. I didn't read the rest, because that really turned me off. So I told Spike I wasn't interested. He said, "Just read the script." When I got back to New York, we continued to speak, and I said, "I'll be honest with you, if I'm going to do this, I would like to be involved with the writing." Ultimately, of course, any decisions on what stayed or got cut were made by Spike, but little things, like the parts where I'm not a fuckin' loser, were written by me.

LEE: Every actor contributes. I mean, people aren't robots that say everything exactly how it is written. I welcome contributions from the actors. But every time I talk about *Do the Right Thing*… look, I'm not going to dispute Danny. It's been 21 years, and he feels what he feels, and I feel what I feel. He can feel that way when it's been 50 years. For me it's a non-issue. What's important is that he gave a great performance, and people are still talking about this film today.

ROBI REED, Casting: Spike and I always tried to use new people in each film we did together. That way the list of actors would be fresh. Wesley Snipes auditioned. We wanted him to play one of the street kids, but he had been offered *Major League*, and it conflicted with our schedule. I had just happened across Robin Harris and Martin Lawrence, both of whom were fairly early on in their careers, so I told Spike, "Next time you're in L.A., let's go see these guys perform at the Comedy Act Theater, and maybe we can put them in the movie."

MARTIN LAWRENCE [Cee]: I remember Robi and Spike coming to the club to see my act. I didn't alter my performance or anything—I did what I did. I guess Spike liked it, because he offered me the job soon after.

LEE: I was in a Los Angeles club called Funky Reggae at a party for my birthday. This young lady was dancing on top of a speaker, and since it was my party, if she fell and broke her neck, I was going to get sued. I told her to please get off, and she jumped down and cursed me out. I had never heard a voice like that before.

ROSIE PEREZ [Tina]: It was my last week in Los Angeles, because I was leaving college to go back home to New York. A friend took me out to celebrate, and when we walked into the club, there were a bunch of African-American girls on the stage bending over. It was a contest to see who had the biggest butt. I jumped on the speaker and started screaming for the women not to degrade themselves.

LEE: I like Rosie, but she was not the activist back then that she is now. She wasn't on top of the speaker saying, "Women, we must rise against this!" She was dancing. Plus, she was the choreographer for *In Living Color*, and *all* the Fly Girls did was shake their asses.

ART SIMS, CEO of 11:24 Design Advertising [Poster and Logo Design]: It was an amazing party. Everybody was there: The Wayanses, Janet Jackson; I think even Michael showed up. But to make a long story short, Rosie was dancing on a speaker. No doubt about it.

PEREZ: I was dancing but not on the speaker. That's fiction. I confronted Spike later and asked, "Why do you tell people you discovered me dancing on a speaker?" And he said, "Because I did." I was like, "Are you on crack? That's not how it happened." I remember a bouncer took me down because I was yelling and screaming. I actually thought I was going to get thrown out of the club. He brought me over to Spike, and I didn't know who he was. He asked me where I was from and I said, "France." They asked me again later, and I said, "Bed-Stuy." Spike and Monty Ross just

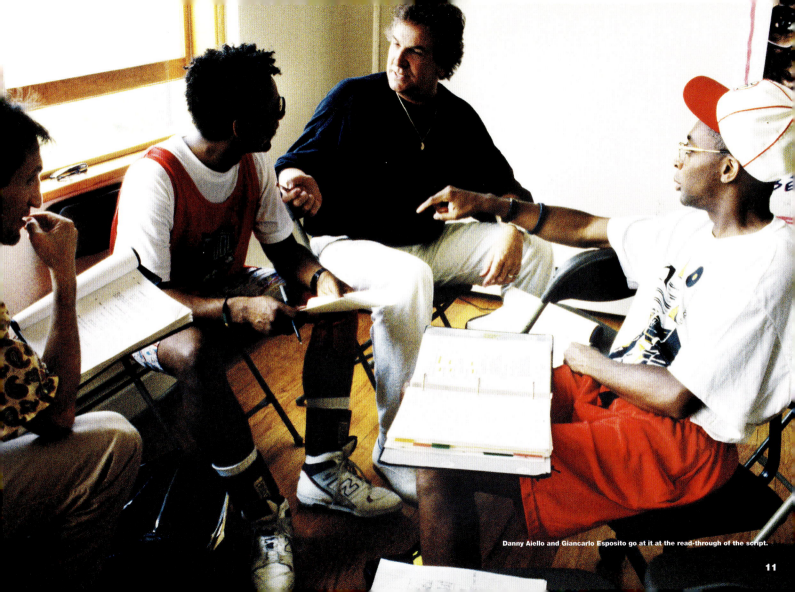

Danny Aiello and Giancarlo Esposito go at it at the read-through of the script.

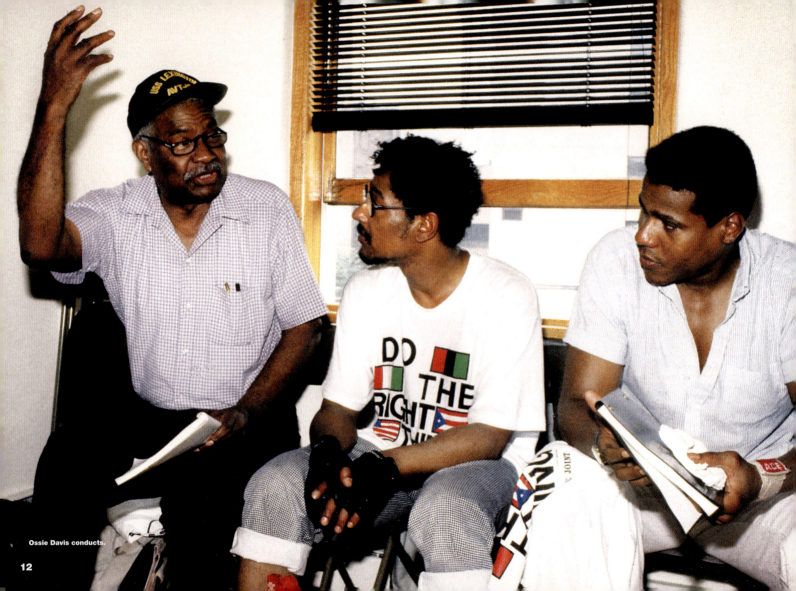
Ossie Davis conducts.

looked at each other and started cracking up. I was like, "What's so fuckin' funny about that?" Monty tried to give me their card, and I wouldn't take it. My friend did. She said, "He's the guy who did *She's Gotta Have It*." I said, "Oh," because I had liked that movie. I read the script for *Do the Right Thing* and thought it was great, but the character was written as a black woman. Spike said, "Don't worry, I'll change it." I was like, "Oh, okay, so I got the part?" And he goes, "No, you have to audition." So he flew me out to Los Angeles to read for Robi. I hated L.A., so it was weird that here's this New York director who wants me for a New York movie, but yet I have to go back to that hellhole that I was trying to escape from to get the job.

REED: Spike just had a feeling about her. I can't remember exactly what she read, but she had me crying. She got so deep into what she was portraying that she was crying, too. I called Spike and said, "She may not have any experience, but she's the real deal."

PEREZ: When they told me I got the part, I couldn't even speak. I was dumbfounded, because it wasn't my medium. I originally said to Spike, "I'm not an actor," and he was like, "Oh, yes, you are."

LEE: When I was in film school, I wrote Ruby Dee and Ossie Davis a letter saying that I was going to work with them someday. They told me that they kept the letter.

RUBY DEE [Mother Sister]: I knew this character from my childhood in Harlem. I remember seeing women on Seventh Avenue leaning out the windows, sitting on a pillow, just watching the block activity as if it was a television program. And they would talk to you as you'd pass by. She actually reminded me of my own mother. I was surprised, however, that someone as young as Spike knew this character. And Ossie was delighted to play Da Mayor, because he wasn't someone who was out of his capacity to imagine. Again, we knew these characters from our own lives.

JOIE LEE [Jade]: I liked Jade, and I was over the moon that Spike had written her for me. And of course, because I was playing his younger sister, I obviously had a place to start in regard to understanding the character. But the dynamic between Jade and Mookie was different, in that Mookie wasn't the ambitious go-getter that Spike is and Jade was parental towards her brother. I guess Spike inverted the dynamic in a way.

LEE: Matt Dillon turned down the role of Pino. His manager, Vic Ramos, told him not to do it. Then I saw the film *Five Corners*, in which John Turturro beats a penguin to death and throws his mother out a window. I was like, "That's the guy I want to play Pino."

JOHN TURTURRO [Pino]: When I read the script, I thought, *this* is what's happening. I grew up in Hollis, Queens, which was basically more black than white. So I knew both sides of the coin. I told Spike that I would prefer to play Pino, because he was a little more central to the story.

RICHARD EDSON [Vito]: Jim Jarmusch gave Spike my number and Spike called and then sent me the script. There was a note attached that read something like, "I see you as Pino, take a look." I still have it. When I read the script, I was like, "Cool, this is a real part in a real movie." Something I could get behind. It was really saying something, unlike [Edson's 1986 film] *Howard the Duck*. When I heard that John Turturro was playing the other brother, I got really excited, because I thought he was a very strong and serious actor. But I was curious, because Pino was a larger part, and I couldn't imagine that he would play second fiddle to me. One day Spike, John, Danny, and I all drove out to the set in Danny's huge car. John and I were in the backseat, and Spike and Danny were in the front. Danny did most of the talking. When we got there Spike showed us around. At one point, John was off by himself, and I went over to him and asked, "What part are you playing?" He looked at me and said, "Pino, of course." I was like, "Oh, okay." And that's how I found out that I was going to be Vito. It really didn't matter to me. From an acting point of view, it would have been more interesting and fun to play the racist, but Vito was closer to who I am as a person, so it was more of a natural fit.

GIANCARLO ESPOSITO [Buggin' Out]: I'm half-Italian and half-black, so I understood both sides on a deep level. And a hard part of growing up for me was that I didn't want to take sides, but for this character, I had to. I take credit for bringing Buggin' Out to life and creating him in my mind's eye and vision. Spike gave me room and leeway to improvise to a certain degree and also to be spontaneous. I, of course, give Spike a lot of credit for drawing up wonderful characters, but I did feel that in *Do the Right Thing*, they were a little over the top. Especially Buggin' Out, who was in your face. I wanted to make him a guy who had a strong desire to change the world around him and be an activist but didn't have all the knowledge and tools to facilitate change. He's very headstrong but also angry. Buggin' Out would agree, as would probably Spike, that African-American men deserved to be angry because of the way the world treated us and the racism that we experienced. So his anger was justifiable, especially in New York during that period. But at the same time, I wanted to make him a fun guy who enjoyed life.

BILL NUNN [Radio Raheem]: I didn't mind not having that many lines, because I was a big fan of guys who didn't talk that much, like Steve McQueen. Spike had originally wanted me to play Mister Señor Love Daddy, who talks all the time. I thought Sam was a better fit.

SAMUEL L. JACKSON [Mister Señor Love Daddy]: I was a stage actor, and in my mind a character was a character, and I would figure out who that character was. I think I was supposed to originally be one of the Corner Men, and Bill would have been Love Daddy and Fish [Laurence Fishburne] would have been Radio Raheem. If I were cast as one of the Corner Men, I would have found my way to be him; if I were cast as Radio Raheem, I would have found my way to be him, too. I was just trying to bring my character to life. That's all.

ROGER GUENVEUR SMITH [Smiley]: All of my work throughout the film was improvised. There's no Smiley in any script. When I was young, I would go with my father every Thursday to buy *The Los Angeles Sentinel*, and the man who sold it talked a lot like Smiley. Later, when I was in high school, there was a guy who had been a great athlete but also had disabilities. So subconsciously, I think those two people had an influence on me creating a man with these particular challenges and skills. At a meeting the morning after Spike gave me the script, I hit him up with the idea of having Smiley walk up and down the block, trying to sell copies of the photo of Martin Luther King Jr. and Malcolm X together. At the end, Spike shook my hand and said, "See you in Brooklyn."

FRANK VINCENT [Charlie]: When Spike first called me, I didn't know who he was. I had never heard of him. He said, "I'm Spike Lee; I'm a director." I said, "Are you a Chinese director?" He said, "No, I'm black." I said, "Are you a black director?" He said, "No, I'm just a director." Then he mentioned that Martin Scorsese had suggested that he call me, and when I heard Marty's name, of course my ears went up. Soon after, I asked my girlfriend's friend's boyfriend, who was black, if he knew who Spike Lee was. He said, "Yeah, man. I know who Spike Lee is." Then he proceeded to show me *She's Gotta Have It*. It made me realize that Spike was someone tangible. After some research, I learned of Spike's reputation—that he was considered racist and loud—so I had some second thoughts, because I had no desire to get involved with all the racial things that were going on at the time. But I liked *She's Gotta Have It*. I knew Danny and John. It seemed like it was going

to be a good movie. And a job is a job. So I went to meet with Spike, and the rest is history.

PAUL BENJAMIN [ML]: The title intrigued me, and I also found the project interesting, because before Spike was even born, I spent a year in Brooklyn trying to make some money for college, and I lived not too far from where the film took place. I also liked the fact that he knew that he wanted me for the role. As I recall, at no time did Spike ask me to read for him.

FRANKIE FAISON [Coconut Sid]: I really liked that Coconut Sid was a balance between the two other Corner Men. Sweet Dick Willie was over the top and outlandish, while ML was very serious and intense. Sid was in the middle. People would tell me how much they loved those three guys and how they couldn't wait for us to show up in another scene, because they knew we were going to say something wild and crazy. I think everyone really related to them. We were a breath of fresh air.

STEPHEN PARK [Sonny]: In the script that I had, my character was known as "Korean Clerk." And when Ginny Yang, who played my wife, and I were called to the set on walkie-talkie, we were referred to as "the Koreans." That really bothered me, especially considering that the film dealt with race relations. So I told Spike, who was with Danny outside Sal's, that I wanted my character to have a name. I mentioned that my Korean name is Sun Kyu, at which point Danny said, "Sonny—I'll call you Sonny." It was a mini–Ellis Island moment. And it meant a lot to me.

Real-life father and son Danny (right) and Rick Aiello.

REED: By the time we got to our table read, which we would do just before rehearsal, I knew that this was going to be something special.

'YOU STEPPED ON MY BRAND-NEW WHITE AIR JORDANS!'

RUTH CARTER, Costume Design: When we sat down to discuss the film, Spike emphatically said, "It's the hottest day of the year, and what do people do on the hottest day of the year—they wear less." He talked about girls having on midget tops and the guys in lots of shorts. Spike had very specific ideas on what Mookie was going to wear. Hands down, you couldn't mess with the Jackie Robinson jersey. We had a lot of support from local merchants in the community. Radio Raheem's shirt was hand-painted by a woman who lived in Brooklyn, and Señor Love Daddy's crocheted hats came from someone local as well. I was flooded with merchandise. I remember getting Radio Raheem's LOVE and HATE rings made at the Fulton Street Mall in Downtown Brooklyn.

PEREZ: I really didn't think the costumes reflected what people were wearing in Brooklyn. Spike wasn't from Bedford-Stuyvesant or Brownsville. He didn't go to the clubs. He was in artsy-fartsy Fort Greene. Maybe kids in Manhattan were wearing that stuff, but on my block, men did not wear biker shorts.

CARTER: I have no doubt that Rosie's outfits were things that she would have really worn at the time. In fact, I even think the red dress she had on during the opening credits was her own! Maybe not the boxing shorts and sneakers, which was one of my favorite costumes.

LEE: John Savage has said that Larry Bird gave him the shirt he wears during the scene with Giancarlo and the Air Jordans. Maybe John's having a flashback or something, but it's just not true. We bought it in a store. Even if Larry Bird was asked for a jersey, once he knew what it was for, he would say, "Hell fucking no, I'm not giving Spike shit!" I never had any problems with Larry Bird. He's one of the greatest players of all time. My issue was with how the media portrayed him as a Jesus Christ. But I never had anything personally against him. I'm pretty sure he knew that I mentioned him in *She's Gotta Have It*, because I was at a Knicks-Celtics game and was sitting opposite the Celtics bench. At one point, Bird was taking a rest, and Danny Ainge elbowed him, whispered something in his ear, and pointed toward me, and Bird just gave me a few looks.

CARTER: Yeah, we bought that Bird shirt somewhere.

JOHN SAVAGE [Clifton]: I may have been mistaken about the shirt, but I thought that Bird once threw it to my sister, who is a big Celtics fan. I seem to remember her having a crush on Larry.

AIELLO: Bird was my favorite basketball player, so Spike and I would joke around about that.

CARTER: I remember thinking that I'd start a trend by putting a big Swatch watch on Joie's ankle. I was like, "Yeah, everybody's gonna start wearing watches on their ankles"—not! I watched the film fairly recently, and I cringed when I saw some of the outfits. They're so '80s pop-culture colors. I thought to myself, okay, that was then and this is now. It doesn't mean that we did something crazy—people were wearing the outfits and were comfortable with them, so it couldn't have been *that* bad!

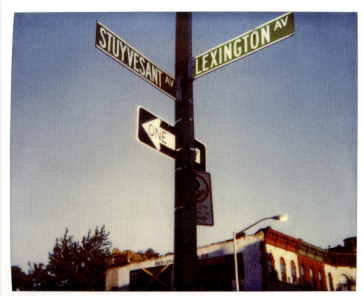

Bed-Stuy Polaroid.

'YOU GOT TO BE DOWN'

PRESTON HOLMES, Production Supervisor: From the beginning, Spike made it very clear to me, Jon, and Monty that this was going to be a union film and we had to work with the unions to make sure it was a two-way street—meaning that they would have to provide avenues and opportunities for people of color to get membership and training.

KILIK: At that time, there were two unions in New York: IATSE, which was the bigger one that directors such as Martin Scorsese, Woody Allen, and Francis Ford Coppola used, and NABET, which was more of a low-budget movie union. Spike wanted to be like the big boys, so we went to IATSE first. We told them, "Look, we want this to be a union film, but we have a dozen or so people who we want to work with and aren't members, and we want to make sure they have a chance to get in either as interns or trainees." That meeting didn't last too long. So we approached NABET, and they were open to the idea and started working with us. That was very brave on their part.

HOLMES: NABET consisted more of younger, hipper guys who were in the business more because they really loved film than because they were the fourth-generation grip from an Italian or Irish family that's been doing it since the dawn of time. In New York, the Teamsters—even more than IATSE—had the reputation as the union you didn't want to cross. And nobody did, until Spike came along. He said basically from the beginning, "Okay, fine, I understand this is how the game is played, but you need to understand that I want to see some people of color, and if you don't have any, then we've got a problem." And the Teamsters had very few people of color. In fact, for this film, one of the drivers, Willi Gaskins, was brought out of retirement because he was black.

ROSS: Spike was on *The Oprah Winfrey Show* talking about filmmaking, and he mentioned the Teamsters. Not long after, Tommy O'Donnell Sr., representing the Teamsters, came to meet with Spike. He was, like, 300 pounds, and I remember him walking up the three flights of stairs to the 40 Acres office. He said to Spike, "You're on national TV talking about us—what do you want?" Spike was like, "With all due respect, we just want what's right. We love New York, and we're committed to making films here. But we need more African-Americans in the union. There are a few people who need to get their books. Tommy, that's all I'm asking for." Tommy said, "You're asking for a lot, kid. You're asking for a lot." Again, it was just Spike being that Young Turk who wanted to change things. And thank God he held his ground.

LEE: My issue with the unions and Teamsters was always about diversity. They would say, "We don't have any qualified people of color," and I would give them a list of people who were qualified. All we tried to do was give qualified people of color, both male and female, a shot at getting into the industry that, for the most part, had shut them out. I was given an opportunity, so I felt like it was my duty and obligation to get as many people in the union as possible. Now, we weren't talking about taking a hooker from around the corner; we were talking about talented, dedicated, hard workers who wanted this to be their career.

KEVIN LADSON, 3rd Assistant Props: I was like, hell, there are more black people working in this industry than I was aware of. I mean, like, in every department. To me, that was historic.

DEE: It was a kind of breakdown of the exclusivity of the film business. He had whites, blacks, Asians, women, physically challenged people. Everybody worked for Spike. It was thrilling that this young director could effect that kind of thing in a work setting that had not been integrated in the past. And it has persisted to this day.

HOLMES: I tell people this all the time—especially if I hear, or hear of, somebody bad-mouthing Spike—there has never been any individual that has done more to increase the opportunities behind the camera for people of color in this business than Spike Lee. Not before and not since. End of story.

'BED-STUY—DO OR DIE'

KILIK: Definitely more than once, the studio suggested we film in L.A. on the back lot. They could have kept an eye on us and the money, and it was written perfectly for that setting: one block on a hot sunny day. They tried to disguise it as: What if it rains in New York? Which it does, and it did. And we dealt with it.

LEE: They also suggested Baltimore or Philadelphia. If they insisted, I would have made it with someone else, because you *had* to do it in Brooklyn.

DICKERSON: We needed the New York accents, the New York architecture. There are brownstones in Baltimore, but even they aren't the same.

DANIEL: I remember Spike being firm about it having to be shot in Brooklyn. And I was very partial to his point of view. I'm from New York. I loved that it was a New York movie and thought it would fit right in with the great tradition of films that use the city as a strong cinematic character.

WYNN THOMAS, Production Design: I scouted every block in Bed-Stuy. From a conceptual point of view, I wanted one with very few trees because I didn't want any of the characters to have an escape from the heat. It had to feel like a desert landscape after a storm: dry, barren, but with splashes of color. The location we settled on, Stuyvesant Avenue between Lexington Avenue and Quincy Street, was the only block I showed to Spike, because it fit all our requirements: two vacant lots directly across from each other, where we could build Sal's Famous Pizzeria and the Korean market; and there was a high vacancy rate, because we needed empty apartments for the We Love radio station plus our other sets. Also, we were about to "invade" and ruin a lot of people's summers, so lots of community meetings were held by our producers and location manager. We were all in constant "seduction mode" to keep everyone happy.

ROSS: People knew that Spike was from Brooklyn, lived there, and now wanted to make a film there. So what he brought to the table resonated throughout the community. Of course, there are always going to be, as the kids would say, "haters," but because Spike was creating jobs and making improvements, most people in the neighborhood felt very good about us being there. So from that standpoint, we got our pass. We explained how we wanted to be inclusive, put local people to work, and not just come in and bogart everything.

LEE: Anytime a film company stays in a location for a lengthy period of time it's like an occupying army. It's a great inconvenience. People can't play their radios or TVs loud; they can't park in certain places. The block party we held before we began shooting was a gesture of goodwill.

THOMAS: The neighbors were fascinated during the construction phase and for the first week of shooting, and then people seemed to want to get back to their lives.

DICKERSON: When you have a location like that, you work with the neighborhood and try to get it on your side. We did some fixing up and spiffed it up a little.

REED: One of the families on the block didn't have a refrigerator, so production bought them one.

LEE: There were several crack houses in the neighborhood. The NYPD was not thought of that highly in most black communities, especially Bedford-Stuyvesant, so we got [Minister Farrakhan and the Nation of Islam's security force] the Fruit of Islam to watch the set and make sure we had no problems.

HOLMES: Prior to *Do the Right Thing*, I worked on a film called *The Super Cops*, which also shot in Bed-Stuy—actually, not too far away from the *Do the Right Thing* block. On that one, we used a group of young men from the local mosque who were in the Fruit to do security. It worked extremely well, so when we were about to make this film, of course it was something I looked to do again. Like the rest of the city and country, Bedford-Stuyvesant was being devastated by crack cocaine, so the presence of the Fruit of Islam transformed the area, at least temporarily. Whatever one thinks about the Nation of Islam and its beliefs, the fact is, the Fruit have always had a stellar reputation in black communities. People respect the way they live: not drinking, not doing drugs, taking care of themselves and their families. And in addition to that, there is also an element of you-really-don't-want-to-mess-with-those-guys, because rumor had it that they were all trained in martial arts. You just would rather not pick that fight.

DICKERSON: It became the safest block in Brooklyn!

JACKSON: They weren't guarding *me*; they were closer to Spike and everybody else. I wasn't a valuable commodity. I was just the guy smoking reefer in the radio station.

EDSON: I tried to get through to those guys. It was kind of a challenge, because I knew they had very strong racial feelings and were there doing their job in their nice suits and little bowties. So every morning, I would say hello and try to engage them. I don't think they ever even acknowledged me. I finally gave up after about four weeks.

TURTURRO: They talked to me all the time. They called me "Brother John." I guess Richard is not as black as I am.

ESPOSITO: Those F.O.I. cats were hardcore. They just didn't like or hang out with white people.

HOLMES: I certainly was not aware of any issues or discomfort with or among the white actors when it came to the Fruit. On the other hand, if I were a white actor, I might have been uncomfortable whether the Fruit were there or *not*. After all, we were shooting in Bed-Stuy!

TURTURRO: The neighborhood had a lot of energy, but it was dangerous to go through at night. I was living in Park Slope, so I used to drive to and from the set. You definitely didn't want to have a flat tire at four o'clock in the morning, because there were a lot of hungry dogs out on some streets.

DARNELL MARTIN, 2nd Assistant Camera: I remember having to step over a dead rat when I was moving my camera equipment. They were everywhere.

AIELLO: Before the block was cleaned up for the movie there were crack vials all over the place, and when we were shooting, many of the people hanging around, watching were, unfortunately, drug addicts. I loved filming there, but it really was a very devastated area.

RANDY FLETCHER, 1st Assistant Director: One day I saw a guy walking down our block whom I played basketball with and had known for years. I said, "Rob, Rob, how're you doing?" He was like, "Stay away from me, I'm on the job." Turned out he was a narcotics detective. We were in an area that was rough as can be and were telling people that you can't hang out or cross the street until we say you can. That didn't make them happy, so we got attitude all the time. They were like, "Fuck you, this is our neighborhood. Are you going to come back after you're done shooting the movie?" One time, there was a baby crying in a building up the block. There was

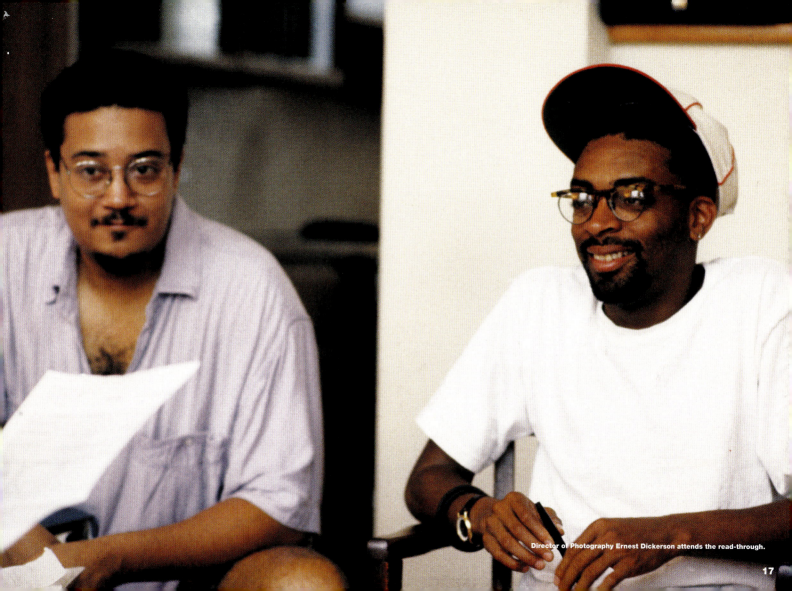

Director of Photography Ernest Dickerson attends the read-through.

no air conditioning, so the window was open and we could hear it. I took our production assistant Mike Ellis aside and said, "Go into that house and calm that baby down. I don't care if you have to breastfeed it yourself; just keep that baby from crying!" Even the police sometimes gave us a hard time. A couple of times I had to say, "We're all filmmakers—just because we're black, don't treat us as if we're criminals." Their attitude was like, "I don't give a fuck if you're doing a movie, you're still all black people in a neighborhood that has problems." When we would open up the block at night, they couldn't tell who was from the film or who was a street person.

JACKSON: I was still in my drug phase then, so I would hang out in the radio station smoking weed and drinking beer all day. I would leave the set and walk to the real stores in the area to buy beer or some potato chips, and the crack dealers would see me and say, "You one of those movie niggers, huh?" I'd be like, "Yeah." Then they would say, "You all are fucking up our business, so we're gonna fuck you all up." I was like, "Well, you can go over there and beat up any actor you want to, but just understand something: I ain't always been an actor. I used to be just like you. So I don't know what I'm supposed to be doing while you're whupping my ass, but I don't think I'll just be taking it." They eventually got used to seeing me, so I'd just go about my business. I would say, "Hey, how are you doing?" and they'd just stare at me. But the Fruit of Islam had to stand guard at night because the dealers had threatened to burn all our sets down.

LADSON: People thought the Korean market was real because it was stocked with actual products. One night, right after we closed the store, a guy came up to us and said, "I just want to get a pack of cigarettes." R.W. Dixon, who was the Unit Manager, told the guy, "This isn't a real store, and we're in a motherfucking war zone." It turns out the guy was a Vietnam vet, and he just snapped. He said, "War zone? I'll tell you about a motherfucking war zone." And then—no joke—he popped out his glass eye. One of the A.D.s was standing there, and his mouth dropped open to the floor.

ESPOSITO: We created our own Do the Right Thing neighborhood. It was really phenomenal. When we were on our block, we were protected. We felt like we owned it. But once you left the set, if you were white, I could imagine you would be nervous. No doubt about it. It felt dangerous.

RICK AIELLO [Officer Long]: It was a little unnerving, because there weren't many white guys around, and I was playing a cop and wearing a police uniform. They always made sure I had a robe on any time I left the block. But to be honest, being from a rough neighborhood in the Bronx, I really wasn't afraid or felt unsafe. It was probably half a tribute to the security and half a tribute to my stupidity and naïveté.

MIGUEL SANDOVAL [Officer Ponte]: Early on, before I was needed on the set, I was bored one day, so I decided to visit the block. I think it was the second day of shooting. I was staying with one of my agents in Brooklyn Heights, but I didn't really know much about Brooklyn, so I hopped on the subway but didn't calculate how to get there very well. I got off at a stop that was probably about ten or twelve blocks away from the set, so, basically, I had to walk through Bed-Stuy. When I showed up, Spike said, "Hey Miguel, who came and got you?" I said, "Nobody." He said, "You took a cab?" I said, "No, I took the subway," and then I explained how I had to walk. He then said, "Don't ever do that again." I thought he was kidding, so I said, "What's the big deal?" He said, "No, no, no—you don't understand. This is Bedford-Stuyvesant." You could tell from his expression that he was thinking: I just almost lost one of my cast members. I never did it again.

SMITH: I lived only two blocks away from where we were shooting. I wasn't trying to immerse myself in any kind of method; it was just convenient. In fact, after we finished making the film, I stayed in the neighborhood for a while and would commute to Manhattan for a play I was doing.

LADSON: It was classified as a bad neighborhood, but some of the nicest people I've met lived on that block.

'PIZZA HEROES CALZONE SAUSAGE'

THOMAS: I spent a great deal of time researching Sal's Famous. I scouted pizzerias all over the five boroughs and found a prototype in Coney Island. The way I looked at it was that Sal had built the place himself from scratch at a time when people really cared about their stores. Building Sal's was a labor of love for my team, and it became a place to hang out for the actors and crew in between takes. The oven worked, so the set was filled with real heat and smells. I think this helped give the actors a sense of time and place. In a way, the ultimate compliment we got was when real people would walk off the street and try and buy a slice. We could have made a lot of money selling pizza.

LEE: Not at $1.50 a slice.

EDSON: I didn't learn how to make pizza. John went out of his way to learn, because he's much more from the Method school of acting than I am. I was like, I can take the broom and the pizza boxes and make it look like I'm at home and comfortable at the pizzeria. There wasn't a plot or story point that involved making pizza. Or maybe I was just lazy.

AIELLO: I couldn't make a fuckin' pizza if my life depended on it.

'WAKE UP!'

KILIK: Not long before we started shooting, Spike had told us that call time was 6 a.m. I checked to see when the sun was supposed to rise that day, and it was maybe 6:15. I told Monty and Randy, "Well, we could have call time be 6:30." They just looked at each other, and one of them said, "Okay, then you go tell him." I went up to Spike and said, "Do you know what time sunrise is for our first day?" He said, "No, but I know what time call time is: 6 a.m." There was another instance, when we were shooting the scene where Da Mayor brings Mother Sister flowers. We were running out of light, and we really needed to get the shot, because Ruby was doing a play on Broadway at the time and could only work with us on Mondays. Spike told Ernest, "Get all the lights you have and make it look like it's daylight." As the sun was going down, Ernest lit the scene, and it totally worked. Spike is not going to wait for the sunrise to start shooting or stop when the sun sets.

FLETCHER: Spike's the coach. He knows exactly what, how, and when he wants things done.

HOLMES: I remember riding back to Manhattan one day at the end of work in a car that included Wynn Thomas and I forget who else. I was lamenting that even though I was having a great time, I couldn't figure out what Spike thought of me. I said, "I speak to him every day, and he hardly says two words to me." Wynn was like, "I've known and worked with him for a long time, and he's the same way with me. That's how he is. Basically, if he's not saying anything to you, everything's fine." On the last day of the shoot, Spike was walking past me, and I said, "Good morning, Spike." And he said, "Yo, what's up? Now that we're done with this one, you ready to do it again?" I was like, "Sure, I'm down." He said, "Alright then," and walked off. I later told Wynn about it, and he said, "See?"

DEE: I watched Spike direct as much as I could, because there was just something about seeing this little young man pull off what I call "astonishing nuggets" of reality, drama, and humor that seemed so intrinsic to things that I've known. I'm always struck by how long it took for me to realize that Spike was not a kid. He looked more like a boy than a man to me. But I did, of course, later learn what a man he was.

'EVERYBODY KNOW WHY THEY CALL ME SWEET DICK WILLIE'

FAISON: We were pretty much on that corner the whole time. I think we may have stood up a couple of times from those chairs, but that was just what it was—we were called the Corner Men. When we were finished, I couldn't say that I missed that corner, but I couldn't say that I was sick of it, either. I could only say that I was done. I haven't been back to it since.

BENJAMIN: There was a beautiful truth happening there on the corner.

LADSON: It was the first day, and I was told to give the Corner Men their beer. So I poured ginger ale, put it in brown bags, and handed it to the three of them. Robin Harris [who played Sweet Dick Willie] was like, "What the fuck is this?" I said, "Ginger ale." He goes, "I'm supposed to have a motherfuckin' beer." I said, "You can't drink while we're working." Man, did he curse me out. So then I go to give Ossie Davis his "beer" and in a tone similar to Robin's, he says, "What's this?" Now I'm thinking, oh, my God, I'm going to get cursed out again, but this time by the great Ossie Davis. So I say, "It's ginger ale," and he responds, "Okay, thanks." Funny though, Robin basically cursed me out the whole film, because I was always in charge of giving him the drink. I think I was the first person he ever called a test-tube baby. I wasn't sure if he was fucking with me or not until we did Mo' Better Blues. He came up to me one day and said, "I was fucking with you the whole time."

BENJAMIN: By the end of each day, I was sick, because my buddy Robin would keep us laughing from the moment we hit the set until they would say, "It's a wrap." I would be in pain from all the laughing.

LAWRENCE: Robin and I shared an apartment near the set. We were always laughing.

JACKSON: Robin was constantly on Martin's ass about the noise he made at night and using up all the toilet paper or whatever. Whenever Robin, Martin, and Steve White, who was kind of like a black Henny Youngman, were around, it was like a one-upman joke fest. Robin usually won.

STEVE WHITE [Ahmad]: We would snap on each other's mamas all the time. Martin didn't want us to snap on his mother, so he would say, "Snap on my aunt." It wasn't quite as vicious as going after his mom, but we said okay and snapped on his aunt. Sometimes you wouldn't even understand what the hell Robin was saying, because he mumbled. But you would know to laugh at the punch line.

FAISON: At first, I didn't know that Robin was a comedian. When I would see him on the set, he

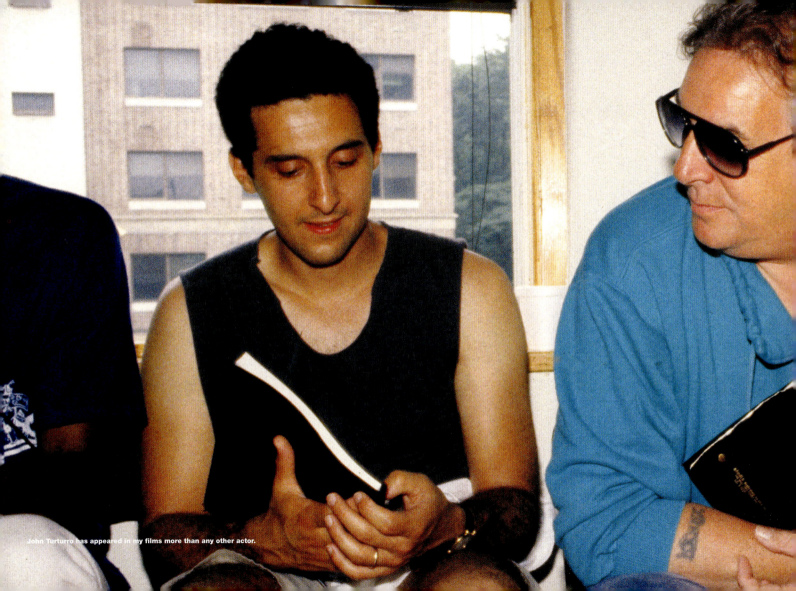
John Turturro has appeared in my films more than any other actor.

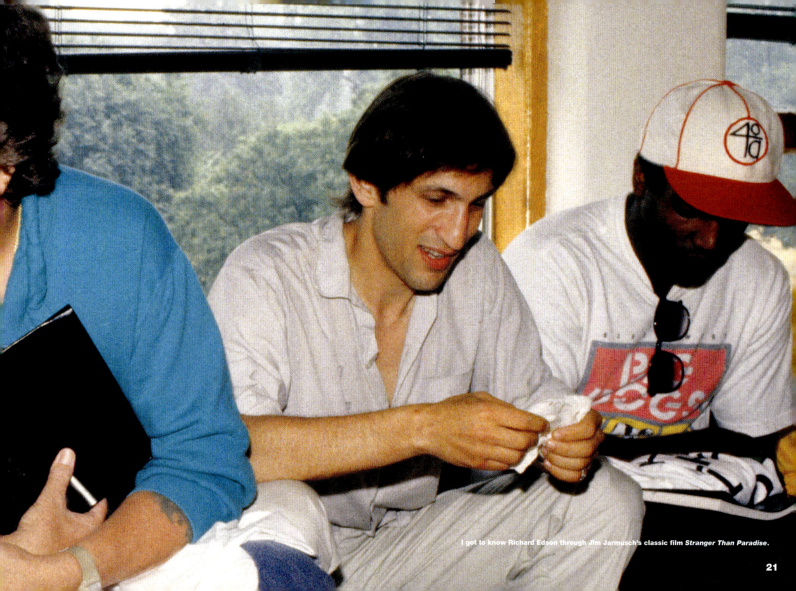

I got to know Richard Edson through Jim Jarmusch's classic film *Stranger Than Paradise*.

would tell me the same joke over and over again. It was usually a line from the film, but occasionally it would be something that wasn't in the script. At first, I thought because he was new to acting, he just needed to go over his stuff more than a normal person might. There were times when I would see him coming, and I would try to hide, because I just knew that I was going to be lambasted with the material. It was funny the first, second, even third time you would hear the jokes, but by the twentieth, I was like, I can't laugh anymore. I eventually figured out that he was working on his timing. After the film was finished, I was in California and saw him do stand-up, and his timing was just perfect.

BENJAMIN: I didn't mind if he told the same joke over and over, because he was just that kind of character.

FAISON: I can't remember exactly where I was when I heard that Robin had died [of a heart attack on March 18, 1990; he was 36]. But I remember thinking what a tremendous loss. I didn't fully realize his genius until I saw him perform. I felt like I was watching the earmarks of a giant in the industry. He had a special gift, like Redd Foxx's or Richard Pryor's. That night in California was the last time I saw him. It just broke my heart.

BENJAMIN: I was in Philadelphia doing the play Fences when I heard the news, and it just wiped me out. Wiped me out.

WHITE: Sad, sad, day.

'DA MAYOR DON'T BOTHER NOBODY, AND NOBODY DON'T BOTHER DA MAYOR'

TURTURRO: A real plus to making this film was that I got to spend a bunch of days hanging out with Ossie Davis. That was huge, because I was really crazy about him. He was a special guy.

AIELLO: I loved him because of the way he treated my sons. He was wonderful to both of them.

LUIS ANTONIO RAMOS [Stevie]: Ossie and I were sitting together eating and talking, and mid-sentence, he looked over my shoulder, got up, and walked away. Ruby had just arrived on the set. He asked her how she was, took her coat, and got her something to eat. I'll never forget the look on his face when he first noticed she was there. Later, I asked him how, after all those years, seeing this woman could bring about such a look. He just said, "We've been together a long time, and of course we've had our troubles, but I love her." When I'm dating a woman, and it's starting to get serious, I tell her about that story and say, "If you see that look on my face, then you know we're good."

WHITE: Before we shot the scene where I curse out Da Mayor about being a drunk, I decided out of respect to say something to Ossie. I said, "Excuse me, sir, I hope you don't mind, but in this next scene I'm going to have to get a little loud and curse you out." Ossie was like, "Bring it on, you young whippersnapper, do your job." So I thought to myself, all right then, I'm going to tear a chunk out of Ossie's butt right now. And no hard feelings. We can split a Miller High Life afterward.

'TAWANA TOLD THE TRUTH!'

THOMAS: I hated the TAWANA TOLD THE TRUTH! graffiti, because I didn't believe that she was telling the truth. However, there wasn't an edict from on high that said we had to agree with everything in the film.

AIELLO: That was a turn-off to me, because everyone knew that it was a lie.

LEE: Even today, I cannot believe that Tawana Brawley would put herself in a garbage bag covered with feces. I'm sorry; I just don't believe that. I feel like we still don't know the whole truth. As Da Mayor says in the film, "Those that'll tell don't know. And those that know won't tell."

'20 D ENERGIZERS'

NUNN: Because we couldn't say "motherfucker" when the film was going to be on TV, we had to change it in looping. For the D battery scene in the Korean market, I had to say, "Mickey Fickey," for every "motherfucker." I thought to myself, this is the most ridiculous shit I have ever heard. I don't know who came up with it, but it had to be a white guy: "D Mickey Fickey, D!"

PARK: Watching this movie censored and with commercials is kind of silly. "Mickey Fickey you!" I mean, what world is that in?

'LET ME TELL YOU THE STORY OF RIGHT HAND, LEFT HAND'

LEE: I'd have to say that the movie that was the biggest inspiration for Do the Right Thing was The Night of the Hunter. That's of course where I got the whole LOVE and HATE idea. It was a great speech written by James Agee that Robert Mitchum recited in the film. I just changed a few words for Radio Raheem.

DICKERSON: I had been living with The Night of the Hunter since I was, like, in high school, so I really knew the film.

NUNN: We did the LOVE and HATE scene pretty quickly, because it was near the end of the last day of the week and I had to catch a plane to Atlanta—it was my wedding anniversary. Plus, we were losing light. If you look really hard, you can see that I flubbed a line, saying the wrong hand or something like that. We looped it later. I'm a big Robert Mitchum fan, so I was honored to pay homage to him and [Night of the Hunter director] Charles Laughton. It was an incredible moment for me. I don't have the rings. Hell, no! Spike's got them in the archive somewhere. I wish I did because I would love to have them. People still ask me about them all the time.

'THERE'S GOING TO BE A LOT OF FUCKING TROUBLE IF YOU GET THIS CAR WET'

RICK AIELLO: The scene with the fire hydrant and car was the first one I ever shot in my life, so I was shitting in my pants. I didn't know what the fuck was going on. Frank and Miguel were

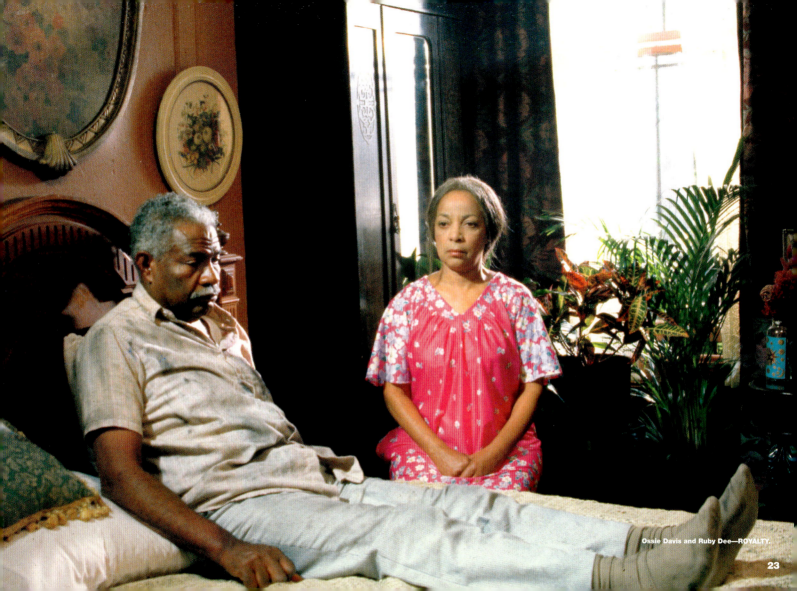

Ossie Davis and Ruby Dee—ROYALTY.

improvising, and I got a little nervous, because I was going by what was in the script. So I didn't really say much. But I remember it was fun as hell.

SANDOVAL: Spike gave us the freedom to come up with whatever we wanted for that scene. When I asked Frank the names of the guys who soaked his car, he answered, "Moe and Joe Black." That was wonderfully improvised. It was hard to keep a straight face during his tirade.

VINCENT: It was easy for me to keep a straight face, because I was wet and uncomfortable. While I was driving the car, I was sitting in waist-high water because it was lined with plastic and filled with water so when I opened the door, it would all pour out. We did it about three times, and after each take I had to change my clothes while the other outfit was being blow-dried.

'THANK GOD FOR KNEE CAPS'

DICKERSON: In the weeks leading up to when we were going to shoot the sex scene, I spent a lot of time talking to Rosie about it. We wanted to make her feel as comfortable as possible, promising not to rush anything. One of the hardest things for an actress to do is a sex scene. And this was Rosie's first acting job, so it was doubly tough on her. She was nervous. One of my camera interns, Darnell Martin [who went on to direct *I Like It Like That* and *Cadillac Records*], pulled focus for the shot, so there was a woman there, because if I remember correctly, it was just me, Spike, Rosie, Darnell, and maybe a boom operator.

MARTIN: I was actually promoted to 1st AC for the scene. Ernest said something like, "We're doing this love scene, and we want Rosie to be as comfortable as can be, so are you ready to pull focus in there?" I was excited to be promoted, but I was uncomfortable, because I really felt that Rosie wasn't so into or happy about what she was doing for the scene. Lots of times, you think you can do something, and then on the day you have to, you can't. That's why now, when I'm casting a woman who has to appear nude, I'm like, "Are you *just fine* with running around naked or are you thrilled about it, like a happy exhibitionist?"

PEREZ: I felt that the nudity was gratuitous. For *She's Gotta Have It*, I understood why it was in there—I got it. But it wasn't needed in *Do the Right Thing*. It was upsetting. You know, it's difficult for me to speak about that. Not because I have negative flashbacks or anything but because it affected my relationship with Spike. We didn't speak for a while. But people change and grow, and we've since mended our friendship. We're beyond that now. Actually, it's ironic, because I always said that I felt exploited, but I started to feel like I was doing the exploiting. I mean, it must have hurt Spike to read about this over and over again. So I just want to move on. Plus, there's so much brilliance in the movie, other than this stuff, that should be looked at and admired.

LEE: Rosie has said that she shouldn't have appeared topless, but it seems like her being upset about that was years after we shot it. Maybe it took a while to sink in; I don't know. Rosie never explained how she felt. I found out by reading about it. But like Rosie says, we both moved on, and we're okay with each other.

'WE WANT SOME BLACK PEOPLE ON THAT MOTHERFUCKING WALL OF FAME—NOW!'

AIELLO: I don't think Sal was a racist, but I don't think he was a nice guy all the time either.

Spike has said that I tried to make Sal lovable, which isn't true. I wanted him to be complicated. I've been acting a lot longer than Spike's been directing or writing, so that's an error on his part. I remember that we screened the film in New York City, and 90 percent of the audience was black, and people came out of the theater saying that Sal had a right not to put the pictures on the wall. It was wonderful that black people understood my character and why he was so steadfast about certain things.

LEE: What Danny has failed to realize is that Buggin' Out's point was just as valid as Sal's. That's why *Do the Right Thing* is complex and why people are still discussing the issues raised in it over 20 years later.

Laurence Fishburne visits the set.

AIELLO: Spike has also always said that when we were filming the fight in Sal's, I was afraid to or didn't want to use the word "nigger." I guess it's actually a compliment, but he's talking about the wrong guy. He might be talking about John Turturro or Richard Edson but definitely not me. What I said to him was, "Do you want to use it this much?" I felt that you diffused the word if you kept saying it. But anytime "nigger" was written in the script, I said "nigger." Spike hired me because he knew that I wasn't afraid to say the word. He knew that I'd used that word my whole life. I'm not proud of it, but I did. I grew up in a black neighborhood, and both blacks and whites said it.

LEE: Danny did not want to say the word. He told me that he had never used it before. I was like, "Come on, you're playing a character and don't tell me that Sal has never used that word before." During the scene, Giancarlo called Danny a "guinea bastard," and Danny flipped and called Giancarlo a "nigger." That's the take we used, because he went berserk.

ROSS: Danny just didn't want to be seen in that light.

ESPOSITO: It was very heated. Danny did not want to say the word, because he felt it was too obvious. I remember Spike saying, "You know you've used that word before." So we talked about how he grew up and how I grew up, so we could get to a place where we could push each other's buttons and say things we really didn't want to. It was always hard for me to accept being called a "nigger." When I was ten years old, I asked my mother how I should respond to being called that, and she said I should call the person "white batter," like you make cakes with. That's not quite as snappy or biting as "nigger." I shared all this with Danny. When we started getting into the scene, it really flew. He called me all these things that he probably hadn't said since childhood, and I said some things that I wouldn't say to anyone. I even called him "white batter." I held off calling him a "guinea," because my father's Italian, so I knew how much Italians hated being called that word. In fact, Danny reminded me at that time of my dad. I grew up with Italians, so I actually believe that I'm more of a "guinea bastard" than a "nigger." Spike kept saying to me that he wanted Danny to get angrier and freak out for the close-up, so when I finally said "guinea," Danny flipped. It was an amazing moment. When we finished, the first thing we did was hug each other. We were both in tears, because that was a lot of hate to access.

TURTURRO: I don't really remember that whole thing about Danny not wanting to say that word, but *I* said it throughout the whole movie! What's the big deal? Give me a freaking break, man. The Ku Klux Klan could have used me as a recruiting poster. I guess some actors want to be liked. I don't really care. I just want people to be awake. It's not like I never heard those words or was never involved with any of that stuff before. Where I grew up, that's part of life. I hadn't used every word in the movie before, but it was still all common terminology. Once I got comfortable, I wanted to go the whole hog; I added a lot of racial insults, especially Italian words. Spike and Ernest would fall down laughing. Still, it was hard to say some of those things in front of people and see their reactions while we were watching dailies. One of the girls in craft services wouldn't talk to me, because she would see and hear these things over and over again. She told me that she hated me. She wouldn't even give me water.

LADSON: She said to me, "That motherfucker is a racist." I told her, "You're taking it a little too hard. He's an actor. He's just doing his job." But she just wasn't having it. Again, she was like, "That motherfucker is a racist."

RICK AIELLO: There was nothing at all like that for me. Nothing stands out in my memory that says, "Whitey, get the fuck out of here."

Tina and Mookie.

TURTURRO: I told Spike that I was worried that some people may think that I was like Pino in real life and I would get hurt on the subway. At that point, we were still living through all that. But the fantastic thing is that I never got one negative comment from the black community.

'I JUST KILLED YOUR FUCKING RADIO'

NUNN: When Danny smashed the radio, Spike said, "Bill, you stand over there…goggles for everyone else." I was like, "You fuckers!" I was trying not to act scared, but I really didn't want to get splintered plastic in my eyes.

EDSON: That moment felt real. It seemed to come from a real place of anger on Danny's part. It was pretty scary, because Danny's a big guy, and he put a lot of weight and feeling into destroying that radio.

LADSON: I have broken pieces of the boom box. They said, "We don't need it; throw it out." I was like, "Oh, no you don't." I put some in a black garbage bag and took it home. Now those pieces are pretty historic.

LEE: The late film critic Gene Siskel was a big collector. He bought the radio that wasn't destroyed.

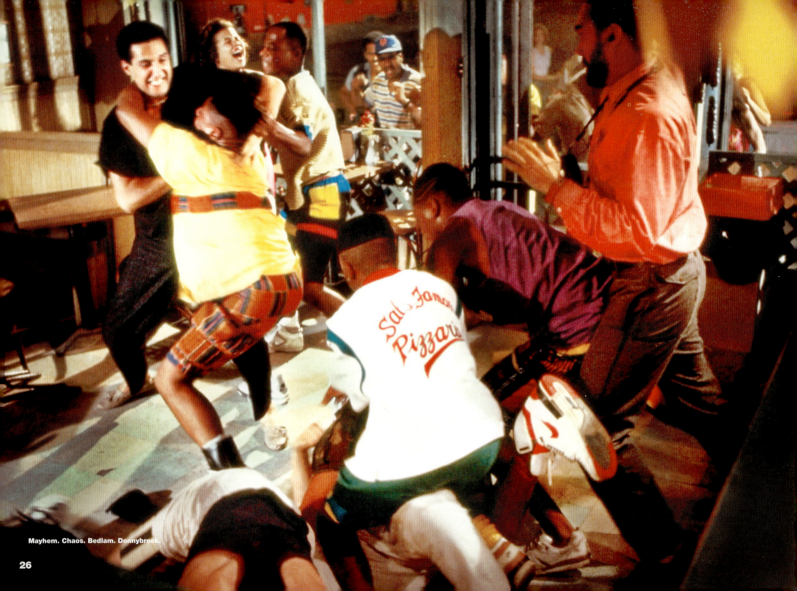

Mayhem. Chaos. Bedlam. Donnybrook.

AIELLO: Spike wanted Bill Nunn to slide me down the counter while bottles bounced off my head. I said, "I'm not doing that shit; it's fuckin' ridiculous. Spike, that's *Comedy Time in the Fuckin' Rockies!*" I thought that what was intended degraded the character, and I told him that if that's what I have to do, I'd walk off the fuckin' movie. It was that serious. I didn't want the scene to be a joke. I wanted it to look as if I was going to be killed. I was like, "I want to be yanked over the counter and manhandled. I wanted to be ravaged. I will not be a cowboy sliding down the thing—that's not vicious. What's vicious is Bill yanking me over and choking me." And that's what we did. I'm a stubborn fuck, so who knows, maybe because of that, I got the Oscar nomination.

NUNN: I don't remember that version, but I'm glad we didn't film it that way, because it sounds really bogus. Maybe I've blocked it. Sliding him like that John Wayne shit doesn't sound cool to me.

TURTURRO: Danny didn't want to have his head smashed. I was standing behind him, and Spike looked over at me, and I shook my head as if to say I didn't agree with Danny. I was really on Spike's side, because Danny had smashed that radio for so long, I felt like, okay, well, now he has to get *his*. I'm not blaming Danny, he did a wonderful job, but that made a lot of people tense.

AIELLO: This was the point in the movie where the riot is about to take place—why start off with a laugh? That's what I thought. Now, Spike evidently didn't think that, but I did, so I voiced my opinion.

LADSON: I stumbled right into the argument between Spike and Danny. At first, I thought they were rehearsing, but then I realized they weren't acting, because Spike had his glasses on. When he was in character, he didn't wear them, but if he had them on, it meant he was directing. It was really tense. You're talking about two completely different people, like Democrat and Republican.

FLETCHER: When parents are having an argument, the oldest kid takes the younger ones out of the room. That's kind of what this was like. We were inside Sal's and there was something like 25 people around. Things were getting heated, and I felt Spike and Danny shouldn't be arguing in front of the cast and crew. I decided to clear the set, so they could have their privacy and say whatever the fuck they wanted to, one on one. They were in there for, like, ten minutes, maybe a little longer. I was right outside, and when they were done, Spike gave me a look as if to say, "Okay, we're cool."

EDSON: When the fight between Sal and Radio Raheem started, there were a few actors who wanted to act as if they were really fighting. It was crazy, because there were like ten of us. So I whispered to Leonard Thomas [who played Punchy], "Let's do a little dance here, make it look like we're wrestling." He was like, "Okay." So we ended up doing like these wrestling moves off to the side. They just let us go. I could be wrong, but if we had more direction or choreography, Leonard and I wouldn't have been able to go off to the side and do our little dance.

LEE: We really didn't have a top-flight stunt coordinator.

NUNN: Danny and I went by the numbers, so our fighting went very smoothly. But some of the guys weren't sticking to the choreography, so it got a bit out of hand.

TURTURRO: I got really hurt in that scene, because some of the actors were inexperienced and there were a lot of people on top of me. My ribs were bruised; I had ice packs all over. We did a take that ran for, like, five minutes, and that's a long time to get hit. I told Martin and Steve, "Guys, you have to pull your punches." They were hitting me in my side.

WHITE: Is that what he said, that Method actor punk? Maybe if he wasn't such a goddamn racist, it wouldn't have hurt. Isn't he in Europe right now doing ballet or something? By the way, this is where it should say, "*KIDDING!*"

TURTURRO: At one point, Martin was falling down, so I tried to grab him, and I put my finger in his eye. He had to go to the hospital and came back with a patch. Then he did this whole stand-up routine as if he was a fighter, thanking God that everything was okay.

LAWRENCE: It was a complete accident and John felt bad. He was very apologetic. Since I was injured, Spike actually wrote it into the scene, so it would work with what we were doing.

RICK AIELLO: It was disturbing to watch the fight between Bill and my father. The way Spike shot it, it just looked so real. Also, someone can get hurt when you have people jumping on each other on that kind of scale. And remember, there were a lot of people from the neighborhood hanging out, and some people who watch movies can't always separate fantasy from reality, so that was a little scary. My brother was doubling for my father, so when he's getting roughed up and kicked, there were twinges of: What the fuck is going on? Is this real or is it Memorex?

NUNN: When Danny and I were fighting, Danny Jr. was coaching his dad. Then Ricky started choking me. Man, the Aiellos ganged up on me!

SMITH: During the fight, I was spitting on people, and Danny's son, who was also his stunt double, didn't understand who my character was. I suppose that he just thought that I was some out-of-control, undisciplined actor, so after a take, he said, "Who the hell is spitting?" It was very tense. And Spike, being the instigator that he is, didn't say, "Oh, that's Smiley, he's mentally challenged." No, he just stepped back and waited to see what was going to happen, because he's always looking for an angle to be used dramatically.

AIELLO: My son Danny jumped up and went nuts. He was going to tear Roger's fucking head off.

FLETCHER: Boy, did that not work out well! Junior, who was a terrific gentleman, starts saying, "He's spitting in my face." He was irate and ready to go off. Coming from Brooklyn [I understood what he was thinking]: I don't care if you're Marlon Brando—you spit in my face, and we're going to fight.

RICK AIELLO: We thought Roger was an extra just being an asshole. Later, I saw Roger's work and realized that he is a really good craftsman, and I thought maybe the spitting was coming from some place inside him and wasn't gratuitous. But at that moment, it pissed me off. Who knows, maybe if he had said to my brother, "I'm going to do this." Maybe he just got caught up in the moment, too. Some of the best stuff an actor does is improvised. But still, when bodily fluids are being exchanged, that's different.

LEE: Once I knew about it, I wanted it stopped.

TURTURRO: There are actors that are really good guys but sometimes they go the whole hog, and someone has to tell them, "Hey, don't do that."

EDSON: I was like, "Wow, that's kind of rude, but it's an interesting choice. I'll go along with it. Of course, he wasn't spitting in *my* face."

'BURN IT DOWN, BURN IT DOWN!'

NUNN: The whole neighborhood felt hot that night. You got the vibe that something could have really jumped off. There was something in the air that was electric—and a little dangerous.

LEE: The garbage can was heavy, and the window was thick plate glass. I threw it two or three times, and it just bounced off. So finally, we had to score it, and then it broke.

JACKSON: We were yelling at Spike, "Come on, man, put your ass in to it!"

WHITE: I think I may have yelled out, "Come on, Chicken Arms!"

THOMAS: This was early in my career, when I would become emotionally attached to my work. I wasn't looking forward to the destruction of Sal's Famous Pizzeria, so Spike burned it down on a day when I wasn't on the set. I thought that was very sensitive.

AIELLO: It was sad to watch it burn down. I thought it should have been preserved, almost like a landmark or tourist attraction.

LEE: It had to be done. Danny, give that up, baby, give that up.

RAMOS: Cedric the Entertainer does a routine about how when a black person sees other black people running, he or she takes off running as well, despite not knowing why. That's kind of what it was like when we tore up the pizzeria. It was basically kids just following what others are doing. But at the same time, there was anger and frustration about what just happened to Radio Raheem. Once they yelled, "Cut!" we had to emotionally recover, because we were all so invested in what was happening.

DEE: In a sense, I wasn't acting, because I had lived through it. In Harlem, I had seen the people running down the streets, ransacking stores, and the cops trying to beat them up. It wasn't hard for me to imagine. I understood why Mother Sister was shouting, "Burn it down!" when Sal's was set on fire, because, as I saw in older women when I was a kid, the people that you didn't think would ever throw a brick did, and the people you thought would have thrown one didn't.

SMITH: Going into the pizzeria while it was on fire was like walking into a huge, propane-fueled barbecue pit. I didn't feel that I was in danger, but it was hot enough outside, so to be inside was pretty crazy.

JOIE LEE: I was sitting still on the curb next to Spike while all around us was pandemonium. I still remember the heat coming from the fire. At one point, Ruby and I were going to be hosed down [by the firemen putting out the fire] and dragged down the street by water. We rehearsed it with a mat that was going to be pulled by a car or something. I was game, but they decided it was too dangerous a stunt.

DICKERSON: I got a little spooked because the flames were crawling up the walls, so we had to cover ourselves with blankets—we were being bombarded with hot exploding glass. There were also things being thrown around, and I remember the cash register landing extremely close to me.

DAVID LEE, Still Photography: We shot the scene right up until the dawn. The sun was coming up, and I remember this beautifully subtle blue sky start to appear out of the black smoke coming from Sal's.

LEE: I wanted to use three Frank Sinatra songs in *Jungle Fever*, so I approached Tina Sinatra, who handled that stuff. She said, "Spike, I don't know. My father wasn't happy about his picture being burned in the pizzeria." It's funny—Pacino never said anything, De Niro never said anything. I had to do some serious smoothing over with Frank, and he finally gave the three songs: "Once Upon a Time," "It Was a Very Good Year," and "Hello Young Lovers." Many years later, I found out that he liked *Malcolm X* very much.

TURTURRO: The photos were all mine. They were copies, but they were from my collection. I didn't just have Italians; I also had Walt Frazier, Homer Jones, and Willis Reed on my wall.

PARK: It wasn't clear from the script where my character stood. Did he actually care about the community, or did he just want to make money? I know a lot of people back then would argue that many Korean market owners were racist toward African-Americans, but I went with my own truth and decided Sonny wasn't like that. Early on, it became clear that Spike was encouraging improvisation, so in the scene where the mob approaches me and I'm yelling, "I no white, I no white," which was written for me, I threw in, "You and me same," and extended my hand to Paul. I was grateful that Spike left that in the film.

BENJAMIN: I liked the fact that neither one of us knew what the other would be saying during the confrontation.

EDSON: All the actors were trying to be true to the moment, but I didn't feel any racial undercurrents. There were no anti-white feelings, no anti-black feelings—none of that. It was more like, "This is a great scene, so let's do it as well as we can." Honestly, I didn't sense any racial divide on the set at all. It just seemed like—corny as it may sound—one big happy family trying to do a job and having a great time doing it. People were being judged simply by how well they were doing their work, not what race they were. It was exactly how race relations *should* be.

'Y'ALL NEED TO CHILL'

SANDOVAL: I remember when Mike Tyson visited the set and when Stevie Wonder came by. Stevie had Spike's arm, and they walked down the block, just the two of them. Of course, behind them was this huge crowd. I remember thinking, Holy mackerel, that's Stevie Wonder! Actually, I'm old enough that I was like, Holy mackerel, that's *Little* Stevie Wonder!

RAMOS: Almost all of us were there for the whole shoot because Spike wanted the principal players to show up in the background of shots. So we spent a tremendous amount of time together. It was very unique for a film. It was actually more theatrical in that sense.

FAISON: You never knew when you would be needed to be pulled into a scene. It wasn't like a typical movie where you are told when to come in and how long they'll need you. Most of the time I hung out with Paul and Robin, but at some point or another, you'd find yourself on a stoop speaking one on one with almost everybody there.

JACKSON: I was just kind of stuck in the radio station, which was one small room: maybe 12 by 20, if that. And it was very hot, because there was no air conditioning. Spike would say, "Alright,

Sam, we're going to pass by the window on this shot," so I'd have to stand up and look like I was spinning records or something. The majority of the time I was asleep in there on a ratty-ass sofa that I'm not even sure was a prop. It may have been something left over from the crack days.

FAISON: The conditions were brutal. It was a low-budget film, so there wasn't a lot of money to be found. They did the best they could, but it got rough.

JACKSON: Even Danny didn't have a trailer. We had a big open room with curtains hanging from pipes—that was our dressing room. Everybody just hung around together and talked. It was like Spike Lee summer camp.

MARTIN: All the girls on the set were wearing tight bicycle shorts, and the guys were always checking out their butts. So in turn, the women decided to hold a contest to see which man had the best butt. This went on for, like, a week. At first, the guys thought it was funny, but then some of them got really upset. We were like, "Now you finally know how *we* feel." By the way, Spike's brother David won the contest. He was very proud of himself. In retaliation, the men held a contest and picked Matiki Anoff, our makeup artist. She and David were the Butt Queen and King.

DAVID LEE: What can I say; I'm forever the Butt King of *Do the Right Thing*. My prize was an unused pair of BVD briefs, which I still have. But let the record show that I didn't mention Matiki's name, because she won't speak to me. She doesn't like to be reminded.

RAMOS: The local school, which we were using as a holding area, had a gym, so a bunch of us would play basketball: Martin Lawrence, myself, Steve White, Leonard Thomas, Turturro, Sam Jackson. It would get pretty competitive. One time, Martin got hit in the eye, and we all freaked out. Randy Fletcher came in and was like, "That's it! No more fucking basketball." That was the end of that.

LADSON: I don't know whether Spike was picking on me or not, but it seemed like whenever there was something somebody didn't want to do, he would say, "Kenny the prop guy will do it for you"—he always got my name wrong. Spike would also make me clean the street. Da Mayor's line about the sidewalk being as clean as the Board of Health could have been written about me. I still get shit about that from other members of the crew. They say, "Yeah, I remember Kevin sweeping the street," and they'll mimic me sweeping. But I kept that bad boy clean. I also remember doing a scene with Ruby on the porch, and all of a sudden, she starts screaming. It turned out that stray cats were living in the building we used as Mother Sister's home. Apparently Ruby hated cats, so Spike goes, "Kenny, go get those cats!" One of them actually became the prop-room mascot. We named him Fleabie. The next year we came back to the block to film the video for "Fight the Power," and there was Fleabie in the street, walking around. That was one strong cat, man.

MARTIN: They also called it Crazy Cat, or Demon Cat, or Devil Cat, something like that. It was really dangerous—it would attack dogs.

CARTER: Because the film took place during the course of one day, we needed multiples of the outfits. Funny, though, even with the multiples, by the end of the shoot, some of the clothes were a little mildewy and falling apart. It got rough. Also, we filmed through August, and it got really cold. Not only did the actors have to keep wearing shorts, I had to keep them looking sweaty, so my department, as well as makeup, was out there sweating the clothing and the actors' faces. We were also providing blankets because they were freezing.

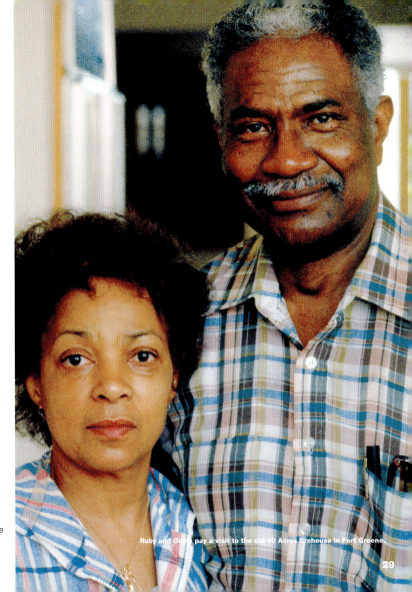
Ruby and Ossie pay a visit to the old 40 Acres firehouse in Fort Greene.

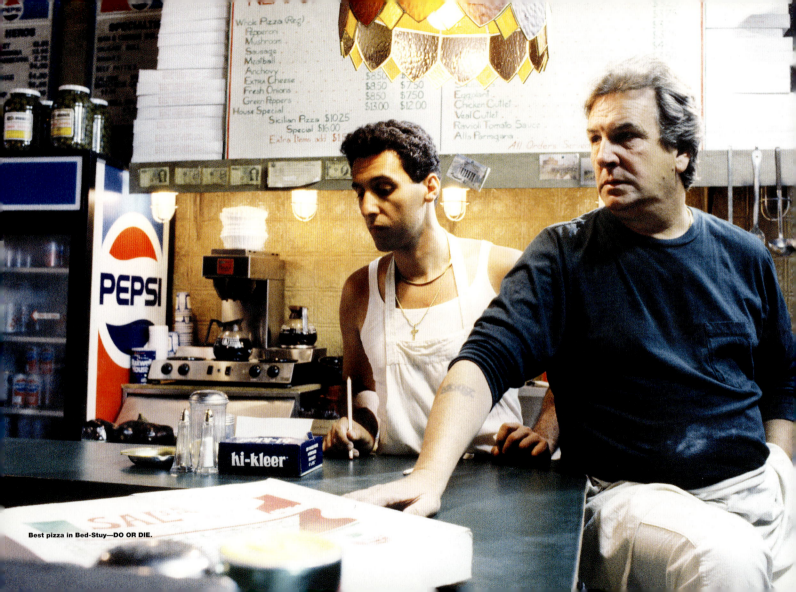

Best pizza in Bed-Stuy—DO OR DIE.

LEE: We had an expensive brass plaque cemented into the sidewalk that said the film was shot on this block. Unfortunately it was stolen.

WHITE: I think the plaque was taken before the cement dried!

LEE: I'm still waiting for it to show up on eBay.

'ELVIS WAS A HERO TO MOST, BUT HE NEVER MEANT SHIT TO ME'

LEE: If you look at the opening credits of all my films, they give the audience a hint, a taste of what the film's about. And Rosie is a great dancer—she was dancing the first time I met her, so that's how I wanted *Do the Right Thing* to start.

PEREZ: Originally, the choreographer, Otis Sallid, had choreographed a 1960s kind of soul dance routine to the song "Cool Jerk." But one day Spike said, "Everything's changed—we got this new song."

CHUCK D [of Public Enemy]: Myself, [music producers] Bill Stephney and Hank Shocklee, and Spike were at a restaurant in Soho, and Spike said that he was doing a film that would reflect what was happening in New York City at the time. He then mentioned that he wanted a song that would signify that theme and that Public Enemy had to be the artist that recorded it.

LEE: I needed an anthem. The first song Chuck brought me was good, but it wasn't an anthem. So I gave him more information about what I was looking for.

CHUCK D: We were touring Europe with Run-DMC, and I told Spike, "When I get back, I'll have the song completed." I remember writing a large portion of the lyrics to "Fight the Power" on a plane over Italy, sitting not too far from DMC and Jam Master Jay.

LEE: When I heard "Fight the Power," I was like, "This is a motherfucka! This is it!"

CHUCK D: I went to Brooklyn to see a rough cut that had a version of the song that was unmixed and incomplete. I remember just sinking deeper in my seat, thinking, "This has to get better." Especially considering how much he used it in the movie. I had never heard a song used in a movie that much.

NUNN: I was thrilled that Public Enemy was doing the song. And when I finally heard it, I thought it was perfect. But we didn't have it during the making of the film. I was just walking around with the radio lights on but no sound.

PEREZ: When we were doing the opening credit sequence, I never got sick of "Fight the Power," because it is brilliant. Its anger and angst actually kept me going when my body was exhausted. I mean, you can't dance for eight hours straight with only a lunch break and ten minutes here and there. I developed tennis elbow, because Spike kept having me punch at the camera as if I was boxing. My back went out, my knees were messed up—I ended up on crutches. Also, we were doing it on a soundstage in Brooklyn, which had a concrete floor. That made it even more taxing, because, unlike wood, concrete has no give. I remember telling Spike that I can't do it again, and he was like, "We're going again." He kept telling me to bring more passion and anger to the dance. At one point, I looked over and saw him sitting there, and I was so pissed off, my nostrils just flared. I kept getting more and more exhausted and angry and was almost on the verge of tears. It's funny, because many people have told me that one of their favorite parts of the scene was when I put my hands on my hips, grinded down towards the floor, and looked to the side. They would say how sexy it was. Of course, I wasn't trying to be sexy—I was just so angry that I couldn't even look at the camera. It wasn't until I saw the movie that I understood what he was doing. I think the emotional part of the sequence is brilliant, but as a dancer, I still have a problem watching it, because I thought my dancing was horrible as a result of how tired I was.

LEE: It's not like we could have cut away from her. Rosie *is* the opening credit sequence, and we only had money for a one-day shoot. Film is a tough business, a tough business. That's what I always tell my NYU film students.

'YOU GOT MY BACK?'—'YOUR BACK IS GOT'

KILIK: Before Cannes, we showed the final print to the Universal executives—Tom Pollock, Sam Kitt, Sean Daniel, and Jim Jacks. They were sitting in the front of the screening room and Spike, Monty, [editor] Barry Brown, and I were in the back. When the film ended, the guys from Universal just sat there—no sound, no nothing. We just kind of looked at each other. Finally Spike stood up and said, "Well, are you going to release it?" That broke the ice.

POLLOCK: I don't remember Spike saying that, but it's very possible he did. I do remember being absolutely stunned. Both profoundly depressed and really moved. But there was no question of whether or not to release the film. One of the lessons we all learned from *Last Temptation* was that you stand by your filmmakers. You never duck and run.

DANIEL: I remember that screening, but there was never an issue about whether to release it. When you see the film for the first time and get attached to the characters and then watch how it builds to the climax and goes to the place it does, you're shocked and taken aback. Part of you is saddened, but another part goes, well, there's no other way this could have ended.

POLLOCK: It wasn't like, "Put a big happy ending where Sal and Mookie kiss." But I did say to Spike, "You've portrayed this accurately—America's fucked—but what should we all do?" There weren't any solutions offered to the problem. Do we just sit here and take it? What's our position? That's when he added the Martin Luther King Jr. and Malcolm X quotes at the end. I'm not sure if that accomplished it or not, but I had no better answer. I still don't.

DEE: Malcolm and Martin, both of whom I knew, would have understood what the impulse was coming from the film—that Spike was writing about the catalysts that create racism.

ROSS: When we got to Cannes, there was a real buzz. It was magic. I remember at the first screening, when the film ended, Spike got a standing ovation. Steven Soderbergh [who was at the festival with his directorial feature debut, *sex, lies, and videotape*] said to Spike, "Congratulations—I've never seen anything like that before."

KILIK: At the press conference, Spike was absolutely amazing. It was May 19. I remember the day because it was Malcolm X's birthday.

LEE: Roger Ebert was a champion of the film. He said that if it didn't win the Palme d'Or, he would never go back to Cannes. It was a noble gesture.

Sal and his sons watch their business go up in flames.

DICKERSON: I was upset that Wim Wenders, who was the jury president, couldn't accept *Do the Right Thing*, because he thought the film had no heroes. Yet he heaped all this praise on *sex, lies, and videotape*. Where is the heroism in that one?

ROSS: At the award ceremony, when *sex, lies, and videotape* was announced as the winner of the Palme d'Or, Steven looked at Spike as if he was going to say something but didn't know what. I took that as him acknowledging that *Do the Right Thing* was the better film. I thought that was very respectful on his part. On our way back home to New York, we were on the same flight as Sally Field, who was a juror. At one point, she looked over at Spike and said, "I voted for your film—it was the best one there."

LEE: Look, I wasn't going to hit anybody in the head with a bat. [Lee was quoted as saying, "I have a Louisville Slugger with Wim Wenders's name on it" after *Do the Right Thing* didn't win the Palme d'Or.] Wim wouldn't have even known what a Louisville Slugger was. I was pissed, that's all. WE WUZ ROBBED! The last time I was on the jury at The Venice Film Festival, Wim had a film at the festival that was in competition for the Golden Lion. I wasn't a one-man jury…but it didn't win.

POLLOCK: We released *Do the Right Thing* in the summer, because we wanted to take advantage of the buzz from Cannes. In fact, I would have released it even sooner, but the promotional-materials—the trailers, the posters, etc.—weren't finished yet.

SIMS: For the film's logo, I wanted it to have an African feeling, so we put Kente cloth bars above and below the letters. Kente cloth was a fabric worn by African-Americans as an acknowledgment of their African heritage. After the movie came out, and it was a hit, advertisers were like, "If you want to reach out to African-Americans, use Kente cloth." For the poster, we set up a photo shoot on the New York street on Universal's back lot. The photographer Anthony Barboza was hired to shoot it. We brought in a little girl, dressed her in a Kente cloth shirt, and had her lay on the ground. The muralist Richard Wyatt drew the logo on the street in chalk. We brought in a car that looked like Sal's Cadillac. Then we had Spike and Danny look up, because we wanted it to be a bird's eye view. It was a sunny day, so Danny and Spike were squinting, which made them both look a bit mean. Originally, there were other things written on the ground besides BED-STUY. We wrote BY ANY MEANS NECESSARY, but that was taken out, because I think the studio thought a Malcolm X reference wouldn't be well received. Later, in the photo lab, we changed the street from black to blue, because I felt the film had a fantasy-like feel to it. Also, at one point, the policeman's gun and bullets, which are in the poster, were pointed at Spike as if he was being shot. We were told to change that, because the studio felt as if we were saying that cops don't like black people.

'TOGETHER, ARE WE GONNA LIVE?'

PEREZ: I remember some people on the set were worried about their careers. I would hear things like, "Do you think this movie will ever see the light of day?" and "Everybody's going to be angry." My reaction was, "This film is necessary. It's not dealing with just a Brooklyn issue—it's worldwide." I knew it was going to piss some people off, but I didn't think anyone would riot. Everybody else started to put that fear in me.

RAMOS: I guess, at some point, I thought about what the repercussions of doing something like this could be. But ultimately, because of that, the work took on greater weight, and I took on a greater sense of responsibility.

BARRY ALEXANDER BROWN, Editor: A friend of mine was going to do a film about a black comic, so I showed him *Do the Right Thing* to check out Robin Harris. Afterward, he said, "You and Spike are irresponsible. You have no idea what you're doing. There are going to be riots and people are going to get killed." And this was a *friend*. I was like, "Whoa," because from the screenings I attended, my sense was that the film was actually *releasing* tension. We had test screenings with predominately black audiences in Washington, D.C., Baldwin Hills, and, I think, Philadelphia. African-Americans dug the film in a big way. It was joyous to them but also disturbing. It conveyed the message that there were big problems and we needed to address them. But my friend wasn't the only one who said that stuff to me.

LEE: People actually thought that young black Americans would riot across the country because of this film. How crazy is that? That was the furthest thing from my mind, because I had faith in my people. But I still feel that a lot of white moviegoers were scared off. They didn't want to go to a theater because it might be filled with crazy black people. *Batman* came out around the same time, and there was violence in that film as well, but I guess critics thought that white audiences would be intelligent enough to discern what was on the screen as opposed to what was real, whereas black audiences couldn't do that. The first day the film opened, I was in front of the National Theatre on Broadway. A huge crowd was around me, and I was signing autographs. Standing next to me were two cops, who were trying to keep me from being crushed. Well,

someone called the cops and reported that black people were attacking cops in front of the theater. Six police cars came screeching down Broadway, sirens blaring. The cops jumped out with guns and Billy clubs drawn. This was just like a scene from the movie. I remember this one cop, his face was beet red, veins popping from his neck. He started yelling at me, and I started yelling back—to which the crowd started cheering. Then it hit me like a ton of bricks: This could be the start of some serious shit. I could see the headlines: SPIKE LEE'S 'DO THE RIGHT THING' STARTS RIOT IN TIMES SQUARE. I remember that Joe Klein wrote that you should hope that the movie wasn't playing in your neighborhood. He still has never owned up to that. I saw Klein on the Acela coming back from the inauguration in 2009, and all I said to him was, "Next time you write a book, don't use 'Anonymous.'"

DANIEL: When I read what Joe Klein had written, I was like, wait, I've been to the previews. I've watched how riveted people were by the film and how much they wanted to discuss it afterward. Where was Klein coming from?

TURTURRO: Spike and I watched the film in some movie theaters with all black audiences, and they were jumping up and down and talking back to the screen. So you didn't know how people were going to react. We were in the middle of some of the situations that had happened in New York, so it hit very close to home.

CHUCK D: I expected some controversy because of the lyrics in "Fight the Power" about Elvis Presley and John Wayne, but I knew the film wasn't going to cause any violence.

SAVAGE: I don't think we needed a movie for people to riot. Even in 1989, there were plenty of things on TV that were sensational, over-reactive—all the things *Do the Right Thing* was accused of being.

SMITH: If it wasn't controversial, then we really wouldn't have done our job, would we?

JACKSON: Back then, for whatever reason, everybody was afraid of Spike. And he knew that and liked to market the controversy. He said things that shocked people so they would pay attention.

TURTURRO: Nothing ever happened, yet nobody ever wrote a retraction or said, "You know what—we were wrong."

LEE: It wasn't that all white critics were negative and all black critics were positive. But even Stanley Crouch [who, in an essay entitled "Do the Race Thing," described Lee's vision as "small" and lacking "subtlety"] never said it was going to cause riots.

ROSS: I don't think enough credit was given to black audiences. Not everyone in the black community deals with things by taking it to the streets. There's intelligence there, and that is what was really overlooked. When people heard about the film, it was more like, "Finally somebody's going to address this hot-button issue in a way that I can understand. I can sit in a comfortable theater and really see what's going on in my community. I can relate to those people."

NUNN: I didn't think there was going to be that much controversy. When a guy from *The Village Voice* showed up at my house in Atlanta before it was even released, I was shocked. I was like, "You want to interview *me*?"

DAVID LEE: It was astounding to me that people had the gall to condemn a voice that was critical of the status quo. It was insulting on so many different levels: an insult to the intelligence of black people, an insult to the reality that black people experience. After the film came out, I spent two years arguing with white people, many of them friends, about Mookie's actions in the movie. It really opened my eyes to just how far apart realities are between whites and blacks in America.

DICKERSON: It bothered me that people reacted that way, but I wasn't surprised, because films that try to deal with racism often get a short shrift. Take Sam Fuller's *White Dog*, which is a brilliant movie. It's about racism, but it's not racist.

SMITH: What really happened that summer was Yusuf Hawkins was murdered [by a white mob

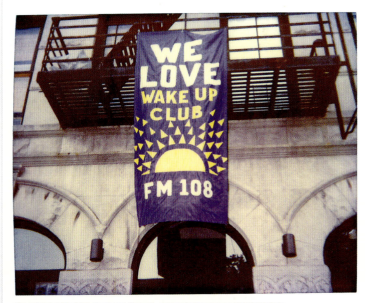

The residents of the block liked to see Samuel L. Jackson in the window of WE LOVE Radio.

in the predominately Italian-American Brooklyn neighborhood of Bensonhurst]. That's what *really* happened.

EDSON: It incited discussion; that's what it incited.

DEE: As an actor, I didn't expect controversy. But I do know how a film can affect a person—I've never seen anything as dastardly or horrible as *The Birth of a Nation*. But for Spike, I think the goal was to lift the veil from the eyes of a different set of people so everybody could see more clearly.

POLLOCK: I don't want to appear naïve, but I never thought that anyone would riot because of this film. I suppose that if something did happen, and people like Joe Klein or Jack Mathews [then a *Los Angeles Times* critic] had been right, then I guess that I would have looked really stupid. Or that I was trying to be a provocateur or something. But nothing happened. When Roger Ebert, who was and still is an extraordinarily important critic, called it a masterpiece and along with Gene Siskel said it was the best film of the year, I knew the perception was going to be that we had made something really great.

DANIEL: We didn't think that the film would cause violence—we thought it would sell tickets. And MCA, which was the corporate entity that owned Universal Studios at the time, didn't back away from supporting *Do the Right Thing*.

ROSS: There were college professors discussing the movie with their students. *The New York Times* wrote about it for several weeks. I remember kids in the sixth or seventh grade would write essays and letters about the movie and send them over to the 40 Acres office.

RICK AIELLO: I love Billy Nunn, but to me—and maybe it's because I'm white—at the end of the movie, I'm more concerned about Sal's Pizzeria than about Radio Raheem. I don't know if it's because of my father's performance or because I'm his son, or maybe it's because you dig deep into Sal's character but don't really know much about Radio Raheem. Maybe if there was a scene or two where Radio was getting his ass kicked by his father, you'd have a better sense of who he is. I have never been discriminated against at that level, but I felt more for Sal, who was a warm guy and you understood and knew where he was coming from.

TURTURRO: Movies are weird like that. White people got more upset about the burning of the pizzeria than Radio Raheem getting killed. When I did *Five Corners*, audiences were more upset when I killed the penguin than when I threw my own mother out a window. Now, I'm not comparing an animal's life with a human's, but that's just how people are. Radio Raheem wasn't given as much of as of a storyline as Sal, Pino, or even Vito. But it's still a horrific act.

NUNN: I guess a lot of people just saw Radio Raheem as a straight-up hood. But there's nothing in the script that says anything like that. He just seemed like an eccentric cat who was respected in the neighborhood.

LEE: It disturbed me how some critics would talk about the loss of property—which is really saying white-owned property—but not the loss of life. *Do the Right Thing* was a litmus test. If, in a review, a critic discussed how Sal's Famous was burned down but didn't mention anything about Radio Raheem getting killed, it seemed obvious that he or she valued white-owned property more than the life of this young "black hoodlum." To me, loss of life outweighs loss of property. You can rebuild a building. I mean, they're rebuilding New Orleans, but the people that died there are never coming back.

PEREZ: All the characters were over the top—not every Italian-American person feels or acts the way John's character did; not every Korean person feels or acts the way Stephen's character did. But for some reason, the Latin community just blew a gasket over my depiction. They were bothered that I was a single mom, that I was—whether they would admit it or not—impregnated by a black man, that my accent was heavy, and that I was uneducated. When I did interviews, they tried to kill me, but I wouldn't back down. I would say, "We got to tell the good, the bad, and the ugly, or else we're not going to get anywhere." I would also say, "If you don't believe that there is truth to my character, walk into a welfare office." That pissed them off even more. I would say, "Listen, I'm a college-educated person, so I'm proof that not every Puerto Rican from Brooklyn is Tina from *Do the Right Thing*. If you keep thinking that, then what the hell is wrong with you? I'm sorry if you are upset with this, but if you are, that means that you are upset by the truth. Granted, it's an exaggerated truth, but there's still an element of truth to my character." The only people in the Latin community who championed my performance were Raul Julia and his wife. The only ones. Is that disgusting or what? But if you get an okay from Raul Julia and his wife, who cares what anybody else says? I'm good, if you know what I mean.

RAMOS: I got off fucking easy. The reaction I heard was, "It's great that Spike had the insight to throw a group of Puerto Rican guys into the middle of everything." In other parts of the country, there's a racial divide between blacks and Latinos, but in New York—especially back then—it isn't the case. And that dynamic comes through in the film. But Rosie and I talked. Look, the truth is: Some people don't like seeing who they really are.

LEE: I was criticized for not putting drugs in the movie. I had thought originally about including the subject in the film but made the decision that that would be another film. I didn't want to do it half-assed. But as a black male, I knew where those critics were coming from, because they just think black people are all crack heads. That it's inherent in us. "There's a film about black people, and there are no drugs in it?" There are so many things to talk about in the film and you're going to say, "Where are the drugs?" What a strange reaction. I don't remember that coming up in regards to *Wall Street*. *All* those motherfuckers were doing drugs, still are.

THOMAS: It was as if they couldn't accept the anger if it wasn't motivated by drug use.

'SURE, SOME OF THEM DON'T LIKE US, BUT MOST OF THEM DO'

POLLOCK: People were surprised by how well it did [at the box office]. But we weren't really thinking in those terms, because the film was never intended to be mass escapist entertainment. It wasn't made for that purpose. But with that said, we felt it could compete against any other movie out there.

AIELLO: Spike brought attention to the film, and that is, of course, good. But he was quite controversial in his press conferences, talking about Malcolm X and so forth. If it wasn't for that, I feel the film had a chance to win the Academy Award for Best Picture. [It wasn't nominated; *Driving Miss Daisy* was the winner.]

LEE: During the Oscar ceremony, Kim Basinger was at the podium and said something like, "There is one film missing from the list of Best Picture nominees, and that's *Do the Right Thing*." I was shocked. I almost fell out of my seat. I bet she caught some hell for that. I thanked her later.

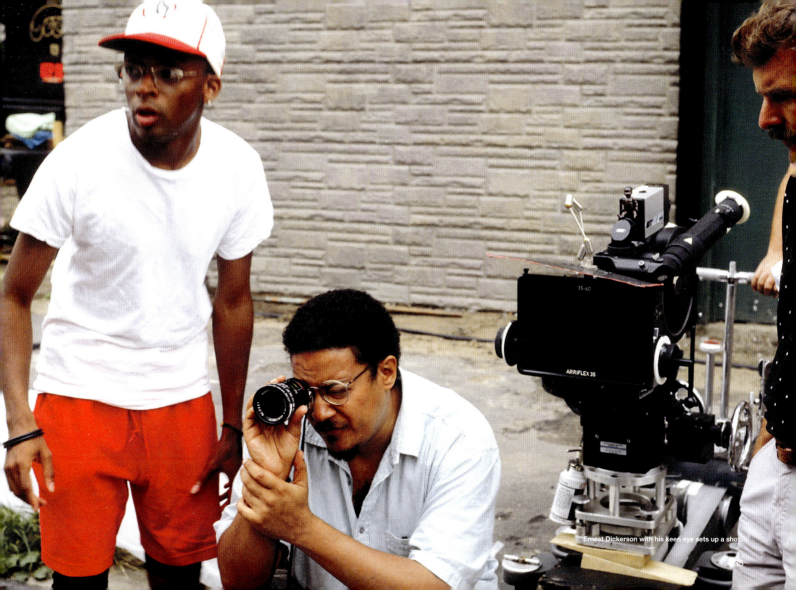
Ernest Dickerson with his keen eye sets up a shot.

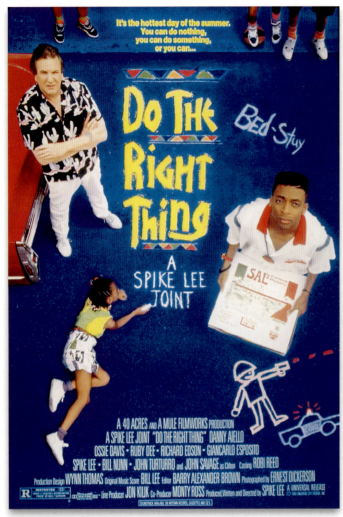

Art Sims has done the majority of my 1 sheet movie posters.

DICKERSON: I could have enjoyed *Driving Miss Daisy* more if we knew more about Morgan Freeman's character. [The fact that it won] still hurts. It definitely does. But we know what we did. Our work speaks for itself.

LEE: I let it go. But let's be honest: If you look at the Academy voters 20 years ago, which movie are they going to like? One with characters named Buggin' Out and Radio Raheem? Or one with a subservient, obedient, yassuh-massuh character? This is the same organization that chose *Ordinary People* over *Raging Bull* for Best Picture. The membership of the Academy is a lot younger today than it was back then. You would have not seen a *Slumdog Millionaire* win. People are more open. We've progressed. We have a black president now. But here's the thing: Is there going to be an oral history of *Driving Miss Daisy*? There are universities and colleges, including Penn, Duke, Yale, and Brooklyn College, that teach classes on the films of Spike Lee and *Do the Right Thing*, so to me, that's the legacy.

TURTURRO: What's the more relevant movie in every way, shape, or form? Okay, then.

POLLOCK: It's often not a question of quality. In most cases it's a likability issue, and *Do the Right Thing* doesn't go out of its way to be likable. And neither does Spike.

KILIK: We weren't part of the club. We were the new kids on the block. *Driving Miss Daisy* had a lot of people involved who had been in the business a long time. But it's funny that looking back, there are certain movies that didn't win awards that you remember, and there are ones that did that you forget. Awards are nice, but it's the film that lasts. And *Do the Right Thing* is not only an important part of cinema but also of America.

AIELLO: I love Denzel [Washington, who beat Aiello in the Best Supporting Actor category for *Glory*], but I always thought that that film was a joke—watching Matthew Broderick with that goddamn mustache was so unreal. Also, I thought Andre Braugher's performance in that movie was even better than Denzel's. I look at that movie today and laugh.

LEE: I loved Denzel's performance in *Glory,* and once that one tear came down his face as he was getting whipped—it was a done deal. A wrap. Finito. And the winner is…

'ALWAYS DO THE RIGHT THING'

TURTURRO: When Spike and I first talked about the film, I told him that I had some trouble with the last part, because the movie shifted tone so much and felt a little separate from the rest of the film. Dramaturgically, I didn't know if I bought Mookie throwing the can through the window. I said, "Maybe my character should do something more to cause everything to happen?" Like stick a knife in somebody's back. When I first saw the film, I found it really upsetting that they killed Radio Raheem, and then on top of that, there's just more destruction. But now, I have a whole different perspective. Maybe something just had to happen, whether Mookie was doing it in protest, or to protect us, whatever, it really seemed like a political action. At the time, I knew where it was coming from, but I thought it could be a little more motivated. But seeing it now, I don't feel that way at all. The film plays better now than ever. It's odd to see a movie that's so raw, visually exciting, and so humorous. You're laughing the whole movie, but it's honest. Obviously, you're looking at it now in a different world. Barack Obama is president. But Spike really did throw the garbage can through the window. And when I read the quotes at the end, I thought that they were so be-

nign compared to what the press was saying. I was like, Malcolm X's quote isn't incendiary at *all*.

LEE: To this day, no person of color has ever asked me why Mookie threw the can through the window. The only people who ask are white. It shows people just see things differently. African-Americans understood what Mookie was going through and how he felt, having just seen his friend murdered.

EDSON: I don't think Mookie did the right thing. He did what he felt he had to at that moment. But then, did Sal do the right thing by smashing the radio? I think there were a lot of wrong things. I'll tell you who did the right thing: me and Leonard Thomas. Doing that little dance during the fight scene—that was the right thing!

AIELLO: Spike is going to say no way, but the night we filmed the riot, I said to him, "You threw that fuckin' can through the window to save me and my sons from getting killed." He changed the object of anger from living human beings to something inanimate. I believe that in his mind, that was the intention, although I know he is going to say that's bullshit.

LEE: Never. If you look at any uprising—Detroit, Newark—it was not started by someone trying to be a good citizen. If that's what Danny thinks, I'm not going to argue with him. But I know historically how black people have felt at the hands of unjust violence.

SAVAGE: Doing the right thing can be heartbreaking. But I didn't see Mookie's act as the right thing. It was his frustration with what *is* the right thing.

CHUCK D: Whether it was the right thing or the wrong thing, it was the necessary thing at that particular time. When Mookie threw the can through the window, I felt so much for both him and Sal, because they were forced to play out a script in which history had lied to both of them.

ROSS: There are two sides to my answer. I grew up during the '60s, so I know what it was like to want to go out in the streets. I never did, however, because my mom always said that she would whip my butt, but I understand the frustration. But it's not right to damage a person's property.

CARTER: I think he did the right thing. He stood up for his neighborhood. He forgot and ignored that his relationship with Sal was multifaceted and did what he felt showed solidarity.

DICKERSON: Mookie did the right thing because he diverted the crowd's anger away from Sal and his sons. He saved their lives.

THOMAS: My feelings about Mookie constantly change. I think part of this has to do with age. As a young man, you want the Mookies of the world to strike out in anger against what he or we perceive to be the "enemy." As an older man, you want to say to Mookie, "Hey, wait a minute, maybe there is another way."

NUNN: I didn't really understand why Mookie did what he did. Sal was like a father to him. Well, maybe not a father, but Sal was doing the neighborhood kids a favor by staying open late. He was trying to do a good thing.

ESPOSITO: Mookie did the right thing for Mookie. Personally, I think he definitely made a mistake. He incited a riot. I don't believe in violence. I believe you can talk things through. I've never thought he did the right thing.

LAWRENCE: That's a hard question to answer. At the time it may have seemed like the right thing, but it caused a riot. He did what he thought was right in a situation that wasn't.

LEE: Mookie didn't cause the riot. The riot jumped off because the NYPD murdered Radio Raheem with the infamous Michael Stewart chokehold, with a whole lot of witnesses looking on.

JACKSON: He had been taking it and taking it. The lady's on his ass, the job's on his ass, the community's on his ass. And while he was down with everybody, Mookie was still in a semi-Tom space. He was the Man's boy. There comes a time when you got to break that chain and let everybody else know that that's not who you are. He had to vent his rage. So yeah, he did the right thing.

POLLOCK: I don't have an answer, because just the fact that I would not have done what he did doesn't make it wrong. Quite some time after *Do the Right Thing*, Spike and I were talking about why Mookie threw the garbage can, and I don't want to put words in his mouth, but he said something to me like, "You just can't know why if you aren't black."

LEE: It's up to the audience to decide.

'WE HAD A GREAT, GREAT DAY'

AIELLO: Spike and I remained good friends. Of course, we have our disagreements on what really unfolded and what was said. I remember them one way, and he remembers them another. Who is correct? Maybe the truth is somewhere in the middle.

LEE: Danny is very opinionated, and so am I. To this day he's going to say one thing and I'm going to say another. That makes for interesting reading, but it doesn't matter. What matters is what's on the screen, and he gave a great performance.

SMITH: People will come up to me on the street and start stuttering, "Ma-Ma-Malcolm. Moo-Moo-Mookie."

NUNN: There aren't many days that go by when somebody doesn't call me Radio Raheem. Another thing I get a lot is, "Where's your radio?" I'm like, "Didn't you see the fucking movie, man? It burned up."

JACKSON: Most of the time nobody recognized me. Bill and I used to hang out a lot so we'd be together and someone would come over and start talking to him about Radio Raheem and wouldn't say shit to me. Occasionally, if a person had watched the film the night before, they would say to me, "Waaaaaake up," or "You know it; it you know." I was channel-surfing the other day and saw on the guide that *Do the Right Thing* was going to be on. I noticed that my name was listed first. I was like, "Hey, look at that." Who knew?

PEREZ: That was my accent, but I kicked it up a notch. People always ask me to say the name "Mookie." And I always say no. They're like, "Come on, I just want to hear it." I go, "So rent the movie." I used to tell them to go to Blockbuster, but now I say, "Try Netflix."

WHITE: I would get, "You didn't have to curse out Ossie like that!" Some people said it in jest,

but others seemed to think that's who I really was, like I would just go around cursing out old people.

SANDOVAL: For several months after the film came out, when I would walk through an airport, young African-American men would point their fingers at me and once in a while say, "You killed Radio!" I was like, "Okay, number one: It wasn't me, it was my partner. And number two: I'm an *actor*."

RICK AIELLO: Black guys in L.A. would come up to me and say, "Why did you do that to Radio Raheem?" I'm sure they were being tongue-in-cheek about it, but the first few times it happened, it was intimidating, because they seemed really pissed off. I would be like, "I didn't kill him. I didn't kill him. It's a movie! I love Billy!" Years later, I got a phone call from someone who accused me of being partially responsible for the L.A. riots. I'm sure my character in *Do the Right Thing* had something to do with that.

ESPOSITO: *Do the Right Thing* really reflected the explosiveness that had enveloped New York at that time. Could it be done now in the same way? No, because we're all different people; we have an African-American president. But it's a film that will live on forever. I also think it is Spike's most profound movie, because it all just came together; it wasn't calculated. And I feel that he was open and vulnerable enough to allow the actors to make the script better.

AIELLO: It was brilliant of Spike to allow the actors to have significant input and make suggestions. That's not to say that there wasn't a full-fledged script there, but as the actors were growing into their roles, maybe they knew more about the characters than Spike did. And he took all that to heart. I wrote the line about how the neighborhood kids grew up on my pizza, and five minutes before we were going to shoot it, I asked him if we should cut it out because it was too corny. He said, "No, I like it. Let's keep it in." And that was one of the lines in the picture that most of the critics quoted.

LEE: *Do the Right Thing* was the first film in which I felt comfortable working with actors. It happened through hard work and experience, because I had two other films to rely on to see what mistakes or weaknesses I had to rectify when it came to getting what I wanted from the actors.

FAISON: It was such an amazing group of actors. You had newcomers—some of which, of course, became major stars—working alongside veterans who had already established a legacy in the business. And we all meshed so well together.

TURTURRO: Would I do it again? Of course, I would. They don't make movies like that anymore, man.

DEE: It's one of the most important films I've ever done.

MARTIN: It was such an amazing and beautiful experience. I, of course, enjoy making my own films, but I have never since seen so many people excited about, and proud of, their craft.

PEREZ: I always get a text or phone call when it comes on television. I watched it a few years ago, and I had mixed emotions. But my main emotion was pride. For most of the film, I just sat there smiling. It made me very, very proud. It's a historic film, an American classic.

BROWN: It's a real document of the times. And white people certainly aren't threatened by it these days!

VINCENT: I thought the movie was brilliant, and I hold Spike in very high regard. Unfortunately, some acquaintances of mine whom I've known through the years didn't see *Do the Right Thing* or *Jungle Fever* [in which Vincent also appeared] because they don't cherish that kind of mentality—the black thing or whatever. *GoodFellas, Raging Bull*—those are the kinds of movies they like. I tell them that they should also watch Spike's movies, and they say, "Nah." I just think that's too bad.

JACKSON: *Do the Right Thing* was a huge shot in the arm. Not just for many of the actors but for a lot of the young people who were looking at filmmaking as a career. For them, it was a statement of viability, that they can do mainstream films that are fun, have a message, and are about themselves.

HOLMES: Working on *Do the Right Thing* made me feel like I was on, I don't know, the '78 Yankees or something—a well-oiled machine that was really special. It was a wonderful experience, and I feel blessed and honored to have been a part of it.

RAMOS: The worst thing about the film was that we finished it. When we were done shooting, it left such a void, because working on it was like being part of a championship high school football team. The relationships that were formed have been long-standing. In fact, me and the guys who I hang out with in the movie—Chris Delaney; Angel Ramirez; Sixto Ramos, who is Rosie Perez's cousin; and Nelson Vasquez—have recently gotten together again. Our intent is to produce a documentary on our experiences working on *Do the Right Thing* and our lives since then. We're considering calling our production company Stevie's Boys.

ESPOSITO: I really wanted my father to see the film, but I was nervous about how he would take it. My biggest worry was that he wouldn't understand my character, but on the other hand, it might explain to him what it was like to be in my skin. I didn't know if he ever really understood that. When he saw the movie, he didn't like it. It crushed me. He said, "Giancarlo, too many curse words, too many curse words." At the time my father was teaching at a school and didn't want to perpetuate cursing. I said, "Papa, these kids, that's what they do. This movie is going to be right up their alley." I don't know if he really got the point of what my performance was trying to portray. My mom loved the movie.

CHUCK D: I'm really proud that Spike selected us to signify a very important piece of work. There was only one movie and one man who spoke volumes about race in the last 25 years of the twentieth century: *Do the Right Thing* and Spike Lee.

ESPOSITO: I loved the movie because it started to allow people to know that we have to live on each other's borders. I did a lecture series after the film about understanding and learning about different cultures and how to respect them. *Do the Right Thing* began that dialogue.

DAVID LEE: The film dealt with something that was boiling over all over America. It was absolutely timely but not exploitive. It wasn't as if Spike made a movie about 9/11 two weeks after the Twin Towers came down.

POLLOCK: Spike didn't make a lot of money on this, and I'm sure that he could have done the

film with a different studio. But we provided him with what he felt he couldn't get elsewhere: the freedom to create what he wanted to without being subjected to market research and that sort of thing. I told Spike that we would support his vision, and we held up our end of the bargain. And he did a great job. I'm very proud of the movie and really glad we made it. I think it was, and still is, one of the most important movies ever made about race in America.

LEE: Tom's really the unsung hero of *Do the Right Thing*. He was attacked after it was shown in Cannes, then he was attacked for releasing it in the summer. "It's going to cause riots—you know how black people get in the summer." So I want to thank him again for not bowing down and going ahead with the release of the film.

TURTURRO: Maybe there will be a sequel in which Pino's married to a black woman and he has his own pizzeria: Pino's Famous. Oh, and it's in Bed-Stuy.

AIELLO: Sal would absolutely rebuild the pizzeria with his own money and keep it in the community.

EDSON: If so, I just hope Vito's not working there.

SMITH: Smiley could run the new place.

AIELLO: And I don't know why, but Sal would rehire Mookie to work at the new pizzeria; maybe because he doesn't like change.

LEE: Mookie doesn't deliver pizza anymore. He moved to Rome, Italy, where he owns and operates his own Brooklyn-style pizzeria. Mookie liberated Sal's famous tomato sauce recipe. He also married a beautiful Italian woman named Anna Magnani. They have three kids: Sal, Vito, and Pino.

ESPOSITO: I would hope that after serving his time, which I'm guessing would have been three to five years, Buggin' Out would now be an evolved human being who realized from his experience with Sal's Famous that he didn't go about things in the exact right way. Maybe he's now teaching at Columbia! I guess Spike wouldn't see it this way, because he actually asked me to reprieve Buggin' Out in *Jungle Fever* as a homeless person. I wouldn't do it, because I felt it would have weakened the character and performance from *Do the Right Thing*. But Spike still managed to convince me to play a homeless guy. And I'm guessing that in his mind, he saw my character as Buggin' Out—so it was all right with him.

DEE: In the sequel, Mother Sister would still be with Da Mayor, and he would still be getting on her nerves! She would also keep her bags packed in case President Obama called her to Washington.

LEE: There was a benefit for Barack Obama on Martha's Vineyard when he was running for the Senate. I didn't really know who he was. He came over and said, "You're responsible for me and my wife getting together." Then he told me how they saw *Do the Right Thing* on their first date and then went to Baskin-Robbins for ice cream and talked about it.

DANIEL: They did? No shit. I *knew* I liked them.

LAWRENCE: I had no idea. How cool!

SMITH: We're actually responsible for a whole new era in American political achievement.

EDSON: I just hope the connection gives me a little bit of pull, so I can play basketball with Barack.

LEE: I think Barack Obama is a very smart man, because if he had taken Michelle to see *Driving Miss Daisy*, things would have turned out a whole lot different: no Michelle, no black President. DO THE RIGHT THING CHANGED THE HISTORY OF THE WORLD. AND THAT'S THE DOUBLE TRUTH, RUTH. PEACE, TWO FINGERS.

THE MOVIE

Opening Credit Title. Art Sims came up with the Kente cloth-influenced graphics.

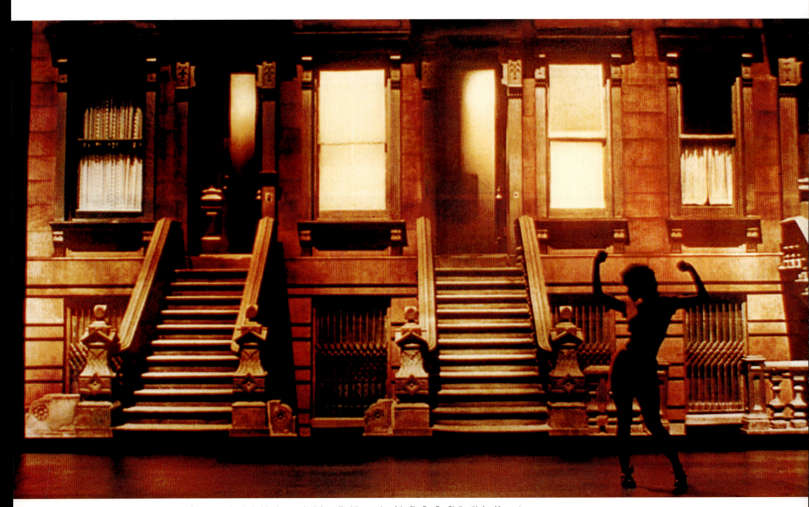

The opening credit sequence was shot on a stage after we completed principle photography. I always liked the opening of the film *Bye Bye Birdie* with Ann Margaret.

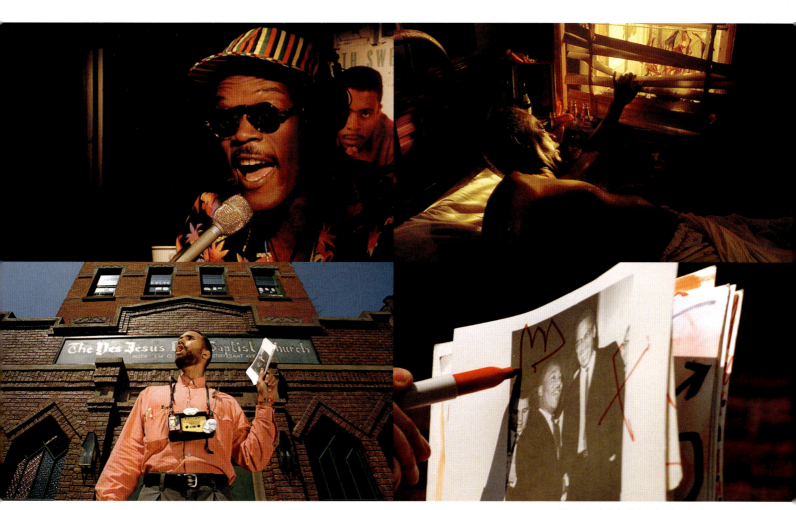

We take time in the beginning to introduce the characters on the block.

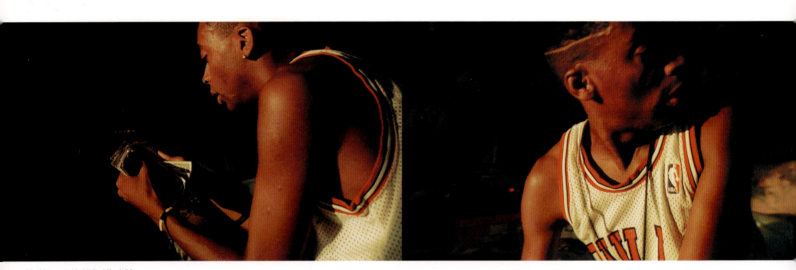

Mookie counts his "dollar bills y'all."

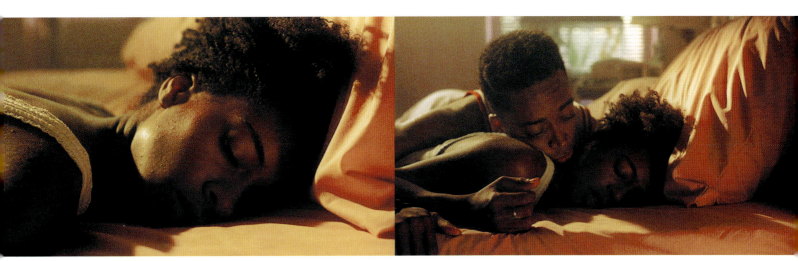

Mookie wakes up his sister Jade.

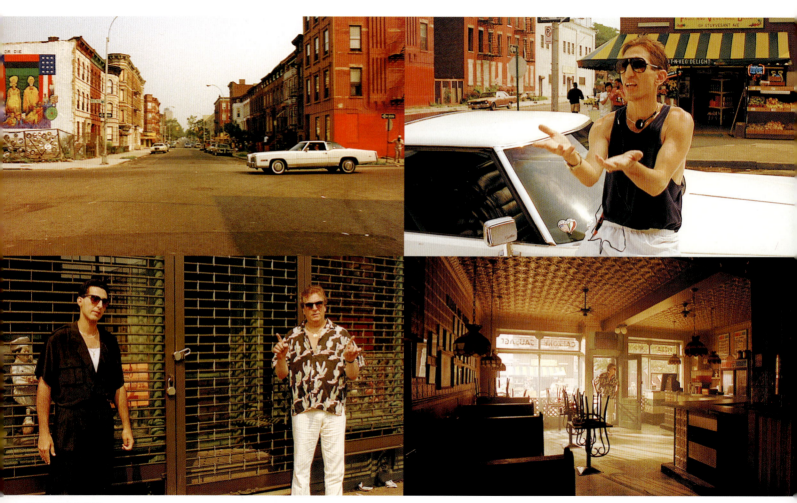

Bensonhurst to Bed-Stuy.

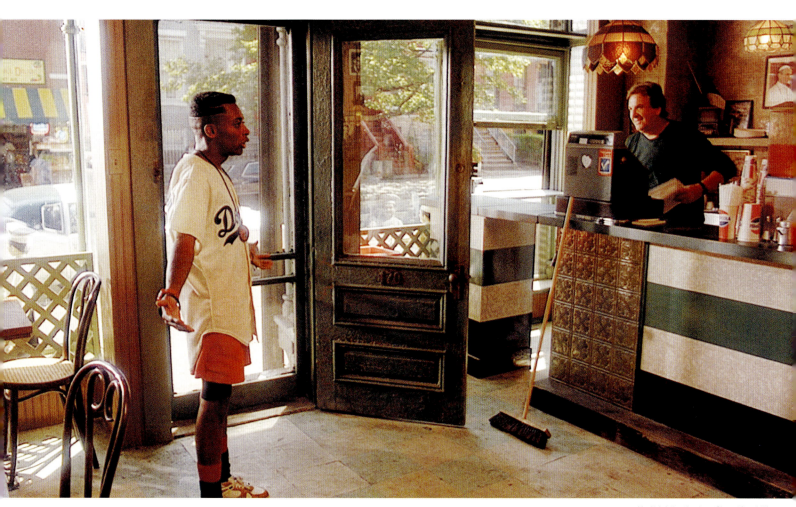

Mookie's haircut is a Larry Cherry "Special."

Da Mayor comes a-courtin'.

Mother Sister is not having it.

Buggin' Out in Sal's.

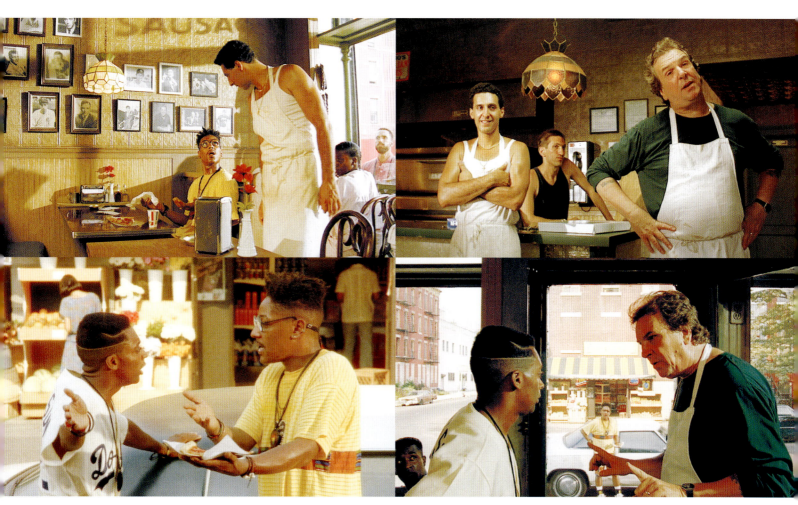

Mookie has to mediate.

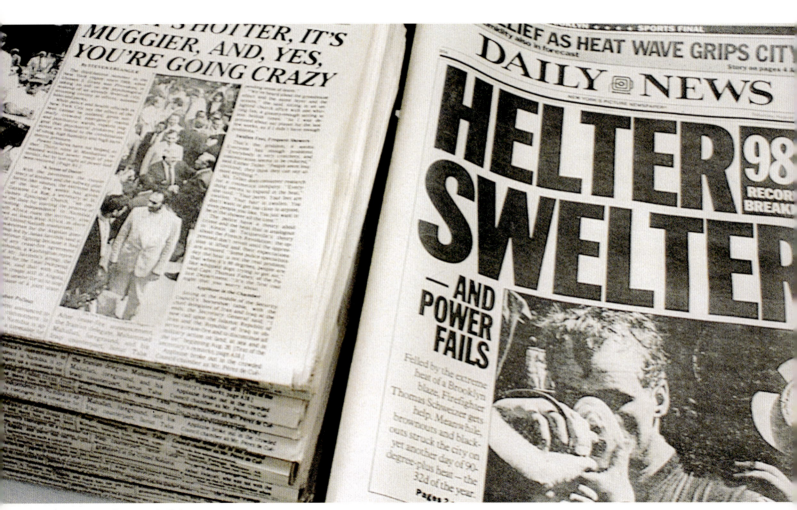

The murder rate of New York City goes up after 95 degrees.

Trying to stay cool.

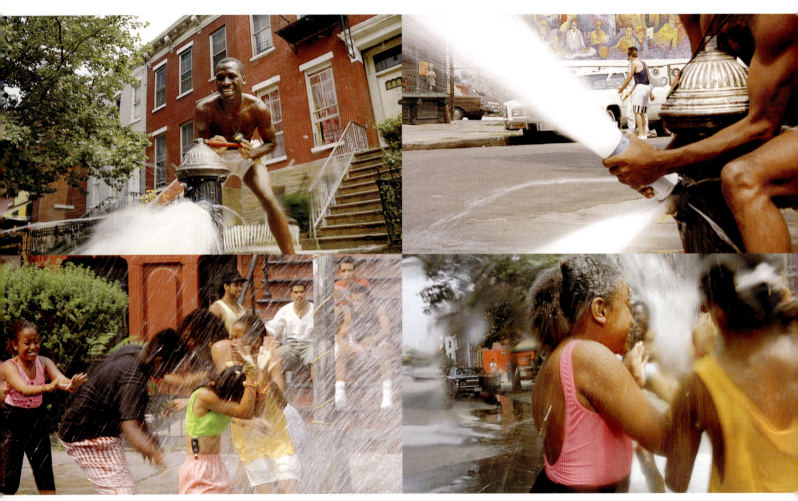

The Johnny Pump.

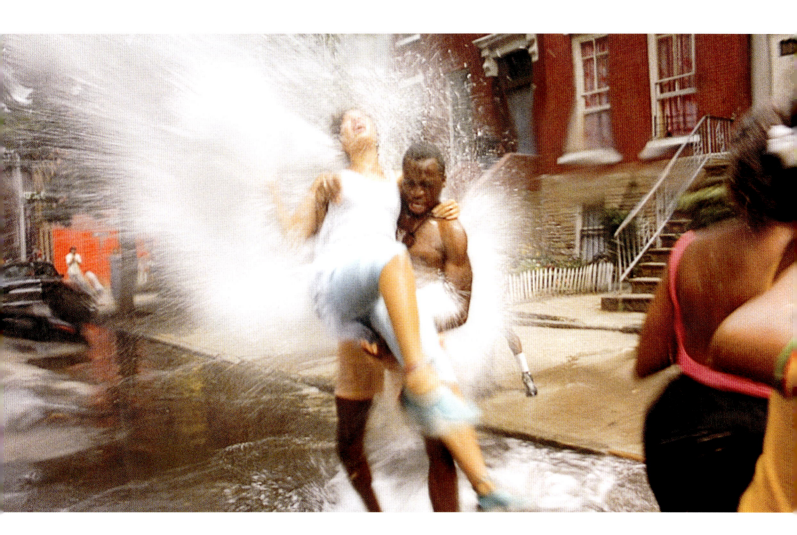

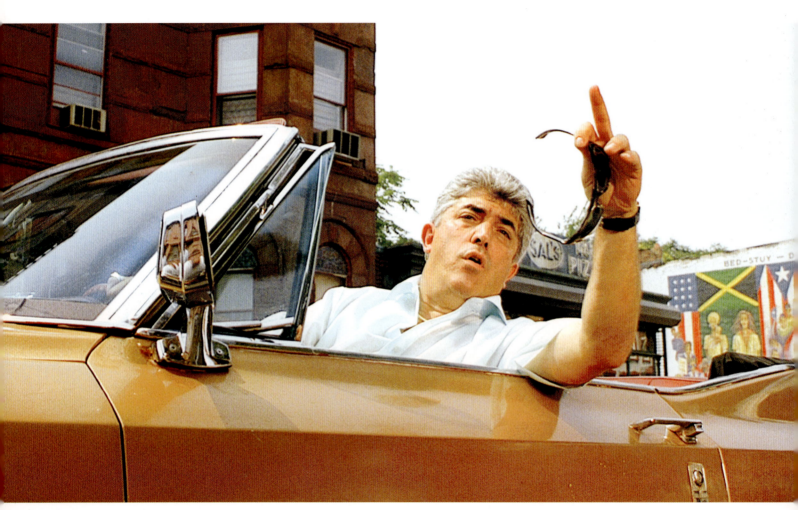

I was introduced to Frank Vincent from the films of Martin Scorsese.

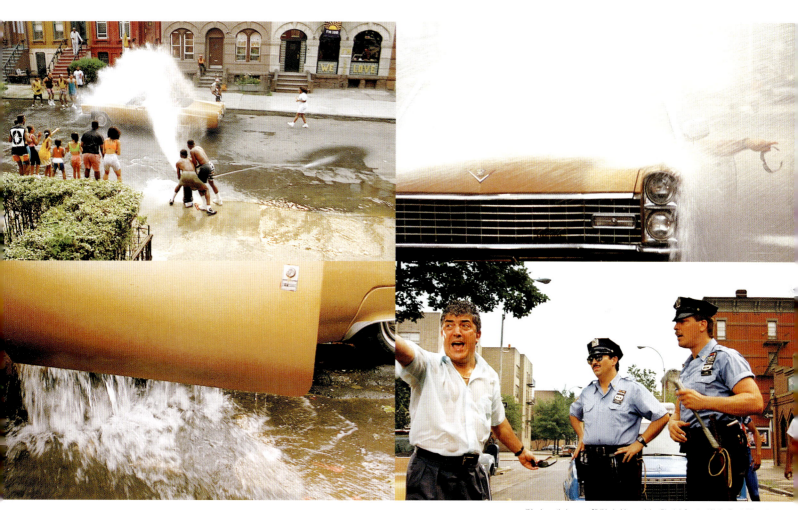

"You have their names?" "Yeah, Moe and Joe Black." Great ad lib by Frank Vincent.

The power of the wide low angle shot.

Music wars.

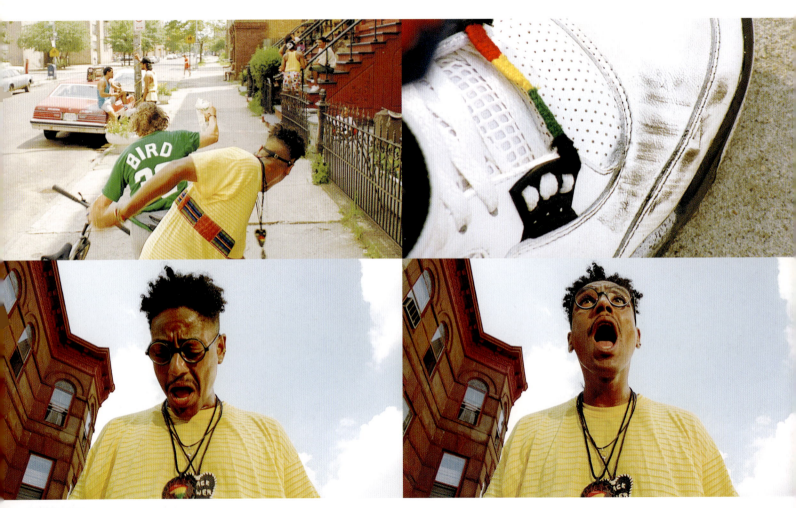

Broken Air Jordans.

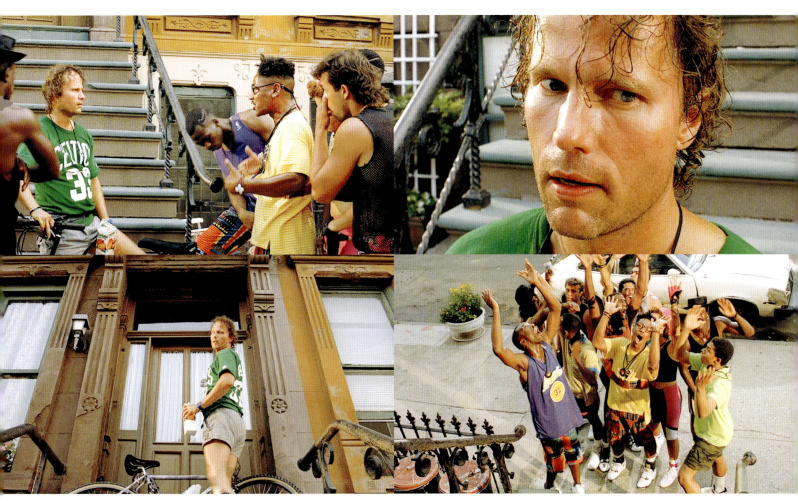

Bed-Stuy is completely gentrified now. We had the crystal ball on this one.

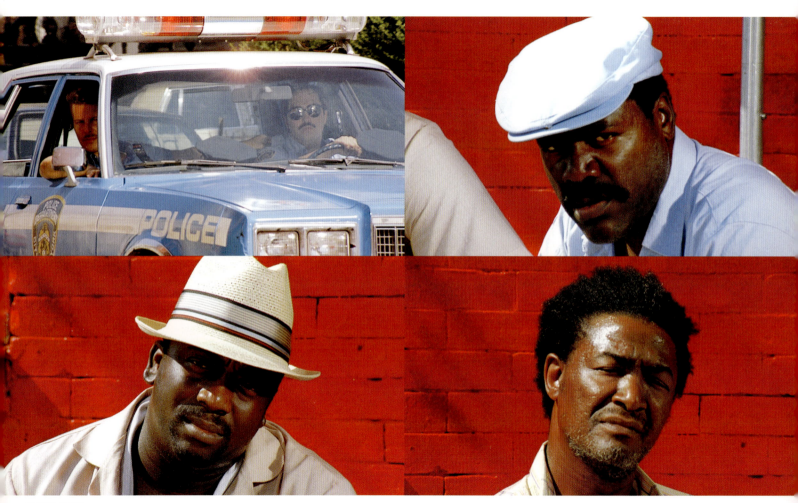
Exchange of glares.

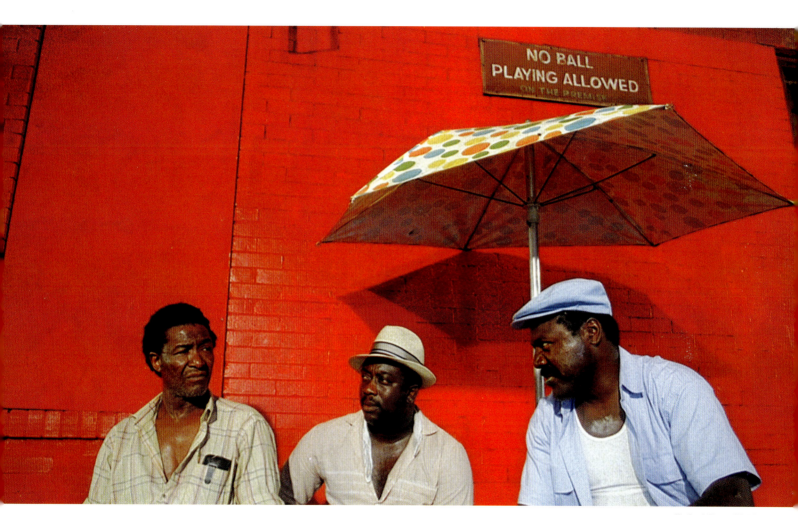

The Greek Chorus of Bed-Stuy.

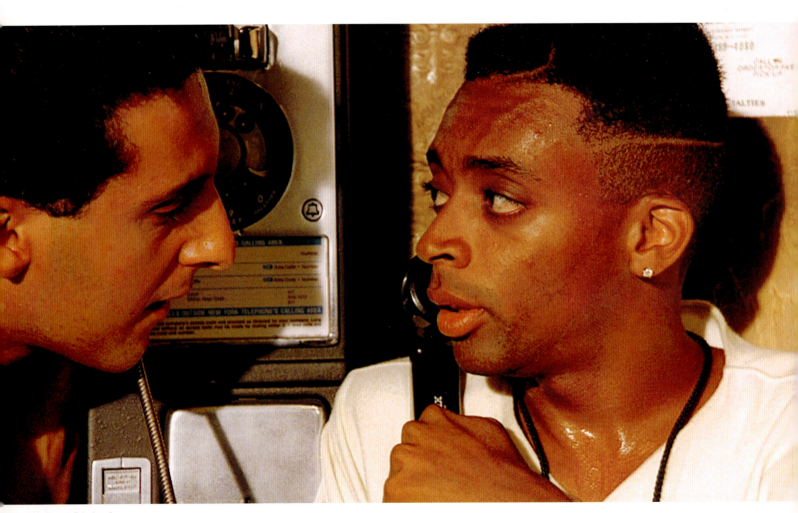
"Mookie, get off da phone."

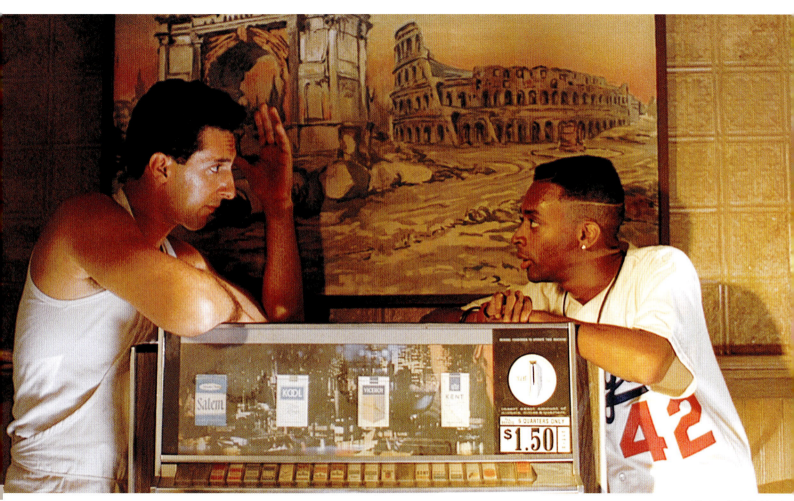

"They're not really black."

To me this is one of the funniest scenes in the film.

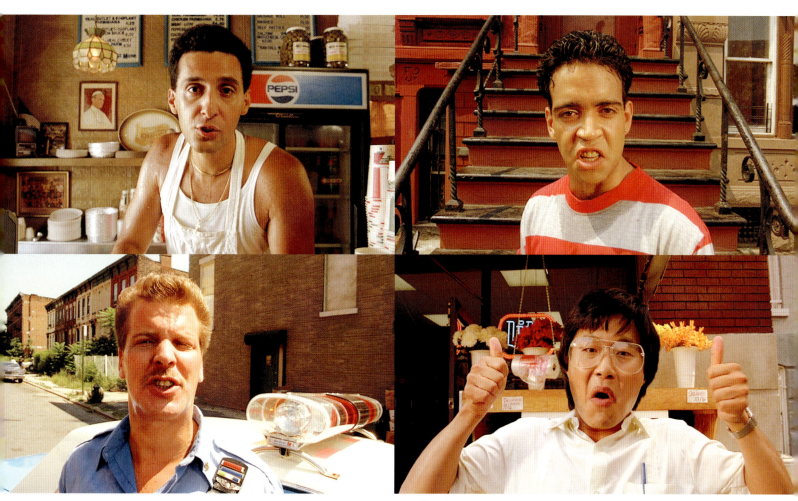

What makes this scene really work is that the actors are looking right into the camera, addressing the audience directly.

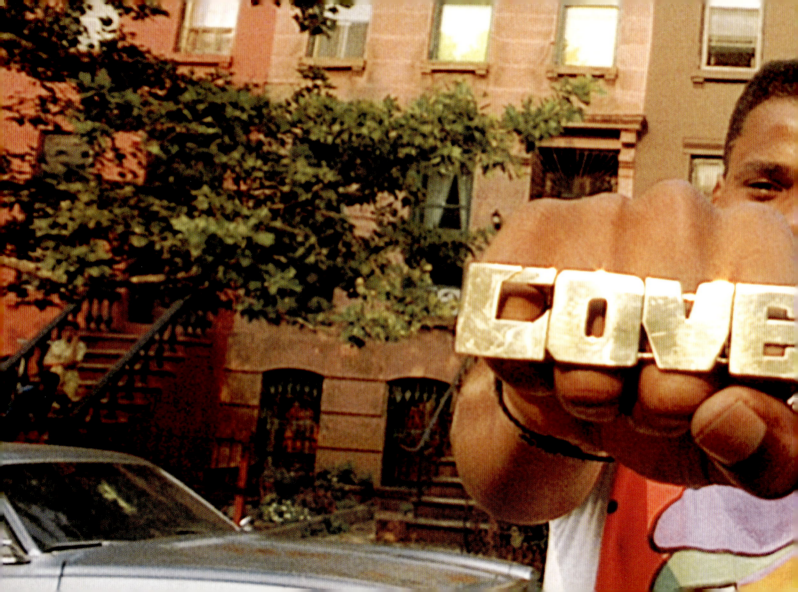

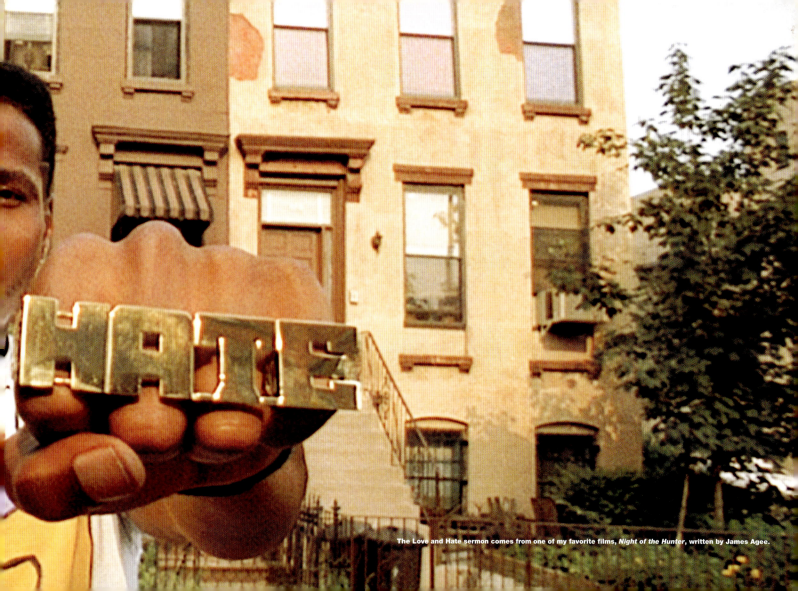

The Love and Hate sermon comes from one of my favorite films, *Night of the Hunter*, written by James Agee.

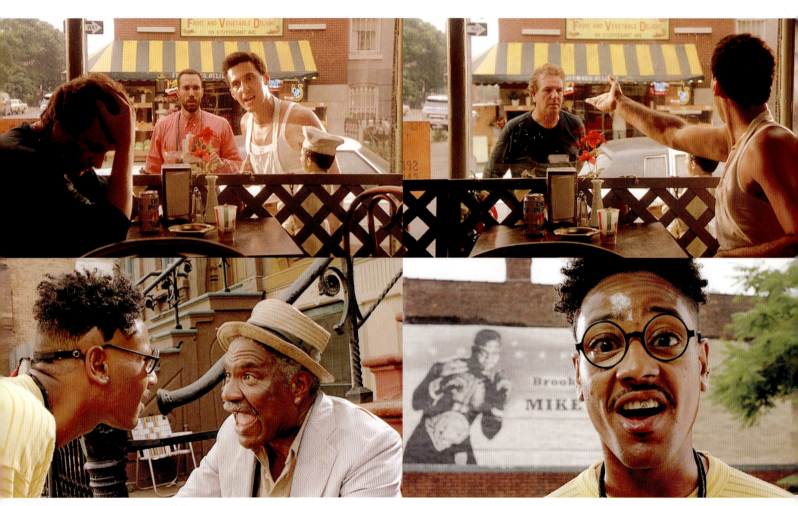

Buggin' Out tries to get support for his boycott of Sal's.

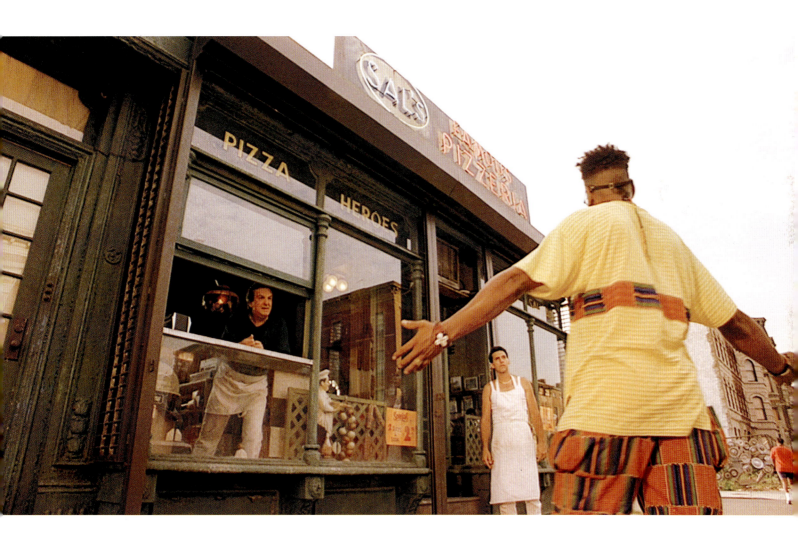

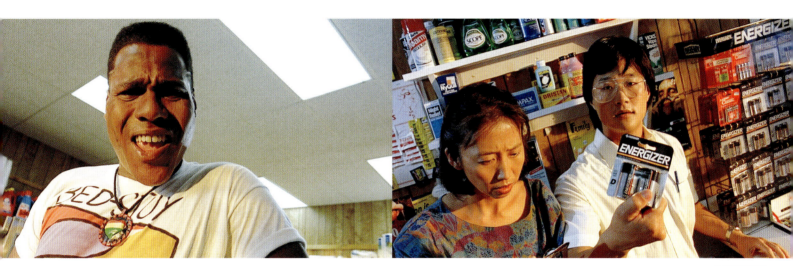

D, muthafucka. D.

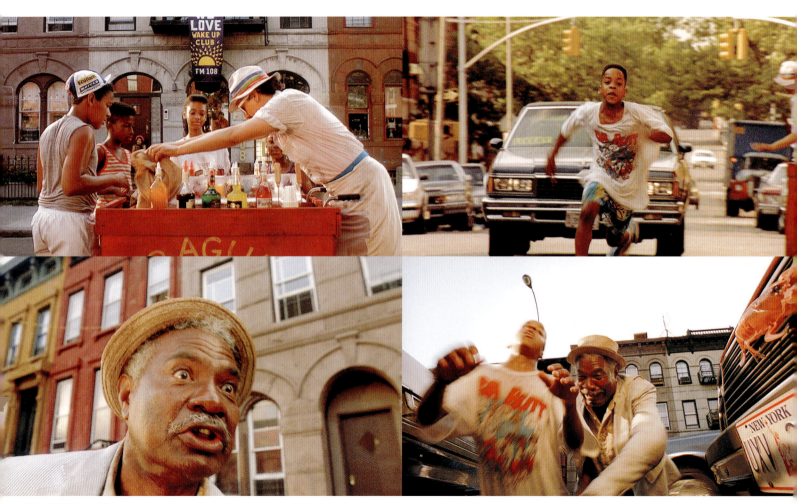

Da Mayor saves a young life.

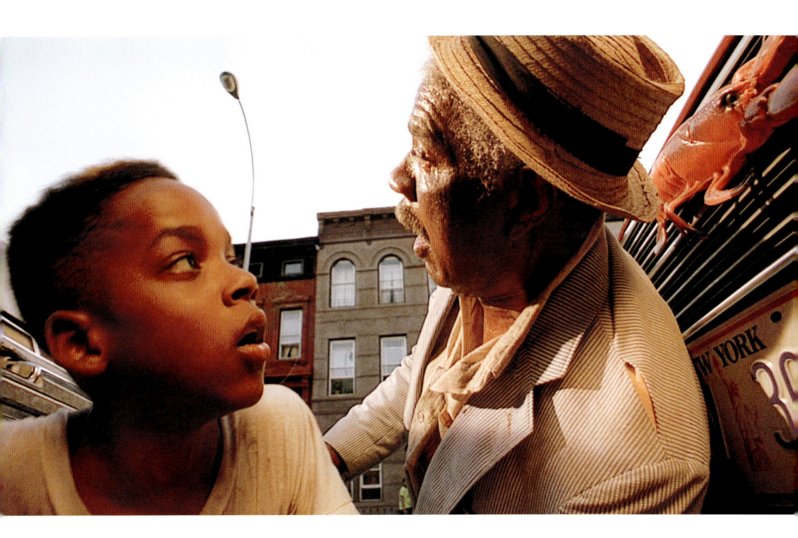

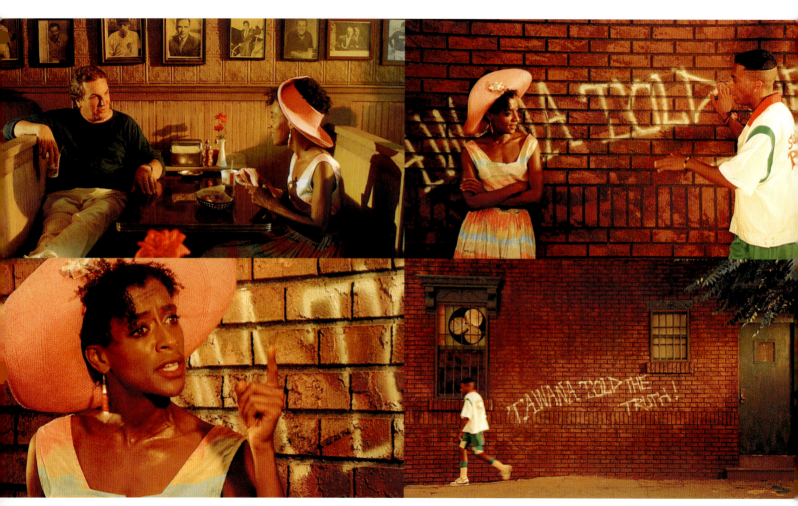

I still don't think, even more than twenty years later, we know the true story behind Tawana Brawley.

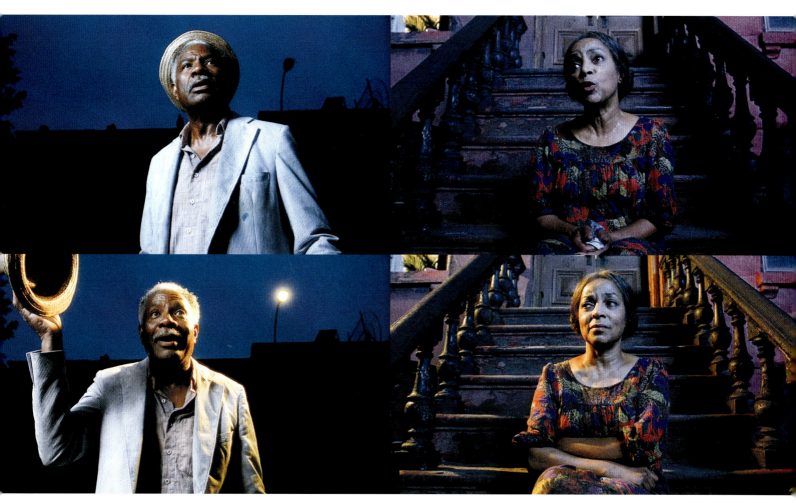

Night comes to Bed-Stuy.

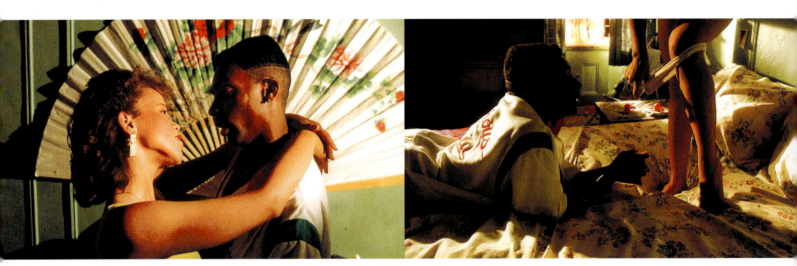

The Cool Out montage.

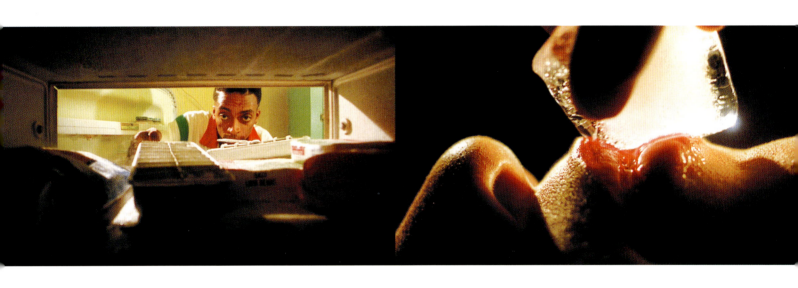

Trouble arrives—Radio Raheem, Smiley, and Buggin' Out.

A lot of screaming and yelling.

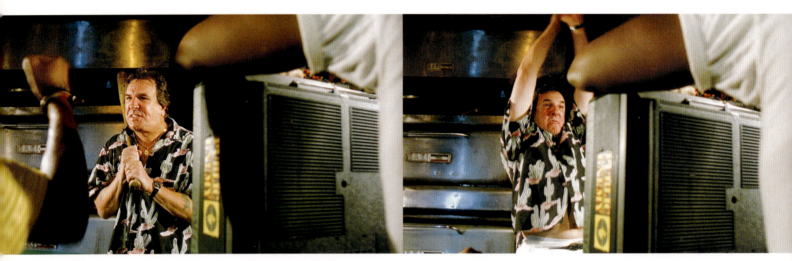
Louisville Slugger.

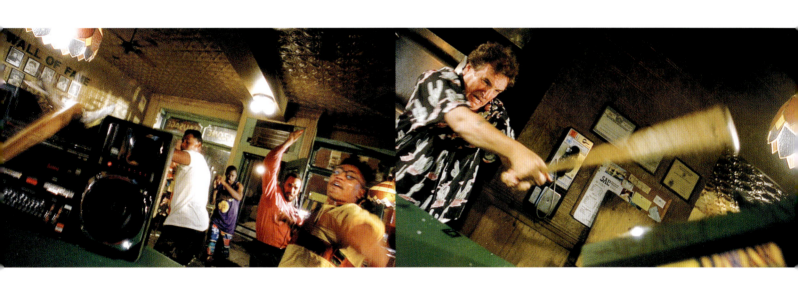

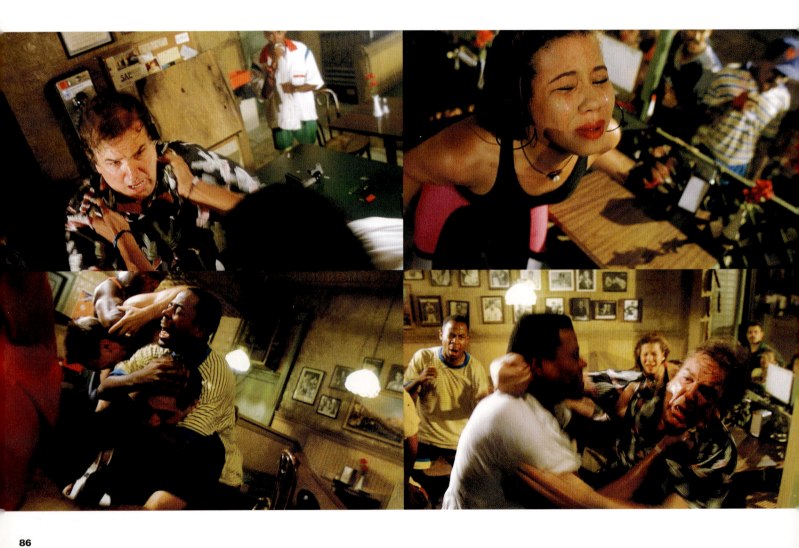

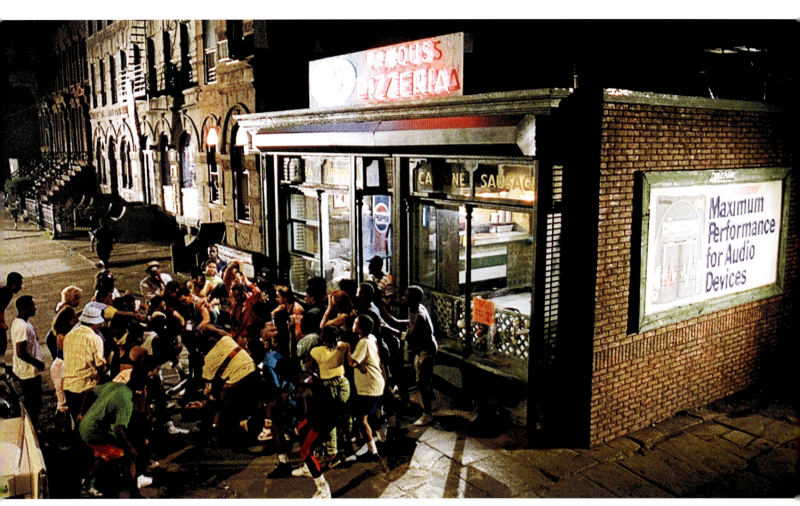
Ruckus spills outside onto the sidewalk.

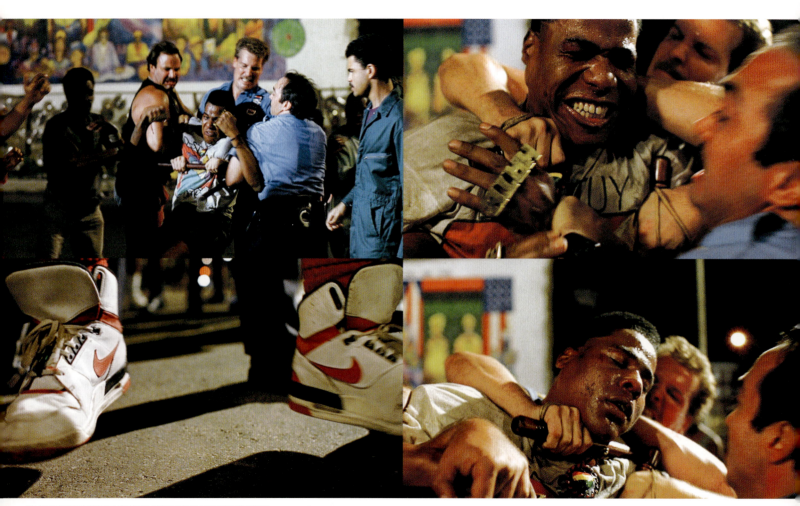

The infamous Michael Stewart chokehold, which has been banned from the NYPD.

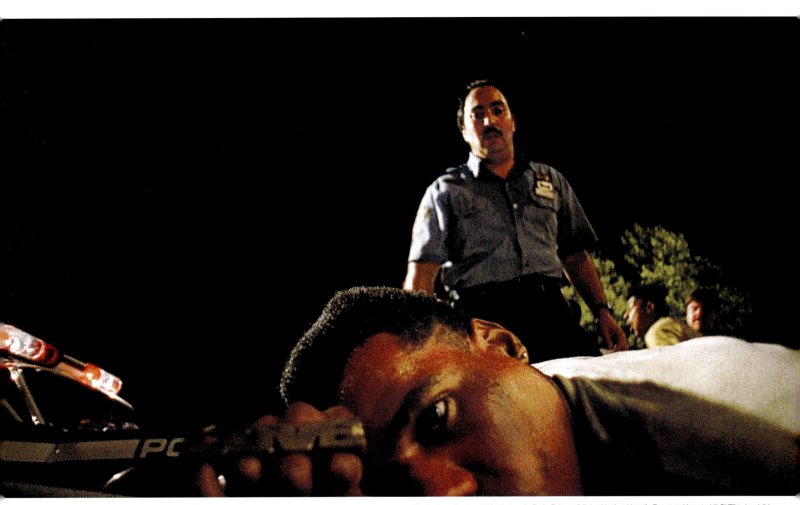

It took a long time to set this shot up. As Radio Raheem fell dead to the sidewalk, Ernest and I wanted "LOVE" to be visible.

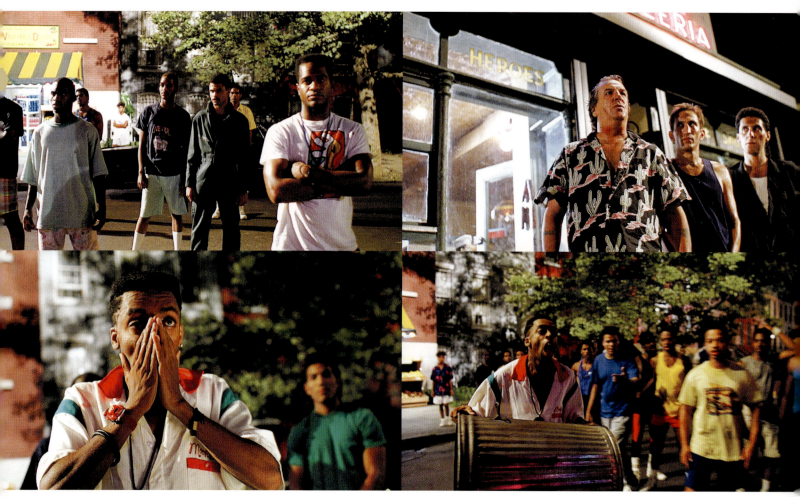
HATE!

Mookie throws the garbage can through Sal's window.

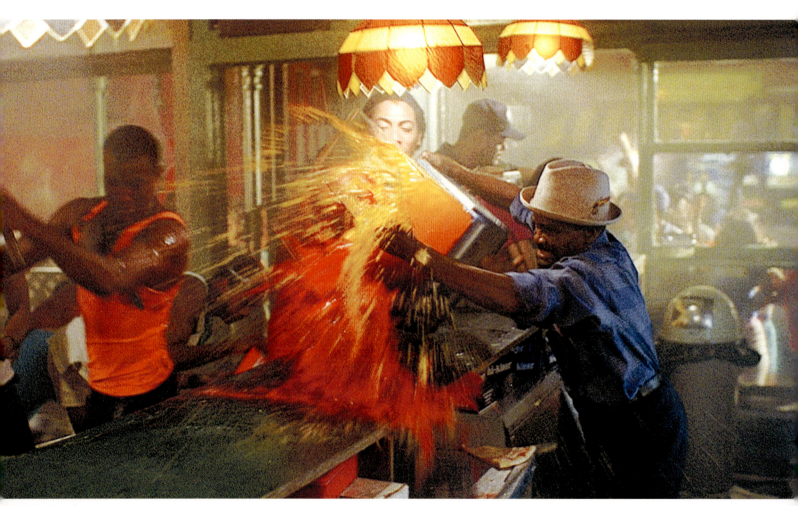

We only got one take in because the extras destroyed it.

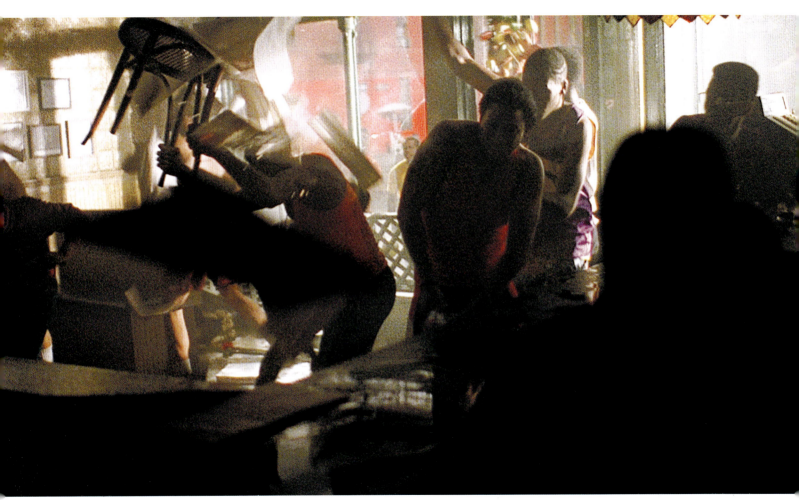
Ernest's idea of filming silhouettes.

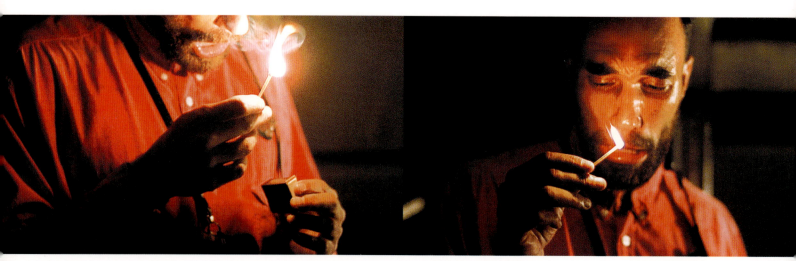
Smiley lights the match.

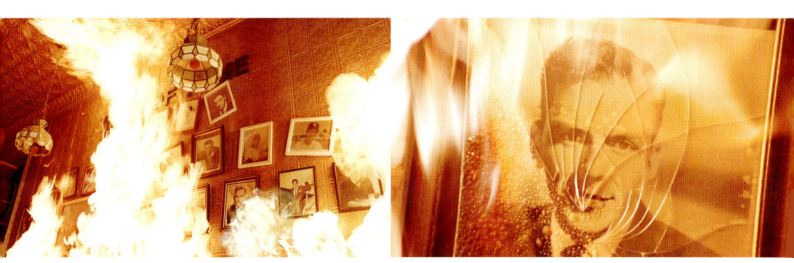

I caught hell from Frank Sinatra. He did not appreciate his picture burning— and I didn't blame him—but we worked it out and left it on very good terms.

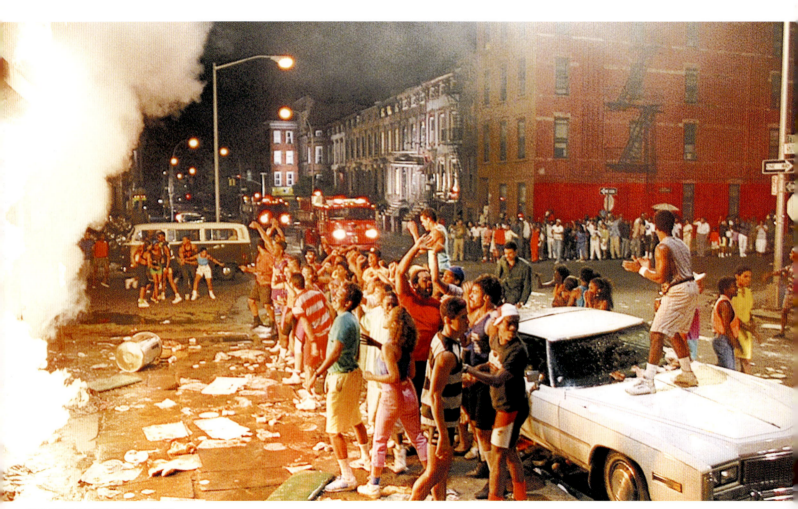

"Coward Beach. Coward Beach. Coward Beach!"

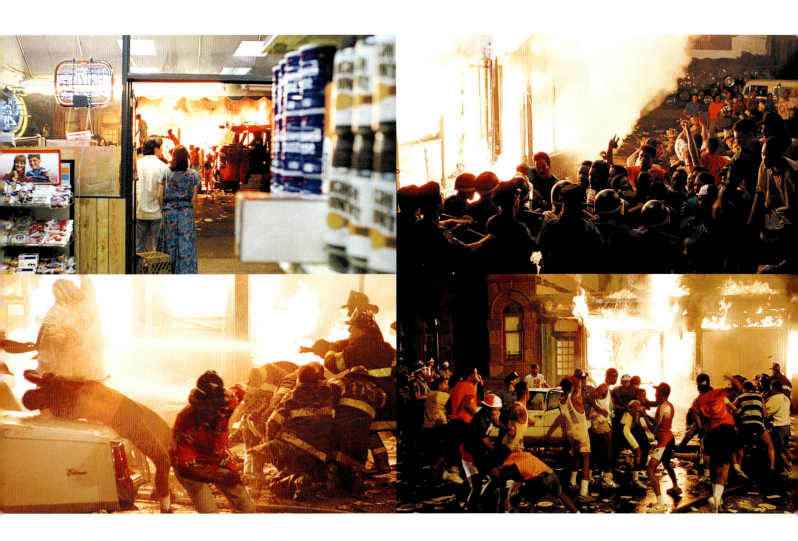

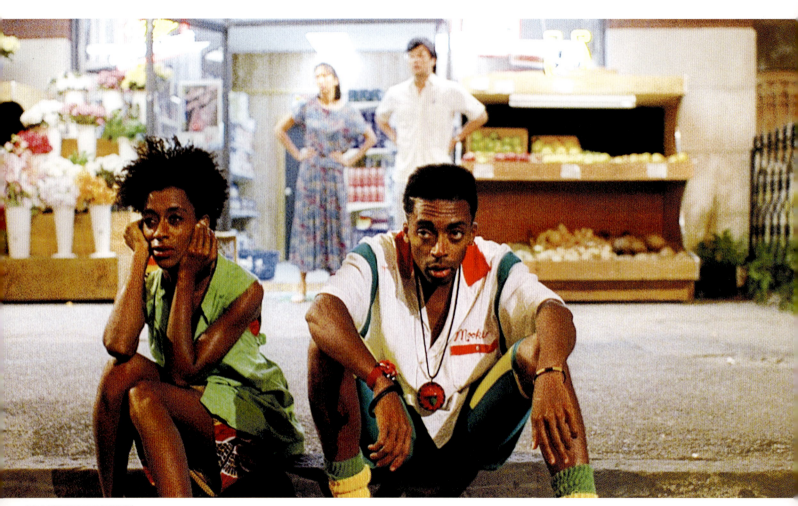
Jade and Mookie look on in disbelief.

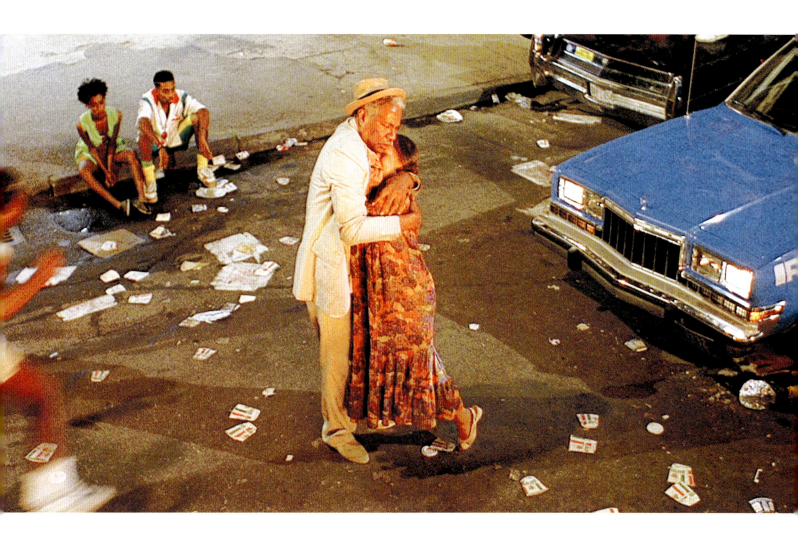

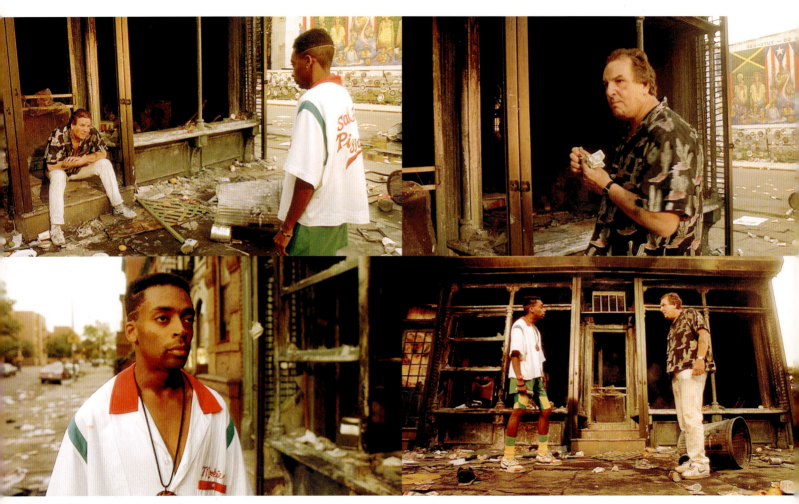

Showdown in Bed-Stuy.

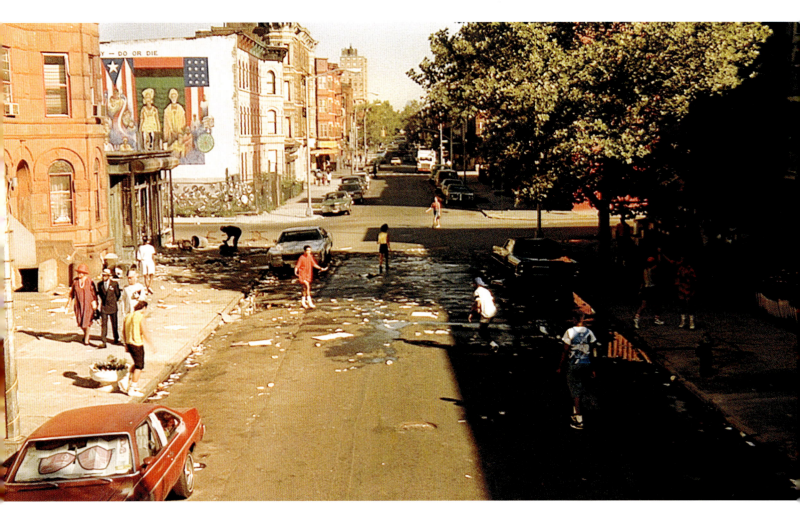

The block comes back alive.

"Violence as a way of achieving racial justice is both impractical and immoral. It is impractical because it is a descending spiral ending in destruction for all. The old law of an eye for an eye leaves everybody blind. It is immoral because it seeks to humiliate the opponent rather than win his understanding; it seeks to annihilate rather than to convert. Violence is immoral because it thrives on hatred rather than love. It destroys community and makes brotherhood impossible. It leaves society in monologue rather than dialogue. Violence ends by defeating itself. It creates bitterness in the survivors and brutality in the destroyers."

Martin Luther King, Jr.

My Morehouse classmate John Wilson ('79) came up with the quotes for me.

"I think there are plenty of good people in America, but there are also plenty of bad people in America and the bad ones are the ones who seem to have all the power and be in these positions to block things that you and I need. Because this is the situation, you and I have to preserve the right to do what is necessary to bring an end to that situation, and it doesn't mean that I advocate violence, but at the same time I am not against using violence in self-defense. I don't even call it violence when it's self-defense, I call it intelligence."

Malcolm X

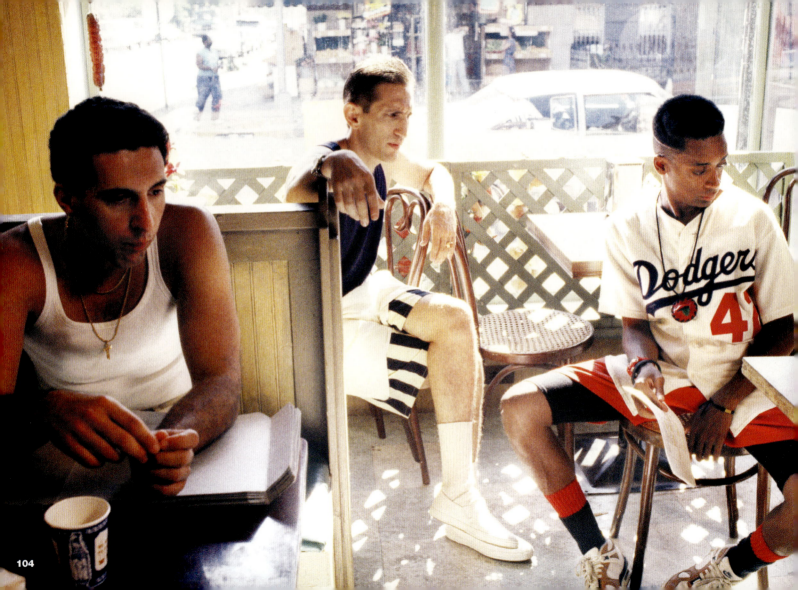

John, Richard, and myself taking a break.

PHOTOGRAPHS BY DAVID LEE

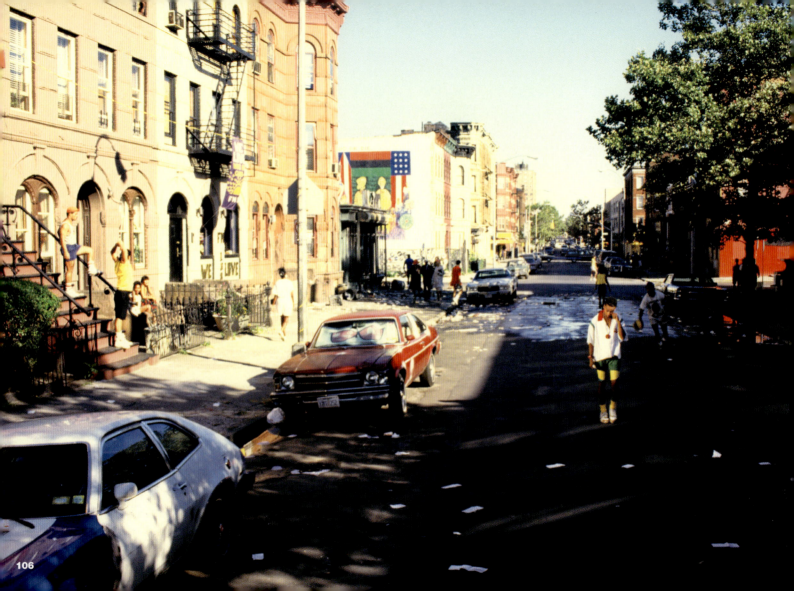

Final shot of the film.

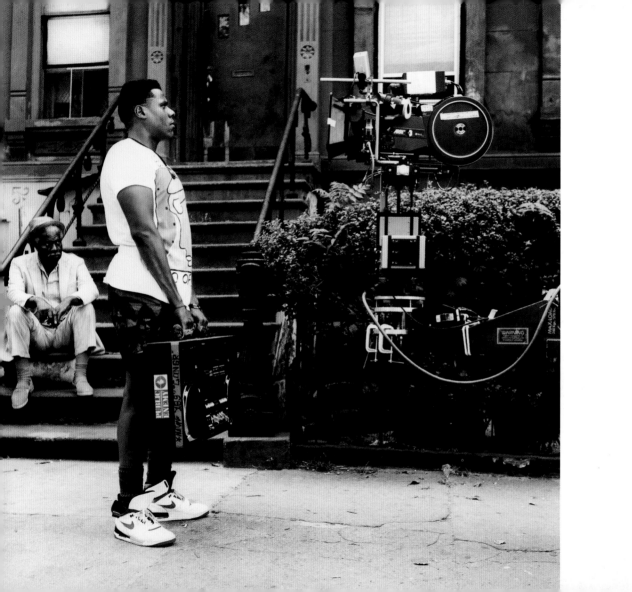

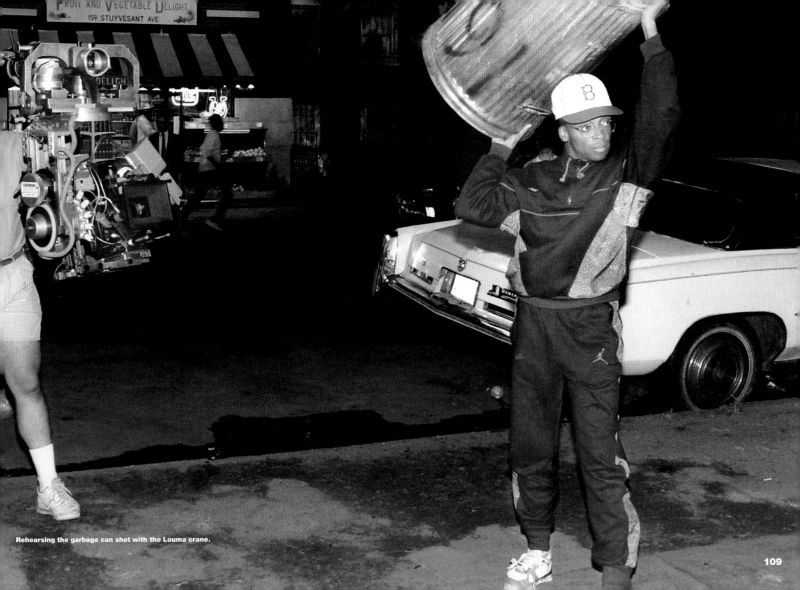

Rehearsing the garbage can shot with the Louma crane.

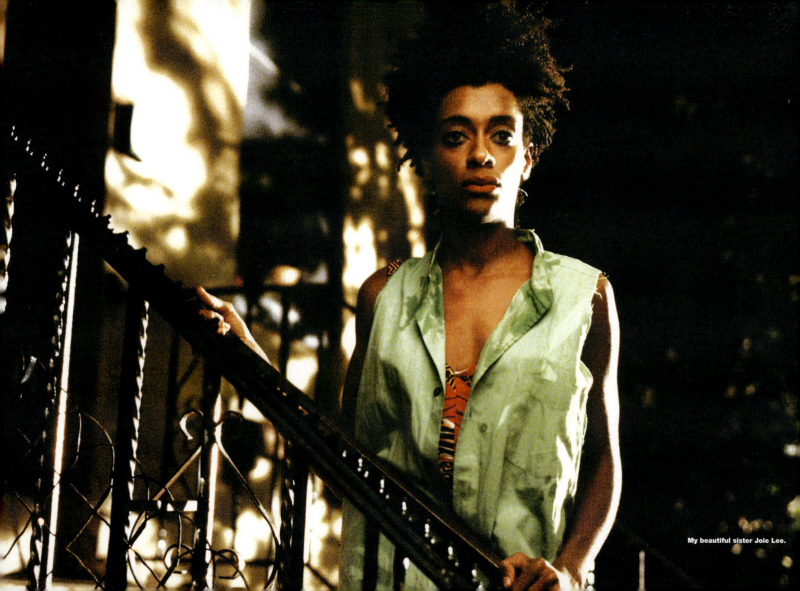

My beautiful sister Joie Lee.

Danny and Ossie got along great.

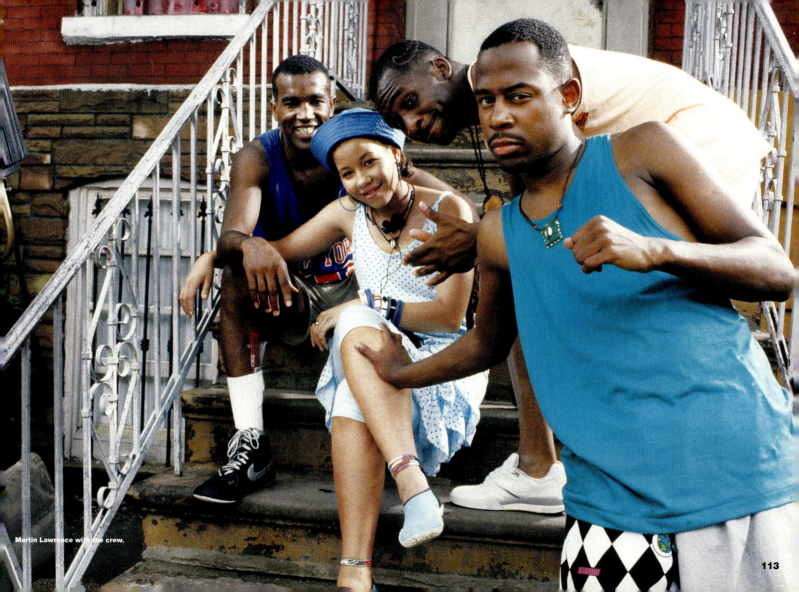

Martin Lawrence with the crew.

We filmed the video for Public Enemy's "Fight the Power" on the same block we shot *Do the Right Thing*.

Chuck D, Terminator X, and Flavor Flav lead the march.

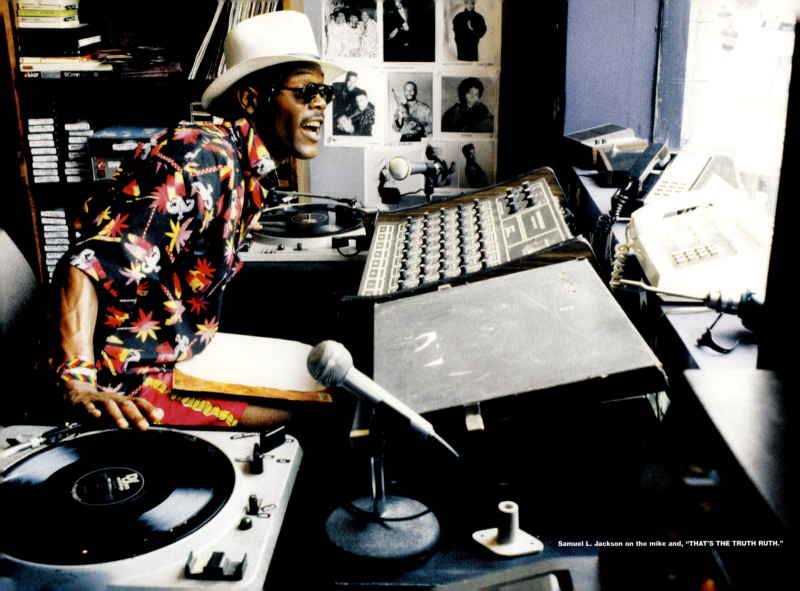

Samuel L. Jackson on the mike and, "THAT'S THE TRUTH RUTH."

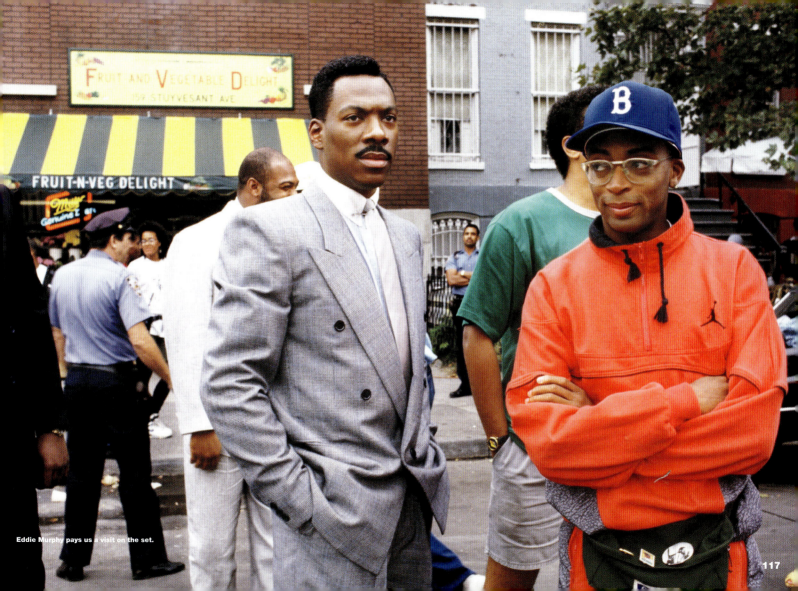

Eddie Murphy pays us a visit on the set.

Roger Smith talked his way into the film, and I'm grateful he did.

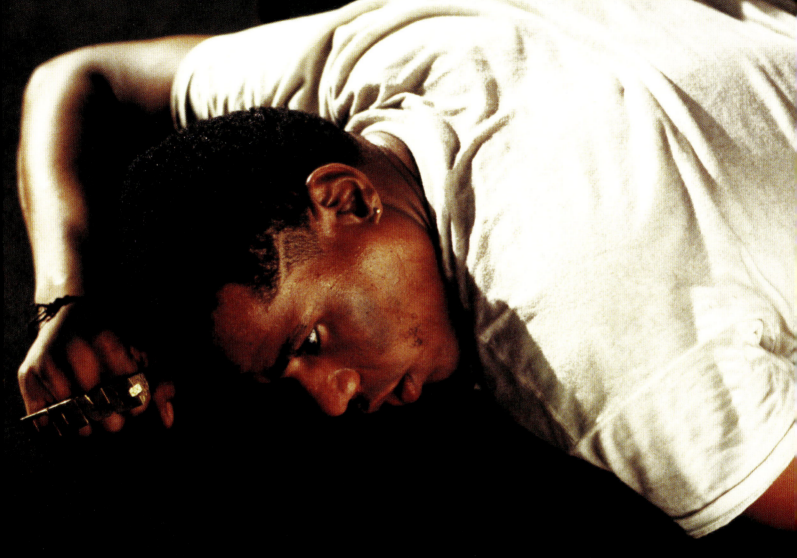

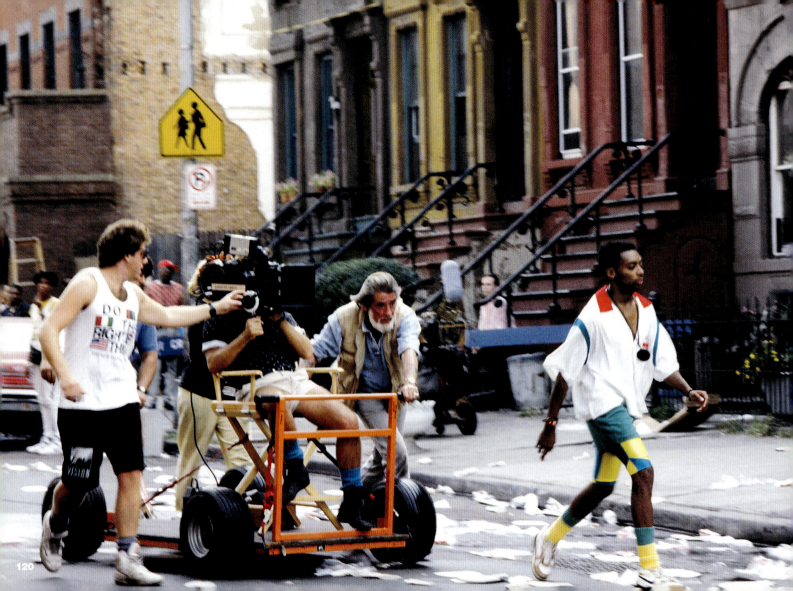

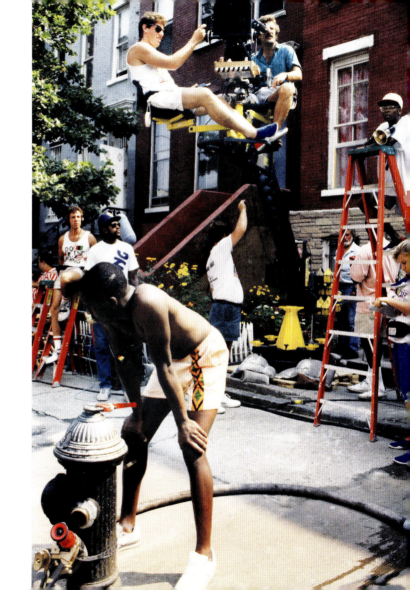

Mookie on the move.

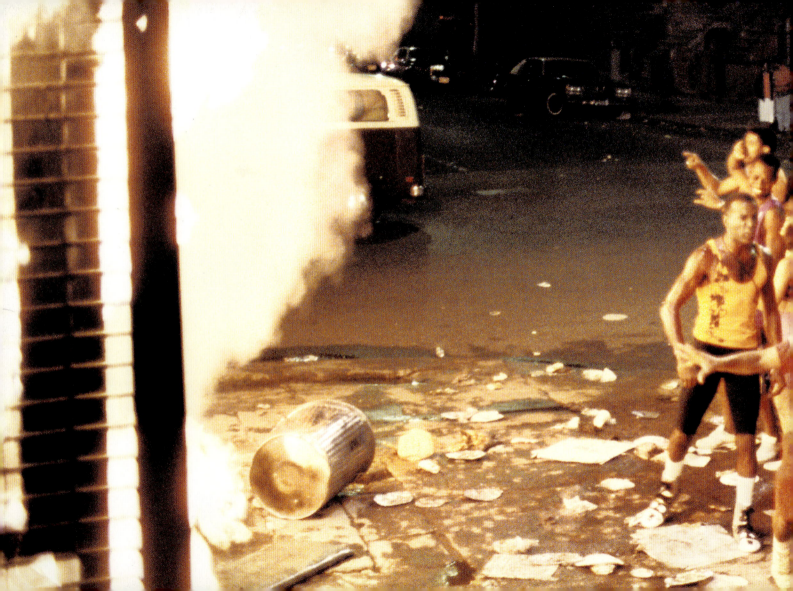

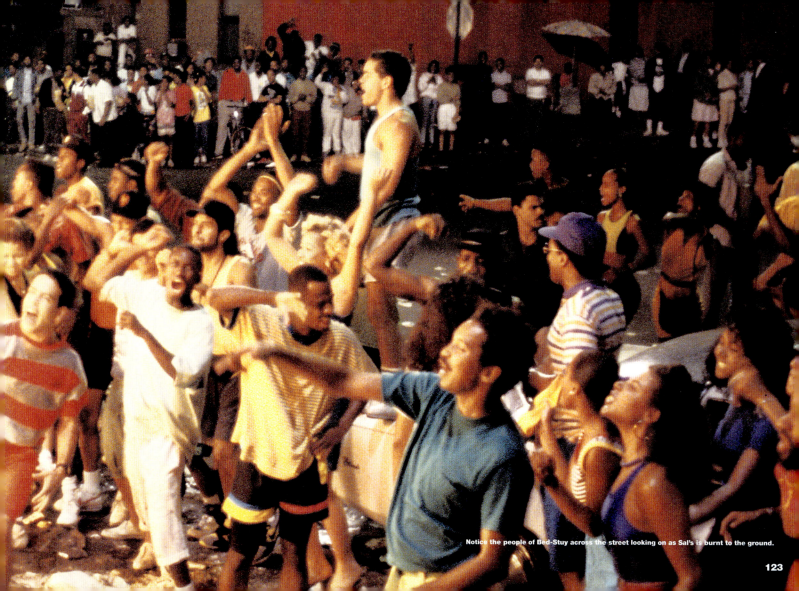
Notice the people of Bed-Stuy across the street looking on as Sal's is burnt to the ground.

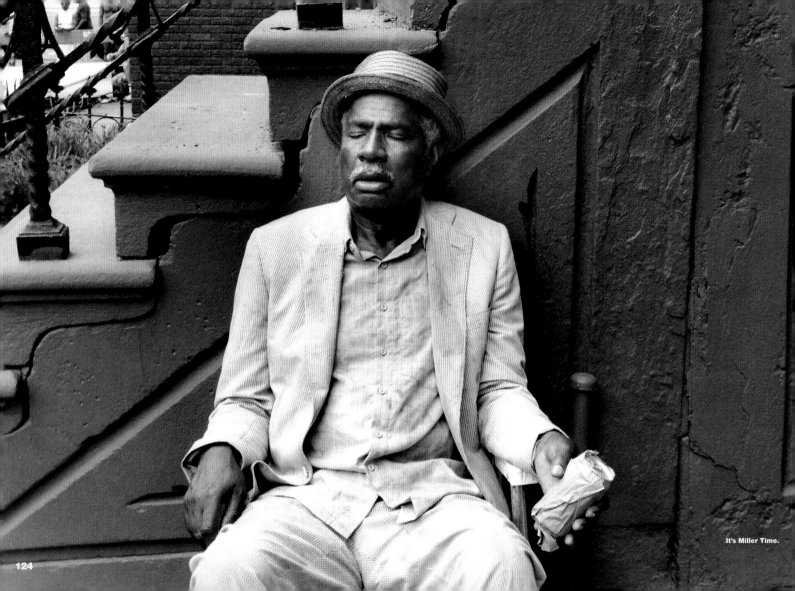

It's Miller Time.

We cast triplets to be switched in and out.

A very, very young Martin Lawrence.

Co-producer Monty Ross hypes the crowd at the block party we gave. Melvin Van Peebles and Danny Aiello look on.

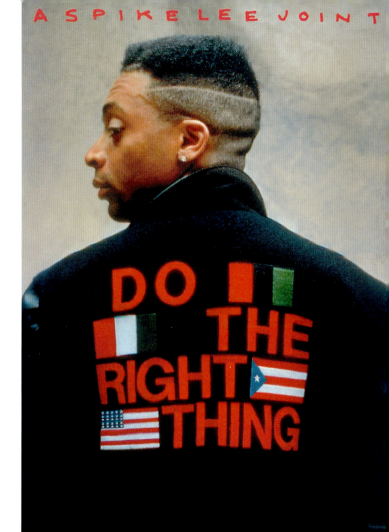

This was never used.

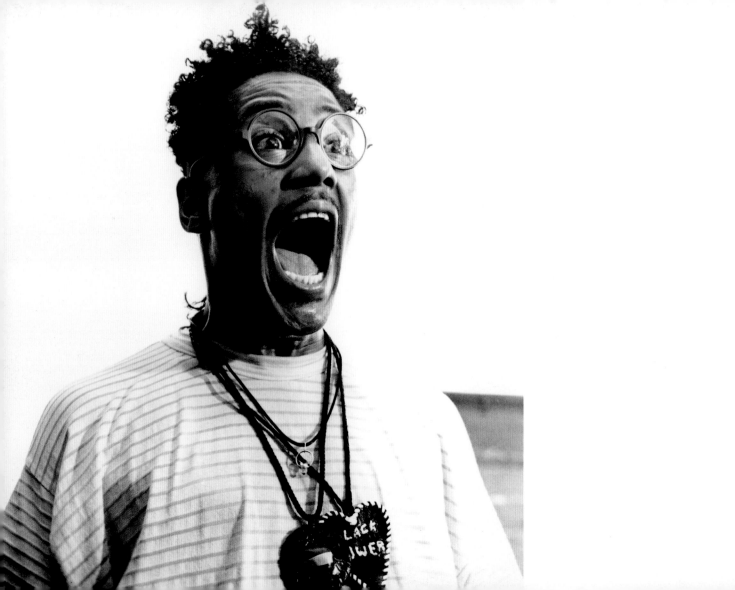

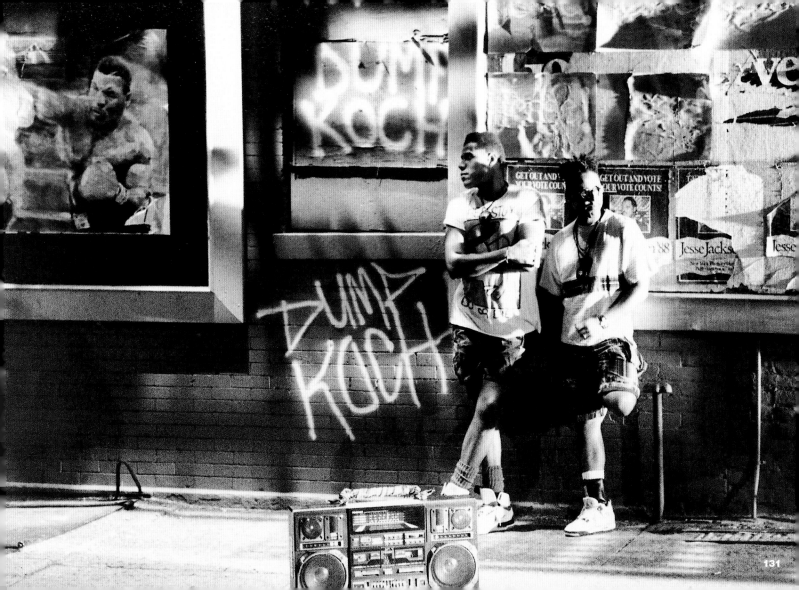

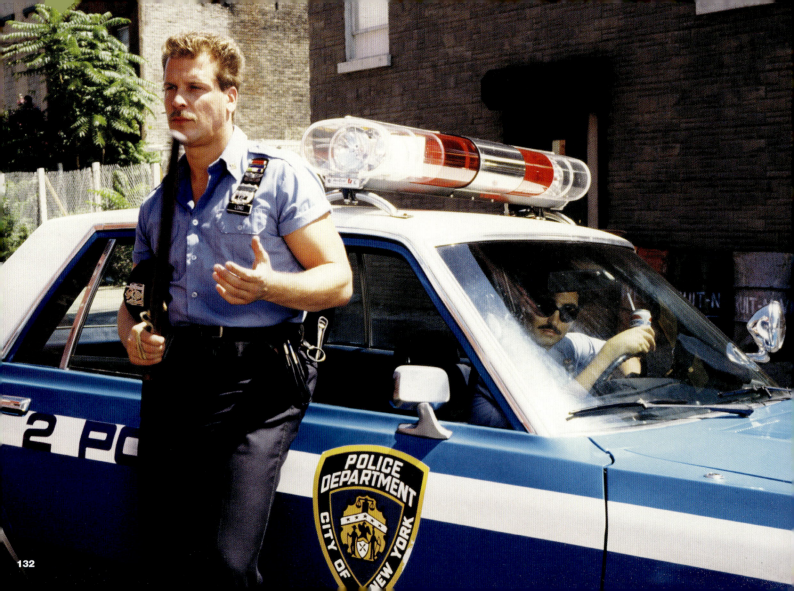

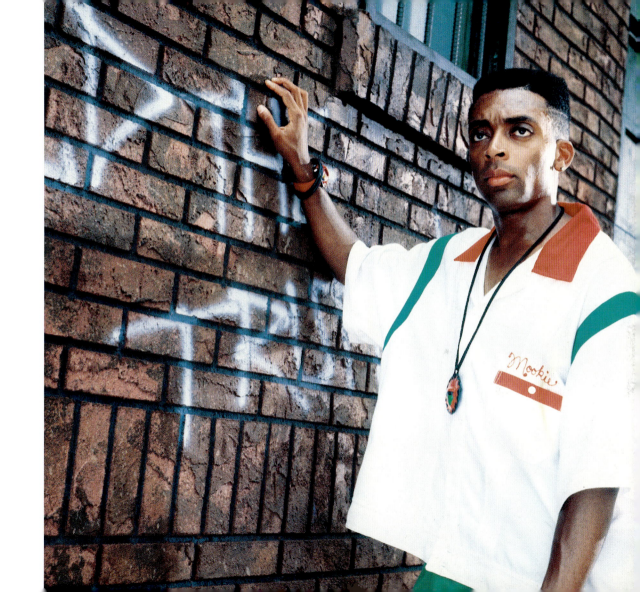

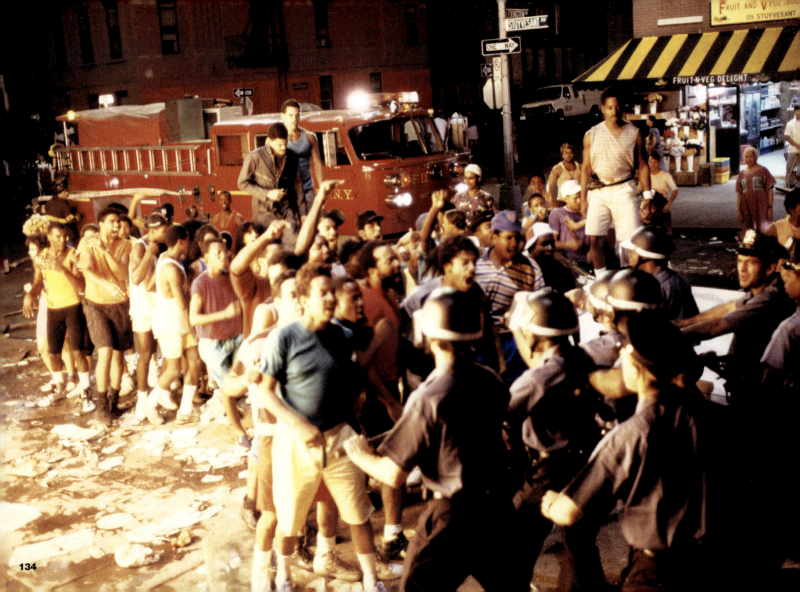

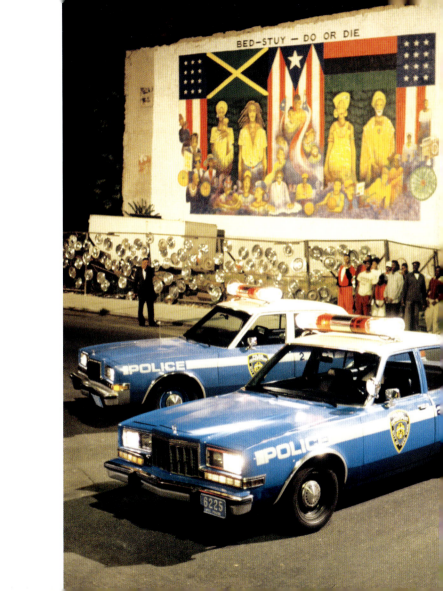

Anytime you see me with my glasses on I'm behind the camera and not in front of it.

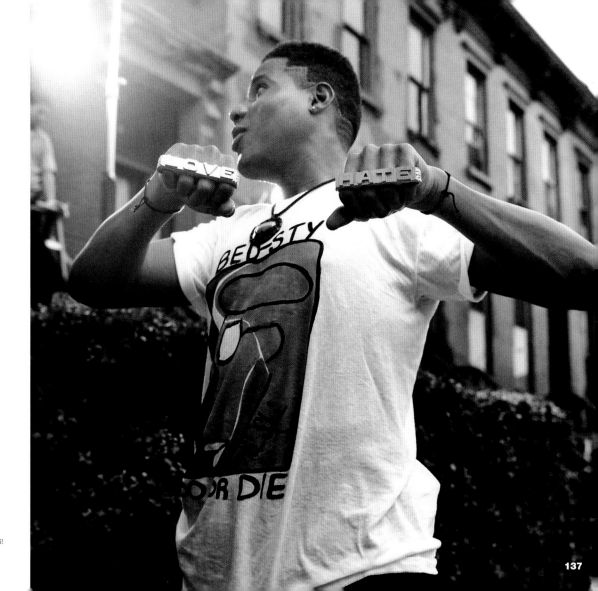

Radio Raheem LIVES!

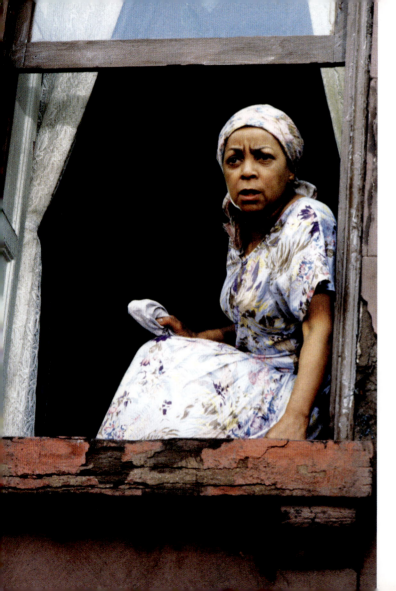

Mother Sister sees the world from her window.

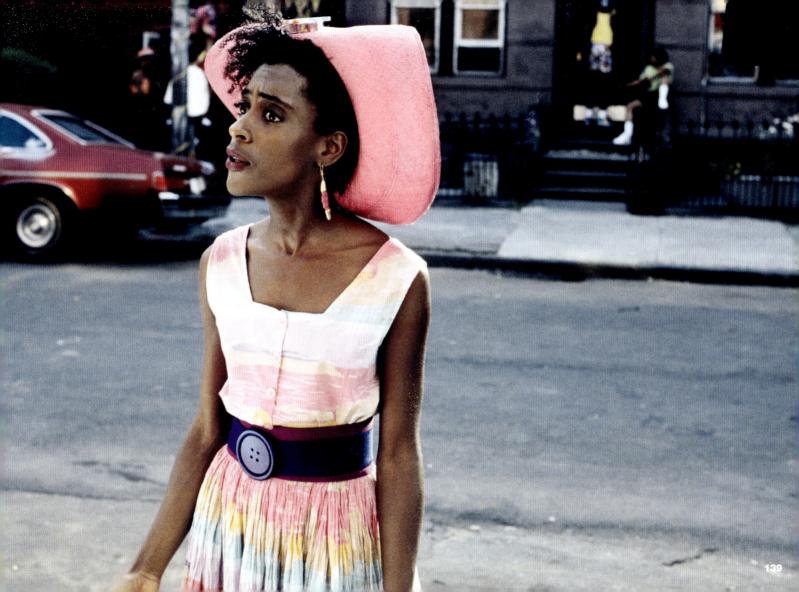

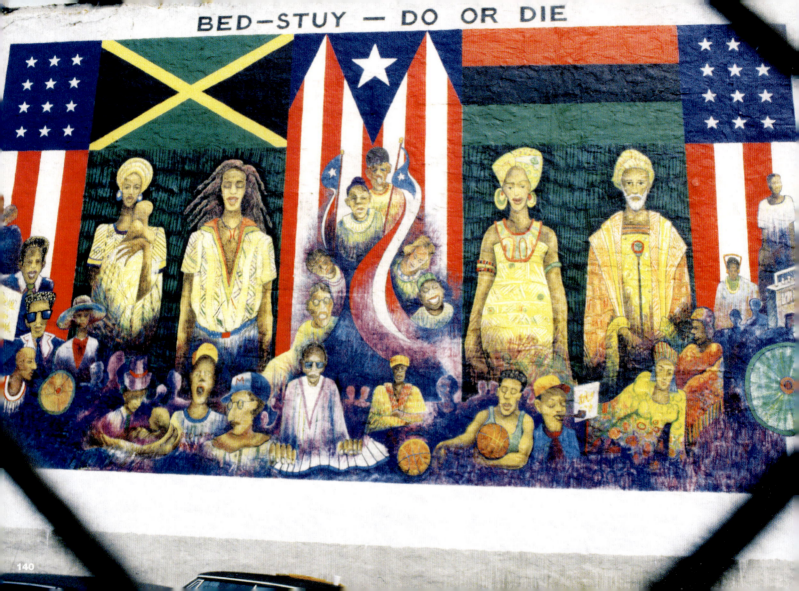

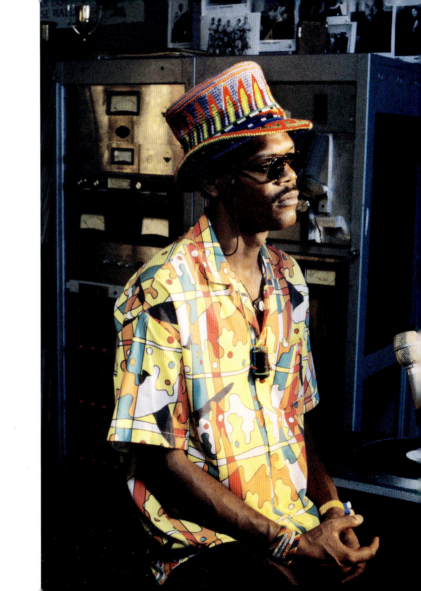

If you go back to the block, you can still see the faint outline of this mural.

The great Ernest Dickerson in front of the Wall of Fame.

Ernest Dickerson's shadow and light.

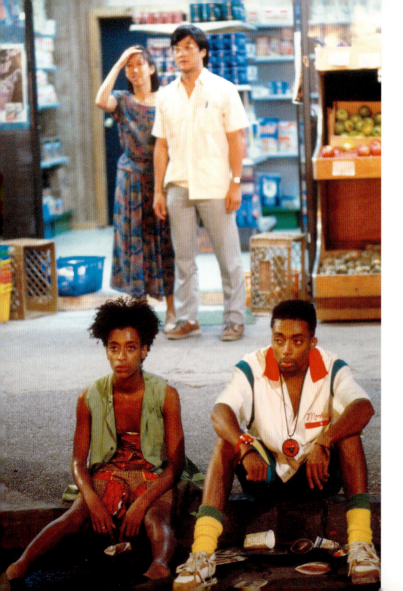

This is a GREAT SHOT.

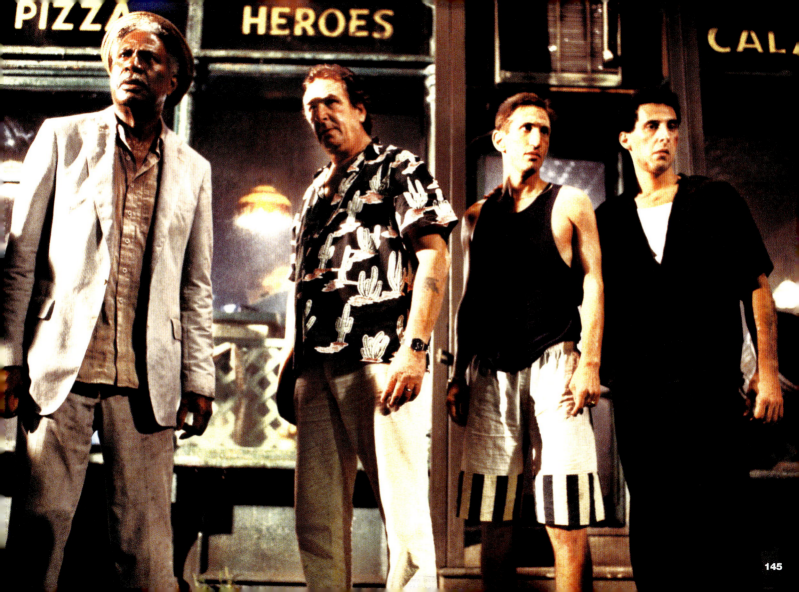

Danny and I on the last day of filming.

Makin' nice with the NYPD.

147

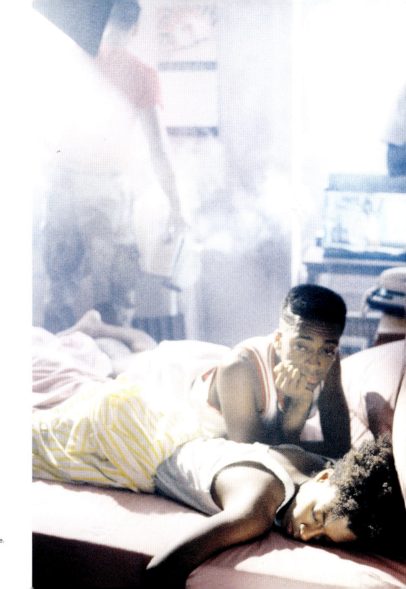

Waiting for the smoke.

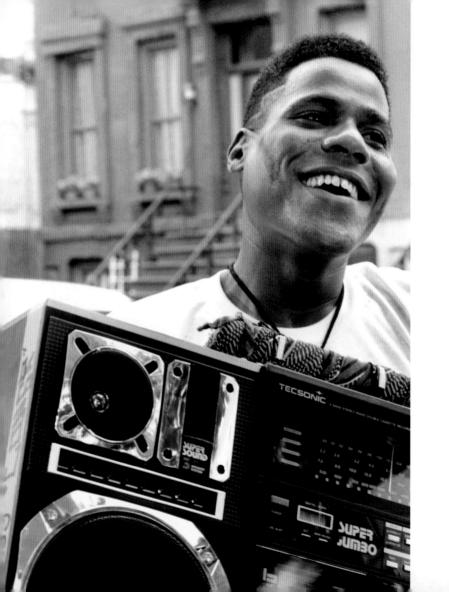

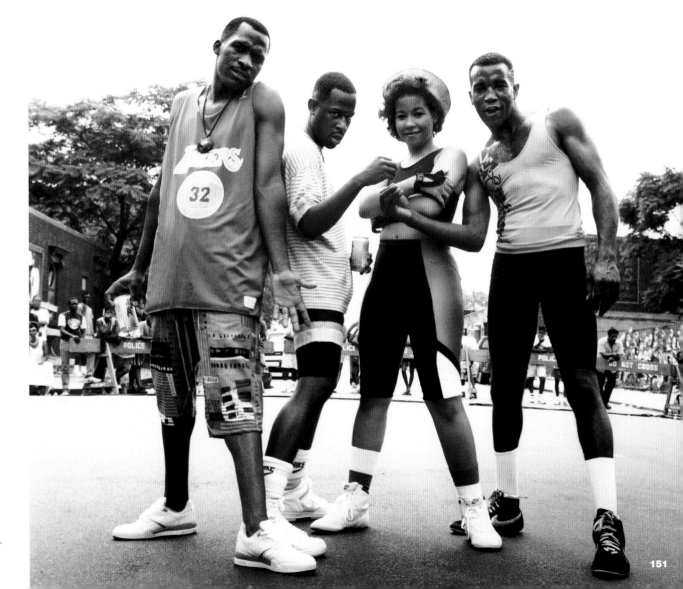

Brooklyn style.

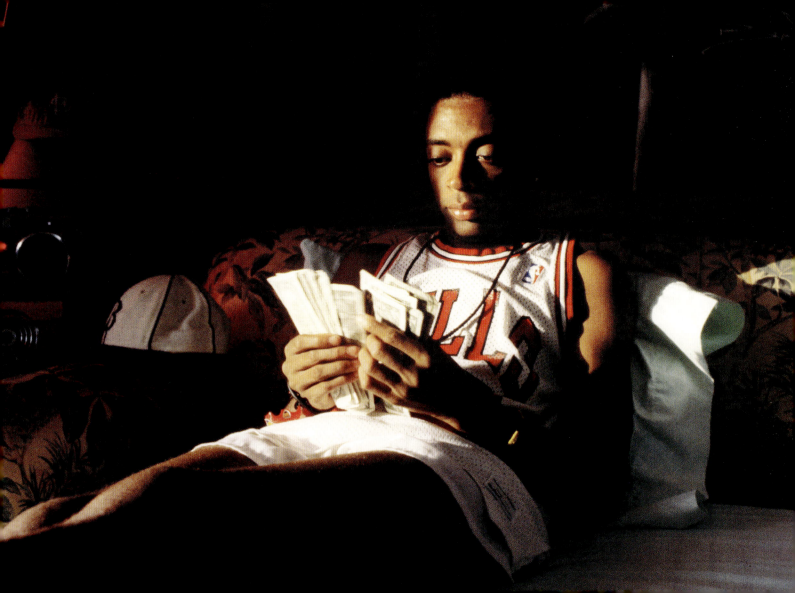

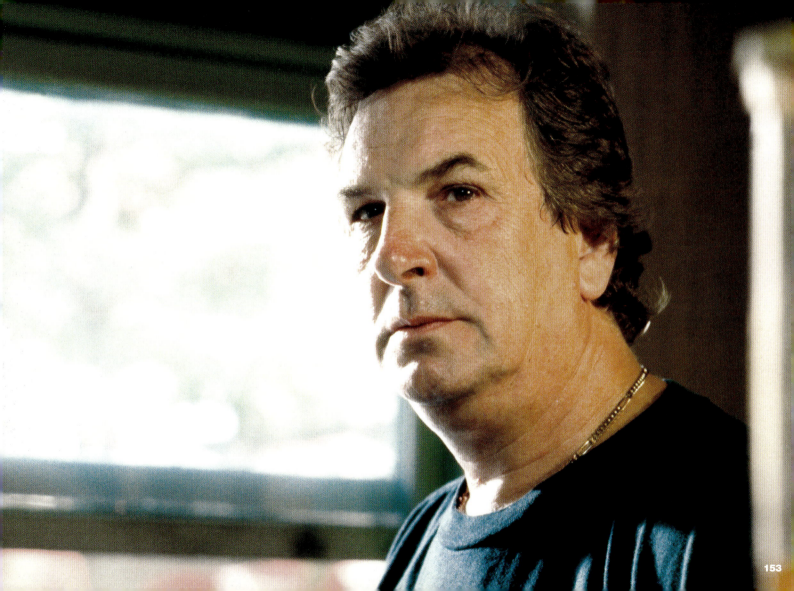

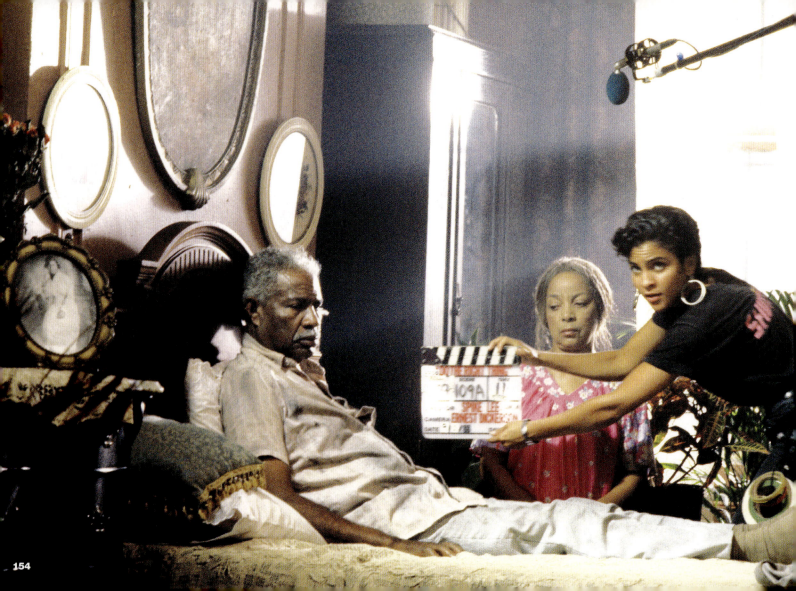

Now film director Darnell Martin, who was a camera PA, slates Ossie and Ruby.

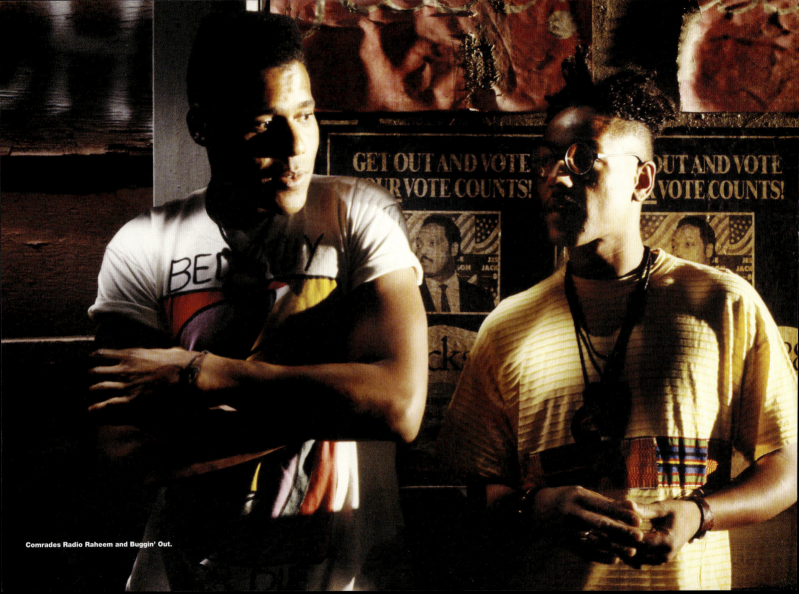
Comrades Radio Raheem and Buggin' Out.

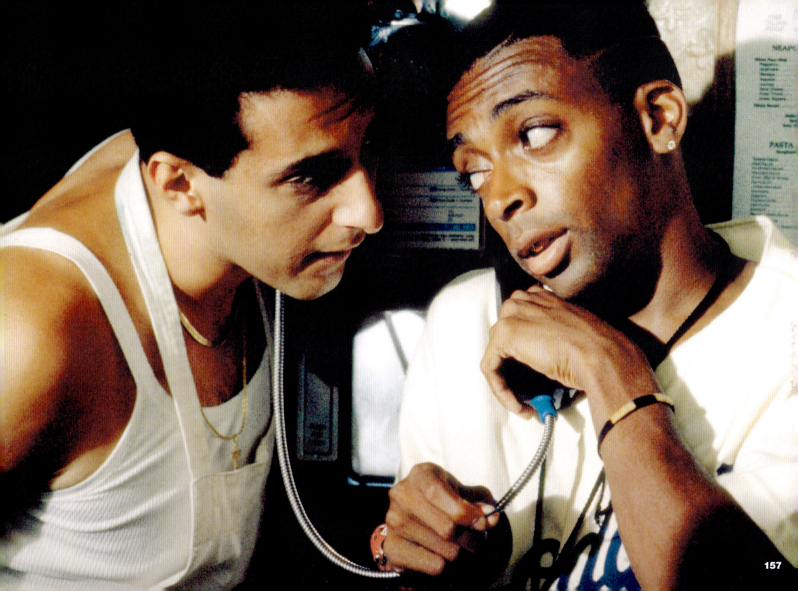

157

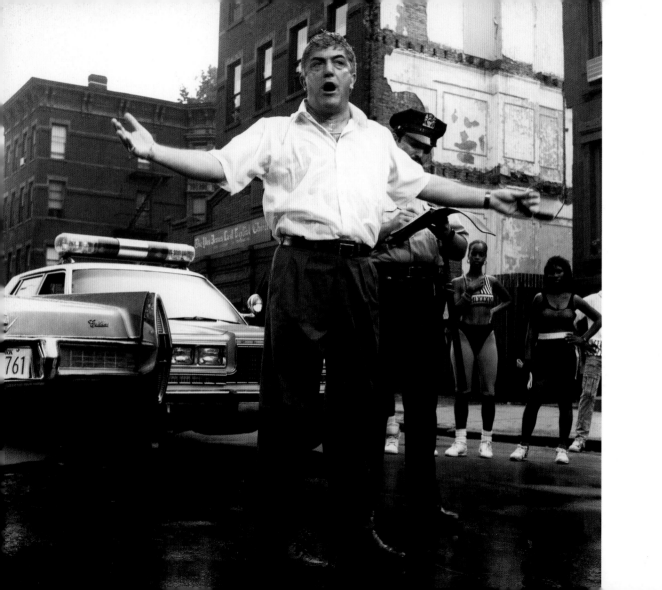

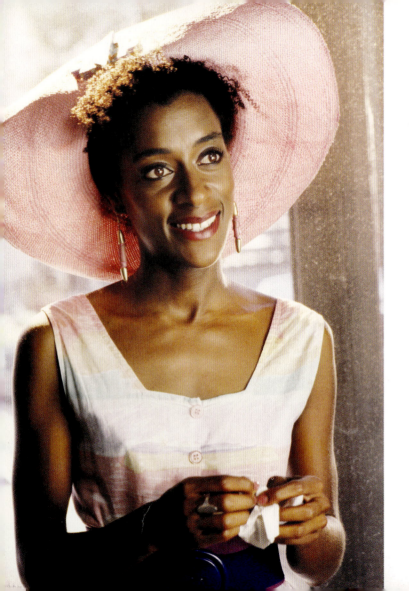

Leonard Thomas, Samuel L. Jackson, Giancarlo Esposito, and Bill Nunn.

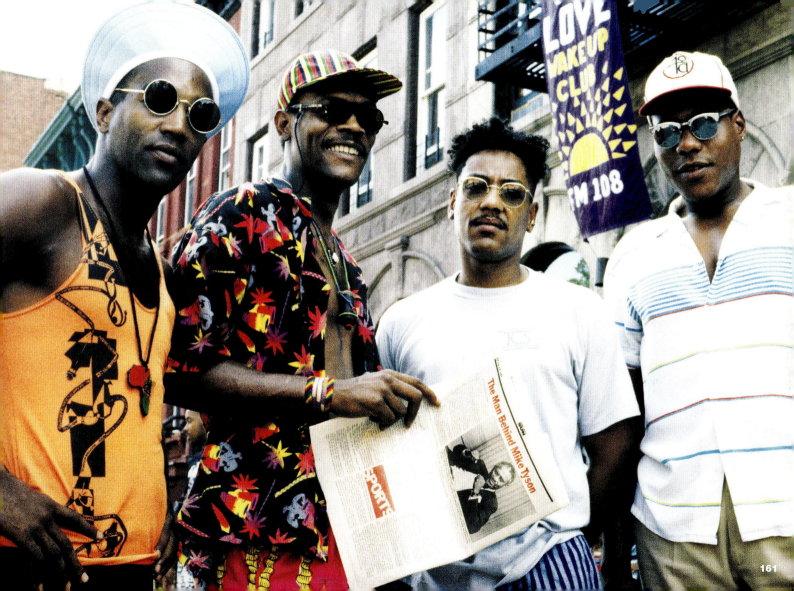

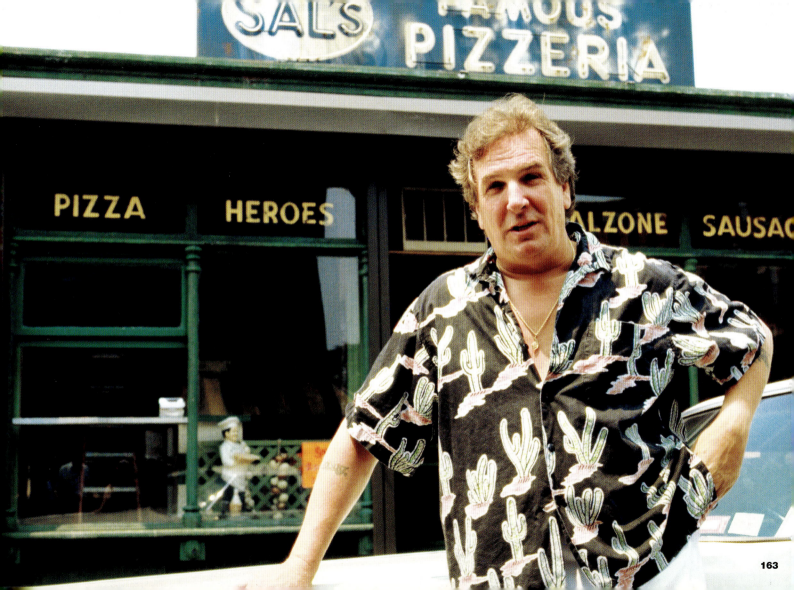

Mr. John Savage.

We shot John's scene in one day. He had to catch a plane; we got it done.

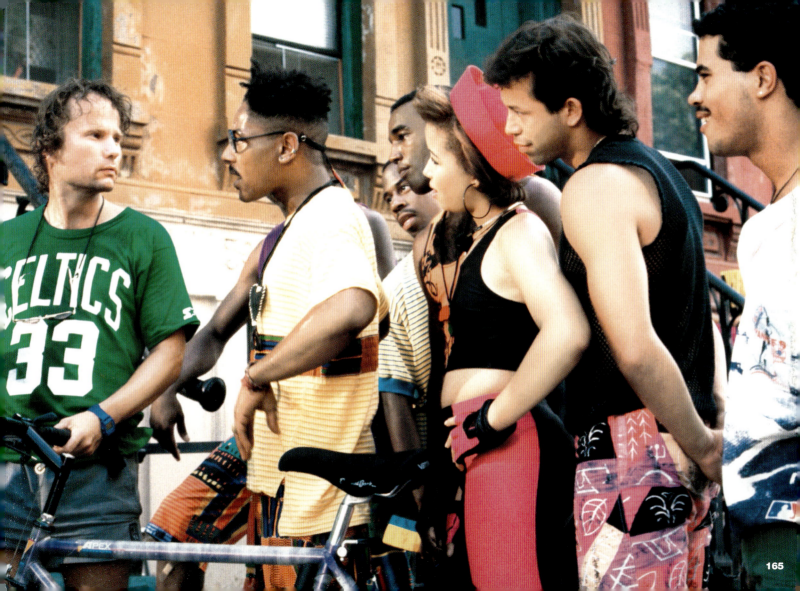

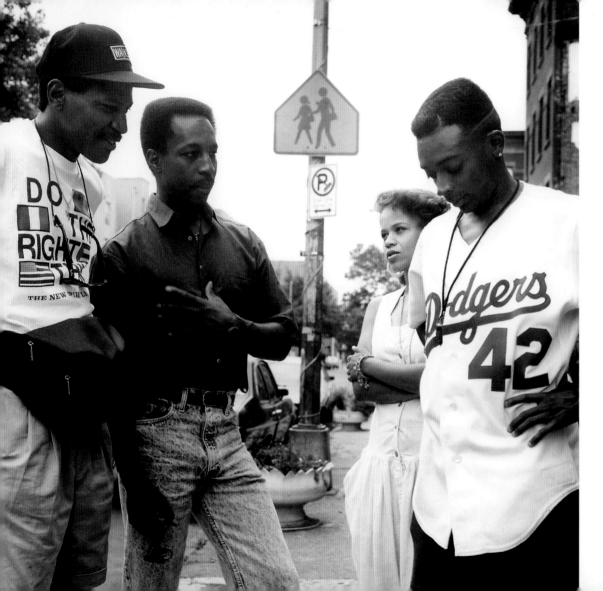

Larry Cherry, Rosie Perez, and I listen to NY Yankee great, Brooklyn's own Willie Randolph.

Sound man Frank Stettner with his young trainees.

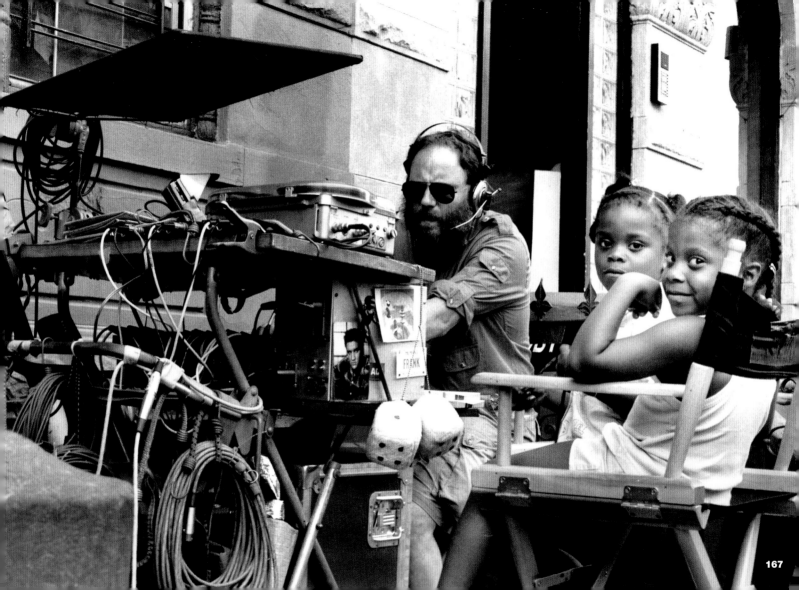

Ernest takes a light reading.

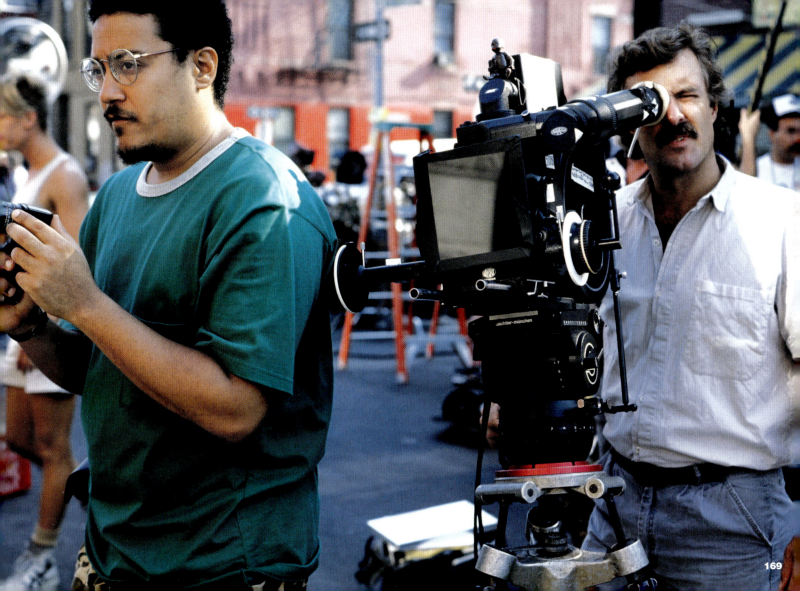

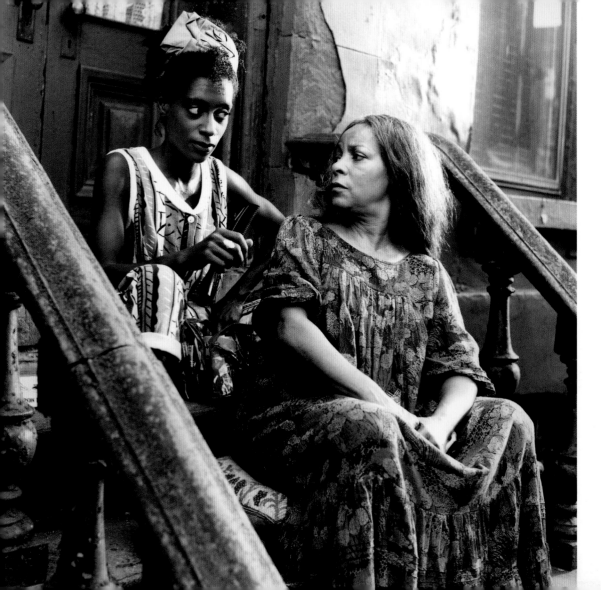

Jade combs Mother Sister's nappy head.

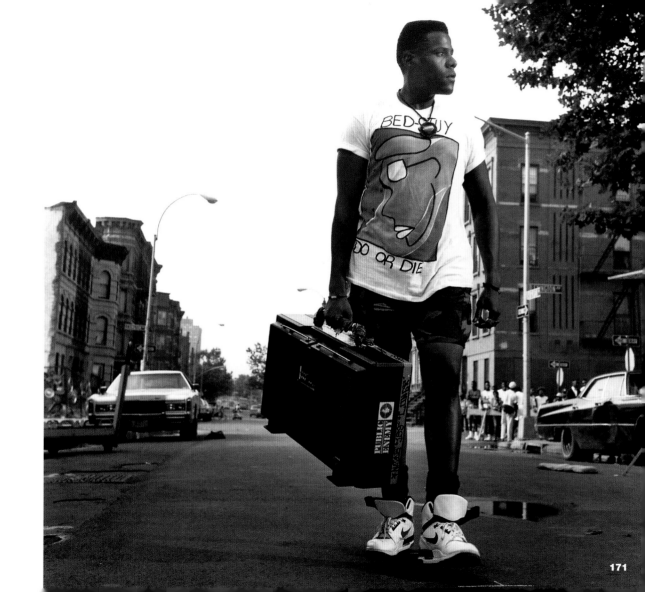

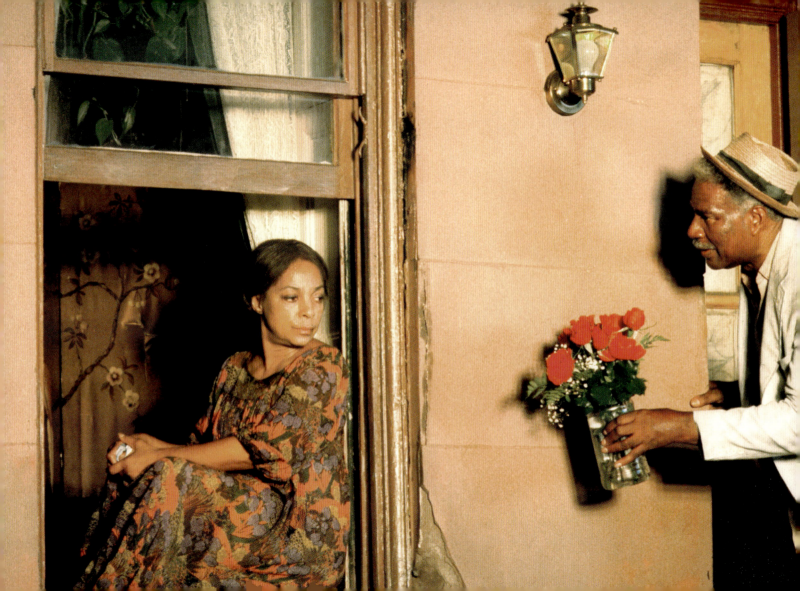

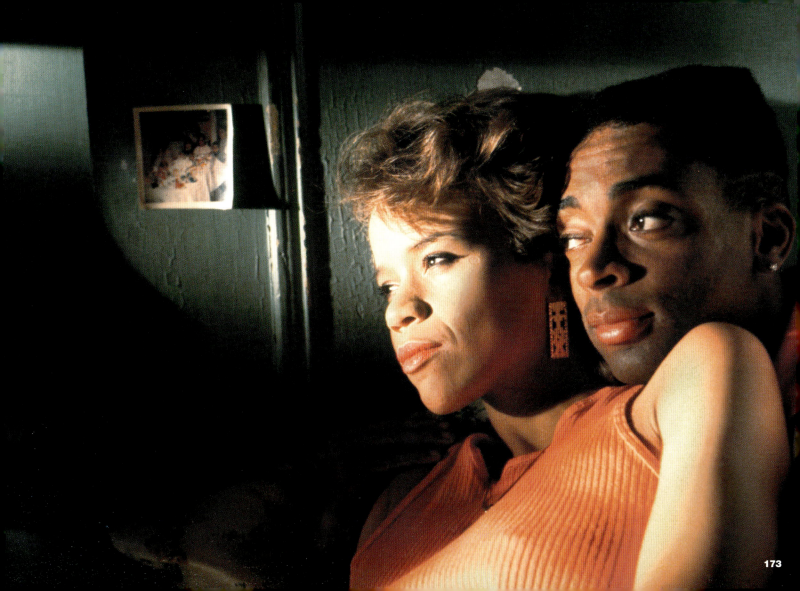

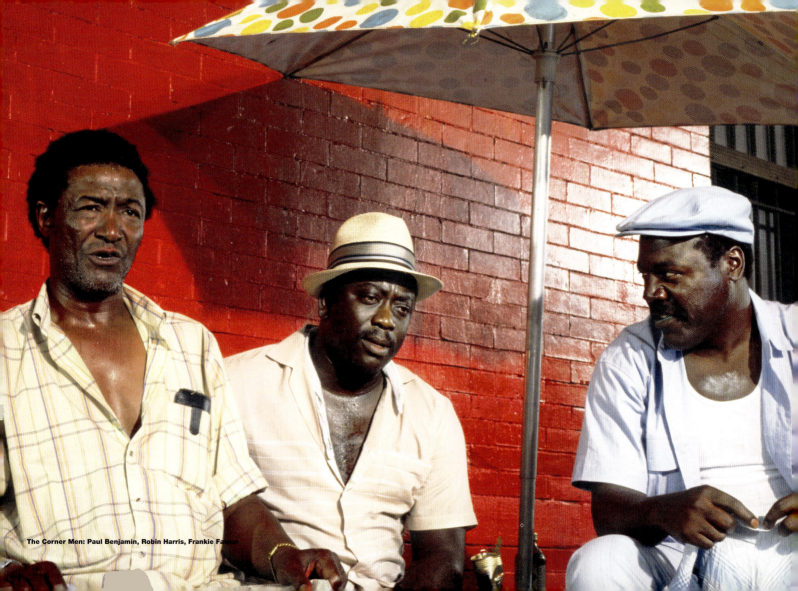

The Corner Men: Paul Benjamin, Robin Harris, Frankie Faison

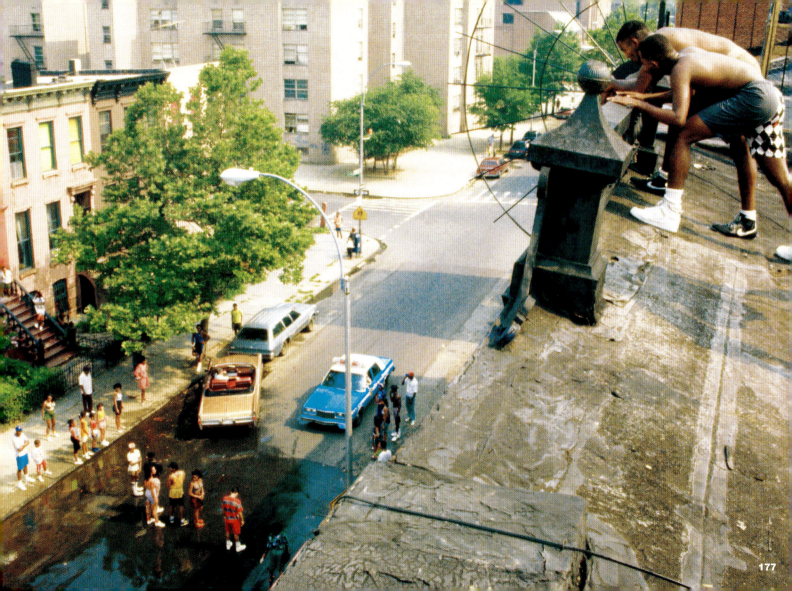

DO THE RIGHT THING

by

Spike Lee

First Draft
Started March 1, 1988 Brooklyn, New York Finished March 16, 1988
Forty Acres And A Mule Filmworks Inc.
YA-DIG SHO-NUFF
BY ANY MEANS NECESSARY
WGA #

FROM THE AUTOBIOGRAPHY OF MALCOLM X

Brooklyn, New York

"The greatest miracle Christianity has achieved in America is that the black man in white Christian hands has not grown violent. It is a miracle that 22 million black people have not risen up against their oppressors - in which they would have been justified by all moral criteria, and even by the democratic tradition. It is a miracle that a nation of black people has so fervently continued to believe in a turn-the-other-cheek and heaven-for-you-after-you-die philosophy. It is a miracle that the American black people have remained a peaceful people, while catching all the centuries of hell that they have caught, here in the white man's heaven. The miracle is that the white man's puppet Negro leaders, his preachers and the educated Negros laden with degrees and others who have been allowed to wax fat off their poor brothers, have been able to hold the black masses quiet until now.

MISTER SENOR LOVE DADDY

Malcolm X as told
to Alex Haley.

MISTER SENOR LOVE DADDY

This is Mister Senor Love Daddy, you voice of choice. The world's only 12

but strong won here on WE-LOVE Radio

①

PLACE
Brooklyn, New York

TIME
Present

WEATHER
Hot as shit!

EXTREME CLOSEUP.

We see-only see big white teeth and very Negroidal (BIG) lips.

MISTER SENÕR LOVE DADDY
Waaaake Up!
Wake up! Wake up! Wake up!
Up you wake! Up you wake! Up you wake.

CAMERA moves back slowly to reveal MISTER SENÕR LOVE DADDY, a DJ, an radio personality behind a microphone.

MISTER SENÕR LOVE DADDY
This is Mister Senõr Love Daddy. Your voice of choice. The world's only 12 hour strong man, here on WE-LOVE Radio

MISTER SENOR' LOVE DADDY [CONT'D]

108 FM ~~nobody~~. The last on your dial
but the first in ya hearts.

The CAMERA which is still pulling back shows that Mister Senor'
Love Daddy is actually sitting in a store front window.
The control booth looks directly out into the street. This
is WE-LOVE RADIO, a modest station with a loyal
following, right in the heart of the neighborhood.
The opening shot will be a TRICK SHOT - the camera
pulling back through the storefront window.

MISTER SENOR' LOVE DADDY

Here I am. Am I here?
Y'know it. ~~Yaknowytt~~. It you know.
This is Mister Senor' Love Daddy,
doing the nasty to ya ears,
th-ya ears to the nasty.
I'se play only da platters dat matter,
da matters dey platter

He hits the cart machine and we hear a station jingle.

VO

L-O-VE RADIO.

 MISTER SEÑOR' LOVE DADDY
 Doing da ying and yang
 da flip and flop
 da hippy and hoppy

He yodels.

 MISTER SEÑOR' LOVE DADDY
 Yo da lay he hoo.
 I have today's forecast

He screams.

 MISTER SEÑOR' LOVE DADDY
 H O T !

He laughs like a madman.

INT. APARTMENT - DAY

An old, grizzed man stirs in the bed, his sheets are soaked with sweat. He flings them off his wet body.

 DA MAYOR
 Damn, it's hot.

INT. APARTMENT-DAY

(CAMERA moves in on a young man sitting at the edge of his bed)

(U- His small hands-

We see him counting his money. This isn't any ordinary counting of money, he's straightening out all the corners of the bills, arranges them so the bills- actually the dead presidents are facing the same way. This is MOOKIE. Once he's finished with that task, counting his money, he sneaks into his sister's bedroom.

INT. BEDROOM-DAY

(U) JADE

JADE Mookie's sister is fast asleep.

Mookie's fingers enter the FRAME and start to play with her lips. Jade pushes his hands away. Mookie waits several beats and he continues. Jade wakes up- MAD.

JADE
Don't you have enough sense not to bother people when they're sleeping?

5

MOOKIE
Wake up!

JADE
Wake up? Saturday is the one day I get to sleep late.

MOOKIE
It's gonna be hot today.

JADE
Good! Leave me alone when I'm sleeping. I'm gonna get a lock on my door, to keep ya ass outta here.

MOOKIE
Don't ya love ya brother Mookie anymore? I loves ya Jade.

JADE
Do me a favor. Go to work.

MOOKIE
Later. Gotta get paid.

He plants a big fat juicy on his sister's forehead.

EXT. SAL'S FAMOUS PIZZERIA-DAY

A 1975 El Dorado pulls up in front of the neighborhood pizzeria- SAL'S FAMOUS PIZZERIA. From the car, comes out the owner SAL, a slightly overweight man in his early 50's and his two sons PINO, 22 and VITO 20. It's time for them to go to work at SAL'S FAMOUS PIZZERIA in the heart of BLACK BROOKLYN. Sal's sits right on the corner of THE BLOCK. THE BLOCK being where this film on the hottest day of the summer takes place.

Pino kicks a beer can in his path into the gutter.

SAL
Pino, get a broom and sweep out front.

PINO
Vito, get a broom and sweep out front.

VITO
See Pop. That's just what I was talkin' 'bout. Every single time you tell Pino to do something he gives it to me.

PINO
He's nuts.

SAL
The both of youse, shaddup.

VITO
Tell Pino.

PINO
Get the broom.

VITO
I ain't getting shit.

SAL
Hey! Watch it.

PINO
I didn't want to come to work anyway. I hate this freakin' place.

SAL
Can you do better? C'here.

Pino now is silent. Sal walks over to him.

SAL
Can you do better?

He pops Pino upside the head.

SAL
I didn't think so. This is a respectable business. Nuthin' wrong with it. Get dat broom.

PINO
Tell Vito.

VITO
Pop asked you.

SAL
I'm gonna kill somebody today

EXT. BROWNSTONE - DAY

Mookie comes down the stoop and walks to work.

EXT. STREET - DAY

MOOKIE
THE BLOCK is beginning to come to life. Those unlucky

[9]

souls who have to work this Saturday drag themselves to it, ~~to work~~, and the KIDS are out on the street to play in the hot sun all day long.

EXT. STOOP-DAY

Mookie stops to say hello to MOTHER SISTER. She leans out her window on the parlor floor. In the summertime the only time when she's not perched in her window is when she's asleep.

 MOTHER SISTER
 Good morning Mookie.

 MOOKIE
 Good morning to you.

 MOTHER SISTER
 Now Mookie, don't work too hard
 today. The weatherman said it's
 gonna be HOT as the devil. I
 don't want you falling out from
 the heat. You hear me son?

 MOOKIE
 I hear you Mother Sister. I hear you.

MOTHER SISTER
Good. I'll be watching you son.
Mother Sister always watches.

INT. SAL'S PIZZERIA - DAY

Mookie enters the pizzeria and Pino is on him before the door closes.

PINO
Mookie, late again. How many times I gotta tell you?

MOOKIE
Hello Sal. Hello Vito.

SAL
How ya doin' Mookie?

VITO
Whaddup?

MOOKIE
Alright.

PINO
You're still late.

SAL

PINO
Here take the broom. The front needs sweeping.

MOOKIE
Wait a minute. Wait a minute. I just got here. You sweep. I betcha Sal asked you first anyhow.

VITO
That's right.

PINO
Shaddup Vito.

MOOKIE
Fuck dat shit. I deliver pizzas. That's what I get paid for.

PINO
You get paid to do what we say.

MOOKIE
What <u>we</u> say. I didn't hear Sal say nuthin'.

Pino looks at his father. He wants to be backed up on this, all he gets is an amusingly look, and a smirk from Vito.

PINO
Who's working for who?

There's a knock on the door and Da Mayor enters.

SAL
Come on in Mayor.

DA MAYOR
Good morning gentlemens. It's gonna be a scorcher today, that's fa sure. Need any work done around here.

Sal looks at Pino, who reluctantly gives Da Mayor the broom.

DA MAYOR
It will be the cleanest sidewalk in Brooklyn. Clean as the Board of Health.

Da Mayor almost runs out of the pizzeria in his hurry, soon as he finishes he'll be able to get a bottle.

12

PINO
Pop, I don't believe this shit. We runnin' welfare or somethin'? Everyday you give dat bum...

MOOKIE
Da Mayor ain't no bum.

PINO
Give dat bum a dollar for sweeping our sidewalk. What do we pay Mookie for? He don't even work. I work harder than him and I'm your own son.

MOOKIE
Who don't work? Lets see you carry 6 large pies up six flights of stairs. No elevator either. and shit.

SAL
Both of youse- shaddup. This is a place of business.

VITO
Tell em Pop.

PINO
Me and you are gonna have a talk.

VITO
Sez who?

PINO
Sez me.

SAL
Hey! What did I say?

MOOKIE
Who doesn't work? Don't start no shit, want be no shit.

SAL
Mookie, no cursing in the store

MOOKIE
Talk to your son.

EXT. SAL'S FAMOUS PIZZERIA - DAY

Da Mayor sweeps the sidewalk happy as can be. As soon as he finishes, he can get that money and get that bottle.

[H]

EXT. STOOP - DAY

A group of youths sit on a stoop waiting for someone. They are CEE, SMILEY, PUNCHY and the lone female ELLA.

 ELLA
 What's keeping him?

 PUNCHY
 You call him then.

Ella stands up and yells.

 ELLA
 Yo Ahmad!

 PUNCHY
 I coulda done dat.

 ELLA
 Yo Ahmad!

She looks up into his window, then sits down.

 ELLA
 Punchy, if you want to do some more

ELLA [CONT'D]
Screaming be my guest. I'm through

The door swings open at the top of the stoop and AHMAD appears.

AHMAD
Who's yelling my name?

ELLA
Punchy told me to.

AHMAD
Don't listen to him, it will get you in trouble.

ELLA
Heard that Punchy.

Ahmad sits down with them.

AHMAD
Today, we're gonna have big fun.

CEE
Big Fun?

[16]

AHMAD
We're gonna fire it up.

ELLA
I'm down.

In the background we HEAR the DUM-DUM-DUM of a giant box. The sound gets louder as the box gets closer. The youths look down the block and see a tall young man coming towards them. He has a very distinct walk, it's more like a bop. THIS IS RADIO RAHEEM. The size of his box is tremendous and one has to think how does he carry something that big around with him? It must weigh a ton, ~~music~~ and it seems like the sidewalk shakes as the RAP MUSIC blares out. The SONG we hear is the only one RADIO RAHEEM plays.

MS. RADIO RAHEEM

Radio Raheem stops in front of the group, looks at them and turns down the volume. It's quiet again.

RADIO RAHEEM
Peace y'all.

ELLA
Peace, Radio Raheem.

CEE
Peace.

PUNCHY
Yo the man, Radio Raheem.

Radio Raheem nods and turns up the volume. Way up.

AHMAD
Just chillin'.

AHMAD
My people. My people.

EXT. WE-LOVE STOREFRONT DAY

Radio Raheem waves to Mister Senor Love Daddy as he walks by.

INT. WE-LOVE CONTROL BOOTH DAY

Mister Senor Love Daddy give Radio Raheem a clinched fist salute.

EXT. FRUIT-N-VEG DELIGHT - DAY

Da Mayor walks into a newly opened fruit and vegetable deli stand that is owned by Koreans

INT FRUIT-N-VEG DELIGHT - DAY

Da Mayor is looking for his beer in the refrigerated cases, his ice cold beer.

DA MAYOR
Where's the Bud? Where's the Bud?

KOREAN CLERK
No mo' Bud. You look what we have and buy

DA MAYOR
No more Bud. What kind of joint is this? How come no mo' Bud? Doctor, this ain't Korea, China or wherever you come from. Get some Budweiser in this motherfucker.

KOREAN CLERK
~~scribbled out~~
You buy other beer

DA MAYOR
Alright. Alright, Y'know your asking
alot to make a man change his beer,
that's asking alot Doctor.

EXT. MOTHER SISTER'S STOOP - DAY

Da Mayor has his can of beer (not Budweiser) and the
brown paper bag is twisted into a knot at the bottom.
He stops and takes a long swill.

MOTHER SISTER
You ole drunk. What did I tell you
about drinking in front of my stoop?
Move on, you're blocking my view.

Da Mayor lowers the can from his mouth and looks up
at his heckler. It's obvious from the look on his face.
he's heard this before. Da Mayor contorts his face
and stares at her.

MOTHER SISTER
You ugly enough. Don't stare at me.

Da Mayor changes ~~his face~~ his face into a more grotesque look.

MOTHER SISTER
The evil eye doesn't work on me.

DA MAYOR
Mother Sister, you've been talkin' 'bout me the last eighteen years. What have I ever done to you?

MOTHER SISTER
You're a drunk fool.

DA MAYOR
Besides that. Da Mayor don't bother nobody. Nobody don't bother Da Mayor but you. Da Mayor just mind his business. I love everybody. I even love you.

MOTHER SISTER
Hold your tongue. You don't have that much love.

DA MAYOR
One day you'll be nice to me. We might be both dead and buried but you'll be nice. At least civil.

EXT. STREET CORNER- DAY

Everyday on this corner, summer or winter, spring or fall a small group of men meet. They have no steady employment, nothin they can speak of, they do however have the gift of gab. These men can talk, talk and mo' talk and when a bottle is going round and they're feeling nice, "They get philosophical. These men become the great thinkers of the world with solutions to all the ills like drugs, the homeless and Aids. They're called the CORNER MEN, SWEET DICK WILLIE, (COCONUT SID and ML. All three are sitting in folding chairs up against a wall in the shade.

ML
The way I see it if this hot weather continues it will surely melt the polar caps and the whole wide world - the parts that ain't water already - be will be flooded.

(COCONUT SID
You a dumb ass simple mothafucker.

COCONUT SID (CONT'D)
Where did you read that?

ML
Don't worry about it. But when it happens and I'm in my boat and ya black ass is drowning don't ask me to throw you a lifesaver either.

SWEET DICK WILLIE
Nigger, your thirty sents away from a quarter. How you gonna get a boat?

ML
Don't worry about it.

SWEET DICK WILLIE
You're raggedy as a roach. You eat the holes out of donuts.

ML
I'll be back on my feet. Soon enough.

SWEET DICK WILLIE
So when is all this ice suppose to melt?

INT. SAL'S FAMOUS PIZZERIA - DAY

Customers are in Sal's, it's lunchtime and it's fairly busy. Sal puts a hot slice down on the counter in front of BUGGIN' OUT, a B-Boy.

SAL
You paying now or on layaway?

Buggin' Out looks at the slice.

BUGGIN' OUT
How much?

SAL
You come in here atleast three times a day. You a retard? A buck fifty.

BUGGIN' OUT
Damn Sal, put some more cheese on that motherfucker.

SAL
Extra cheese is two dollars. Y'know dat.

BUGGIN' OUT
Two dollars! Forget it.

Buggin' Out slams his money down on the counter, takes his slice and sits down.

ANGLE - TABLE

All around Buggin' Out peering down from THE WALL OF FAME are signed, framed 8 X 10 glossies of famous Italian-Americans. We see JOE DiMAGGIO, ROCKY MARCIANO, PERRY COMO, FRANK SINATRA, LUCIANO PAVAROTTI, LIZA MINNELLI, GOVERNOR MARIO CUOMO, AL PACINO and of course how can we forget SYLVESTER STALLONE as ROCKY BALBOA.

CU - BUGGIN' OUT

He looks at the pictures hovering above him.

BUGGIN' OUT
Mookie.

CU - MOOKIE

MOOKIE
What?

CU- BUGGIN' OUT

BUGGIN' OUT
How come you ain't got no brothers up?

CU- MOOKIE

MOOKIE
Ask Sal.

ANGLE PIZZERIA

BUGGIN' OUT
Sal, How come you ain't got no
brothers up on the wall here?

SAL
You want brothers up on the wall of fame,
you open up your own business then
you can do what you wanna do.
My pizzeria, Italian Americans up
on the wall.

VITO
Take it easy Pop.

SAL
Don't start on me today.

BUGGIN' OUT
Sal, that might be fine, you own this
but ~~I~~ rarely do I see any Italian-
Americans eating in here. All
I've ever seen is Black folks. So
since we spend <u>much</u> money here,
we do have some say.

SAL
You a troublemaker!

Pino walks over to Buggin' Out.

PINO
You making trouble.

BUGGIN OUT
Put some brothers up on this wall of fame.
We want MALCOLM X, ANGELA DAVIS
MICHAEL JORDAN tommorow.

Sal comes from behind the counter with his Mickey Mantle model baseball bat, Vito is by his side
but Mookie intercepts them taking Buggin' Out with him.

SAL
Don't come back either.

BUGGIN' OUT
Boycott Sal's. Boycott Sal's.

EXT. SAL'S PIZZERIA - DAY

MOOKIE
Buggin' Out, I gotta work here.

BUGGIN' OUT
I'm cool. I'm cool.

MOOKIE
Come back in a week, it will be squashed.

BUGGIN' OUT
It's squashed.

They give each other five.

INT. SAL'S FAMOUS PIZZERIA - DAY

Mookie enters.

SAL
Mookie, if your friends can't behave,

SAL [CONT'D]
they're not welcome.

MOOKIE
I got no say over people.

PINO
You talk to em.

MOOKIE
People are free to do what they wanna do.

SAL
Don't want no trouble.

I know This is America, but I?

EXT. STREET- DAY

Mookie walks down the block with pizza box in hand when he sees Da Mayor sitting on his stoop.

DA MAYOR
Mookie

MOOKIE
Can't talk now

DA MAYOR
(...here Doctor.

Mookie turns around and goes back.

DA MAYOR
Doctor, this is Da Mayor talkin'.

MOOKIE
Ok. ok.

DA MAYOR
Doctor, always try to do the right thing.

MOOKIE
That's it?

DA MAYOR
That's it.

MOOKIE
I got it. NILDA

INT. TENEMENT BUILDING DAY

Mookie is hiking up a flight of stairs.

ANGLE - STAIRCASE

He puts the pizza box down and takes a breather.

CU MOOKIE

Sweat drips off his face.

ANGLE - MOOKIE

He bends down to pick up the pizza box and tackles the last few flights.

CU DOORBELL

Mookie pushes the buzzer.

ANGLE - DOOR

A young Puerto Rican woman opens the door.

NILDA
I hope it's not cold.

Mookie hands her the pizza.

MOOKIE
No it's not cold. 12 dollars for the pie.

Nilda hands him a handful of singles. Mookie looks at the crumpled mess. Nilda attempts to close the door, but Mookie's foot says hell no.

MOOKIE
Hold it. Let me count this first.

He first straightens out the dollars, then counts the bills.

MOOKIE
You're short.

NILDA
I counted the twelve dollars myself.

MOOKIE
Twelve is right, but no tip.

NILDA
No tip.

MOOKIE
Look lady, I carried your pizza

[32]

 MOOKIE (CONT'D)
 up five flights of stairs and shit,
 the cheese didn't slide over to
 one side like it sometimes does
 with delivery people who don't care.
 I do care. May I get paid?

Nilda looks at him and sees right away he's not going anywhere.

 NILDA
 Wait here.

 MOOKIE
 I'll wait.

Nilda goes into the apartment and we hear her talking in Spanish to a male.

ANGLE: MOOKIE

Mookie bends down to tie his sneakers.

ANGLE - DOOR

Nilda reappears and holds out a lonely lone dollar for him.

EXT. MOTHER SISTER'S STOOP - DAY

Jade sits down next to Mother Sister on the stoop.

MOTHER SISTER
Jade, you're late.

JADE
I know Mother Sister, but I'm here now. Where's the stuff?

Mother Sister hands her a bag that is at her side.

MOTHER SISTER
Seen your brother just walked by

Jade unwraps a head scarf from around Mother Sister's head and a full head of long black hair falls to her shoulders.

JADE
This might take some time.

MOTHER SISTER
I got nowhere to go. We haven't had a good sitdown for a long while.

Jade begins to part, grease and comb out Mother Sister's hair.

MOTHER SISTER
Tender headed runs in my family. You tender headed?

JADE
Me too.

MOTHER SISTER
That's why I don't fool with it now. Only let you touch it.... Ouch!

JADE
Sorry, comb got caught.

MOTHER SISTER
Be gentle, child. Mother Sister is an old woman.

JADE
How are you holding up in this weather?
MOTHER SISTER
I'll do.

MOTHER SISTER JADE
I don't know why you still haven't bought on air conditioner?

JADE
Don't like em'. A fan is fine for me.

ANGLE - DA MAYOR

Da Mayor stands in front of the stoop, he's smiling for days.

DA MAYOR
I didn't know you had such beautiful long hair.

ANGLE - STOOP

MOTHER SISTER
There's alot you don't know in this world fool.

36

CU- DA MAYOR

> DA MAYOR
> I'm not stopping. I'm on my way.

ANGLE - STOOP

> JADE
> You are too cruel to Da Mayor, it isn't right. You and him would make a nice couple.

> MOTHER SISTER
> Child, be quiet. Don't talk foolishness.

> JADE
> Whew!

CU- JADE

She looks up at the white hot sun.

CU MOTHER SISTER

She does the same.

CU- THE WHITE HOT SUN.

HOT, HOTTER and HOTTEST MONTAGE

Right now FOLKS we're gonna suspend the narrative and show how peoples are coping with the OPPRESSIVE HEAT.

a) People are taking COLD SHOWERS.
b) Sticking faces in ICE COLD water filled sinks.
c) heads stuck in refrigerators
d) A wife telling her husband "Hell no, I'm not cooking. It's too hot. The kitchen is closed."
e) Men downing six packs of ICE COLD BREW
g) faces stuck directly in front of fans
h) And how can I forget the papers, the newspaper headlines:
 New York Post - "A SCORCHER"
 New York Daily News - "2 HOT 4 U?"
 New York Newsday - "OH BOY! BAKED APPLE"
 New York Times - "RECORD HEATWAVE HITS CITY"

(1) JOHNNY PUMP

POV) A powerful gush of water flies out right at the camera.

EXT. STREET - DAY

Ahmad has just turned on the Johnny pump and the white stream of water flies across the street.

This attracts all the people on the block. It's a chance to cool off and momentarily beat the KILLER HEAT.

ANGLE - CEE and PUNCHIE

They both scrape beer cans on the sidewalk.

ANGLE - ELLA

She stands with caution ~~away~~ away from the fire hydrant. Ella does not want to get wet.

ANGLE - CEE and PUNCHIE *Punchy as first appeared*

They're still scraping away.

ANGLE - STREET

Folks, young and old begin to get in the water and play.

ANGLE - CEE and PUNCHIE

Both now have cans with the ends scraped away, and go to the johnny pump. Punchie bends down behind the hydrant and places the can over the water. The can now directs the water into giants streams.

ANGLE- ELLA

Ahmad sneaks up behind Ella and he picks her up.
She's kicking and screaming furiously.

ELLA
Ahmad! Put me down. Put me down.
I can't get wet. I'm not playing.

Ahmad is not having it. He carries a kicking Ella
into the middle of the street in direct line of fire.

AHMAD
Yo!

ELLA
No!

They both are hit with a blast of water and are
soaked to the bone. Ella starts to punch Ahmad who she chases
after.

ANGLE- STREET

We hear the familiar RAP MUSIC of Radio Raheem's box.

CLOSE - RADIO RAHEEM

Radio Raheem is too cool. By the way he's dressed it could be fall, not the HOTTEST DAY OF THE YEAR. But you could never tell it from him. He's too cool.

Raheem looks at Cee, he wants to get by and he doesn't want to get wet either. And if his box gets wet somebody is gonna die. Cee knows this too.

ANGLE - JOHNNY PUMP

Cee stands in front of the hydrant blocking the water so Radio Raheem can pass.

ANGLE - RADIO RAHEEM

He slowly bops across the street as all eyes watch. When he's clear Cee moves and the water gushes out again as folks play.

ANGLE - STREET

We hear a car horn blowin'. People move out the way as the vehicle speeds through the spray.

ANGLE - WHITE CONVERTIBLE

An older man stops his white convertible and blows his horn.

MAN
I'm not playing. There's gonna be trouble if you fuck around.

CLOSE CE and PUNCHIE

PUNCHIE
Go 'head. You got it. You got it.

CLOSE MAN

MAN
This is an expensive car.

CLOSE CEE
Been up Wesley, got all day.

CEE
You won't get wet?

He cocks off more to the car, for they know.

ANGLE - HYDRANT to hopen

Both Punchie and Cee sit in front of the hydrant once again.

42

blocking the water.

ANGLE - WHITE CONVERTIBLE

The car cautionly eases forward. He doesn't trust Cee and Punchie at all.

CLOSE MAN

> MAN
> I'm warning you.

CLOSE - CEE and PUNCHIE

> PUNCHIE
> C'mon.

> CEE
> Hurry up. We ain't got all day.

ANGLE - STREET

The people all move to the car, for they know what is about to happen.

ANGLE HYDRANT

Lee and Pundie leap off the hydrant unleashing a jet blast that flies directly into the man's car. The WHOLE BLOCK is dying.

ANGLE-STREET

The man's flooded car over to the curb, jumps out and pulls runs to get hold of Lee and Pundie. Of cause, he's slow as both turn into track stars and make like Carl Lewis.

ANGLE MAN

The man, a wet mess tries to buy some sympathy from the folks, none is to be bought.

MAN
I'm fucking soaked. If I ever catch those fucks they'll be sorry. Sonabitches!

The ranting continues, and people laugh at him.

MAN
You people make me sick.

44

A COP CAR with sirens wailing screeches to a halt in front of the man. Two officers, LONG and PONTE get out.

MAN
Officers, I want an arrest made. Now.

OFFICER PONTE
What happened?

MAN
Two black kids soaked me and my car. It's fucking ruined.

OFFICER LONG
Where are they?

MAN
Where are they? What kind of fucking asshole question is that? They ran the fuck away.

OFFICER PONTE
Do you wish to file a complaint?

MAN

Officer Lang goes into his car and gets a wrench.

ANGLE JOHNNY PUMP

Officer Lang turns off the hydrant then puts the cap back on.

OFFICER PONTE
This hydrant better not come back on or there's gonna be hell to pay.

MAN
What about my car? I want justice.

Officer Lang sides up to Da Maya who's been looking on.

OFFICER LONG
You know anything about this?

Da Maya is quiet.

MAN
He knows. He's a witness. They all know.

Officer Ponte goes to Da Maya's other side.

OFFICER LONG
Who were the punks?

DA MAYOR
Those who'll tell don't know.
Those who know won't tell.

OFFICE PONTE
A wise guy.

Mookie emerges from the crowd and leads Da Mayor away from the interrogation.

MOOKIE
Let's go Mayor.

OFFICER LONG
Keep this hydrant off. You want to swim, go to Coney Island.

MAN
He's leaving? What about me?

OFFICER PONTE
I suggest you get in your car quick before these people start to strip it clean.

The man looks at the crowd of Blacks and Puerto Ricans around him and he considers what he just heard.

OFFICER LONG
Let's go break it up. Go back to your jobs.

OFFICER PONTE
What jobs?

Both cops laugh.

ANGLE STREET

The man drives away fuming.

EXT. ROOFTOP DAY

Lee and Punchie look down from a roof on all the HAVOC and CONFUSION they've started. Both laugh.

INT. SAL'S FAMOUS PIZZERIA - DAY

Mookie enters.

SAL
Mookie, what took you so long? I gotta a business to run.

MOOKIE
Run it then.

SAL
Here, this goes to the radio station.

He gives Mookie a bag full of food.

VITO
Pop, I'm gonna go with Mookie.

SAL
Good, make sure he don't jerk around.

PINO
Yeah, hurry back, it's getting crowded.

EXT. STREET- DAY

Vito and Mookie walk down the block.

VITO
~~Nunor~~ Mister Señor Love Daddy is cool.

MOOKIE
Ya like him, huh?

VITO
Yeah. This one time and he'll next

MOOKIE
Y'know Vito, I know Pino is ya brother and shit but the next time he hits ya, the next time he touches ya, you should house him. Kick his ass

VITO
I don't know.

MOOKIE
If you don't make a stand, he's gonna be beating ya like a egg for the rest of your life.

VITO
That's what you think?

MOOKIE
That's what I think.

VITO
I don't like to fight.

50

 MOOKIE
 Do it this one time and he'll never
 touch you again.

EXT. WE LOVE RADIO - DAY

Mookie and Vito wave at Mister Senor Love Daddy
through the storefront window and he buzzes
them in.

INT. RECEPTION AREA - DAY

 RECEPTIONIST
 How ya doin' Mookie?

 MOOKIE
 Tryin' to get paid.

 RECEPTIONIST
 Are'nt we all. Go on in.

INT. CONTROL BOOTH - DAY

Mookie and Vito very quietly walk in, the man is on the air.

MISTER SENOR' LOVE DADDY

Peoples my stomach's been grumbling
but help has arrived. My man main - ?
Mookie has saved the day, straight
from Sal's famous Pizzeria. Come
up to mike Mookie.

Mookie goes to the mike.

MISTER SENOR' LOVE DADDY

C'mon don't be shy. Mmm, smells
good. This is ya Love Daddy
talkin to ya, starvin like Marvin.
Say something Mookie, while I ~~bedazzle~~
~~eat my pizza~~.

MOOKIE

Mister Senor Love Daddy I'd like
to dedicate the next record to
my heart, Tina.

MISTER SENOR' LOVE DADDY

Alright. Let me play this record while
I go to work on my Chicken Parmigiana
Hero with extra sauce, cheese and
extra sauce.

He hits the cart machine...

VO
I just looove you so much Mister Senor' Love Daddy.
WE LOVE RADIO 108 FM

Then cues up the record.

MISTER SENOR' LOVE DADDY
Here ya are.

He hands Mookie a 20 dollar bill.

MISTER SENOR' LOVE DADDY
Keep the change.

MOOKIE
That's right on time. This is my friend - Vito. His Pops is Sal.

MISTER SENOR LOVE DADDY
Tell ya father he makes the best heros in Brooklyn.

VITO
I'll do that.

MOOKIE
We're outta here.

MISTER SEÑOR LOVE DADDY
Thanks for stopping by.

EXT. STREET - DAY

On a stoop, a group of Puerto Ricans sit talking, drinking cerveza frio and playing dominoes. One of their cars sits in front of the stoop from which SALSA MUSIC BLASTS.

ANGLE - RADIO RAHEEM

As usual, we hear the RAP MUSIC of Radio Raheem but underneath the SALSA MUSIC, Radio Raheem does not like to be bested, the SALSA MUSIC from the parked car is giving him competition, this is no good. Radio Raheem stands in front of the stoop and raises his decibel level.

ANGLE - STOOP

The Puerto Ricans look at him then begin to yell

54

at him in Spanish. There is a standoff, the RAP and SALSA clashing in a deafening roar. One of the men STEVIE gets off the stoop and goes to the car.

ANGLE - CAR

Steve turns the car radio off.

CLOSE - RADIO RAHEEM

Radio Raheem smiles, nods an turns his box to a reasonable listening level and bops down the block. Radio Raheem still the loudest. Radio Raheem still the King.

 STEVIE
 You got it bro.

ANGLE - STOOP

The men curse in spanish and shake their heads in bewilderment and Stevie turns the Salsa back on.

EXT. STREET - DAY

Vito and Mookie see Buggin Out on their way back to Sal's.

MOOKIE
You the man.

BUGGIN' OUT
You the man.

MOOKIE
No, you the man.

BUGGIN' OUT
No, I'm just a struggling Black man trying to keep my dick hard.

Buggin Out gives Mookie five and a menacing look at Vito.

MOOKIE
Vito is down.

EXT. STREET - DAY

Buggin Out is walking down the block when a YUPPIE accidentally bumps into him, stepping on his new sneakers.

56

CLOSE - BUGGIN' OUT

He looks at his sneakers.

CLOSE - SNEAKERS

There is a big black smudge on his new white unlaced Air Jordans.

ANGLE - BUGGIN' OUT

He runs down the block after the Yuppie.

 BUGGIN' OUT
 Yo!

The Yuppie turns around.

 BUGGIN' OUT
 Yo!

 YUPPIE
 Yes.

 BUGGIN' OUT
 You almost knocked me down. The word is excuse me.

YUPPIE
Excuse me. I'm very sorry.

BUGGIN' OUT
Not only did you knock me down you stepped on my new white AIR JORDANS that I just bought, and that's all you can say excuse me.

This commotion has attracted a crowd including Ahmad, (ee), Punchie and Ella.

BUGGIN' OUT
I'll fuck you up quick two times.

HERE WE GO!

BUGGIN' OUT
Who told you to step on my sneakers? Who told you to walk on my side of the street? Who told you to be in my neighborhood?

YUPPIE
I own a brownstone on this block.

BUGGIN OUT'
Who told you to buy a brownstone
on my block, in my neighborhood
on my side of the street?

The crowd likes that one and they laugh and egg him on.

BUGGIN' OUT
What do you want to live in a
black neighborhood for?

YUPPIE
I'm under the assumption that
this a free country and one can
live where he pleases.

BUGGIN' OUT
A free country?

AWWW SHIT! Why did he get Buggin' started.

BUGGIN' OUT
I should fuck you up just for that
stupid shit alone.

|09|

Buggin' Out looks down at his marred Air Jordans, the crowd, smelling blood, wants to see some.

AHMAD
Your Jordans are dogged.

CEE
You might as well throw em' out.

PUNCHIE
They did look good before he messed them up.

ELLA
You use to be so fine.

AHMAD
How much did you pay for them?

CEE
A hundred bucks, Connecticut.

AHMAD
A hundred bucks!

BUGGIN' OUT
You're lucky the Black man has a loving heart. Next time you see me coming, cross the street

AHMAD
He's dissing you.

BUGGIN' OUT
Damn, my brand new Jordans. You should buy me another pair.

YUPPIE
I'm gonna leave now.

BUGGIN' OUT
If I wasn't a righteous Black man you'd be in serious trouble. SERIOUS.

The crowd gives their approval.

BUGGIN' OUT
Move back to Connecticut.

INT. SAL'S FAMOUS PIZZERIA - DAY

Mookie and Vito enter the shop.

SAL
I should have Vito go with you all the time.

PINO
Yeah, no more 90 minute deliveries around the corner.

MOOKIE
Pino, I work hard like everybody in here.

VITO
He's right.

PINO
(: here.

Pino smacks his brother

PINO
Don't get to friendly with da Mook.

SAL
That's gonna be the last time you hit Vito.

MOOKIE
Smack him back.

[62]

PINO
What?

MOOKIE
Remember what I said.

Vito stands frozen in front of his brother

PINO
Are you gonna listen to this Mook? Listen to him tell you to smack me? Your only brother?

Vito walks away and Mookie is disgusted.

PINO
I didn't think so.

EXT. STREET - DAY

Officers Ponte and Long drive down the block and at the corner they stop, glare at "The Corner Men"

CLOSE - OFFICER PONTE

CLOSE - SWEET DICK WILLIE

CLOSE - OFFICER LONG

CLOSE - COCONUT SID SWEET DICK WILLIE

ANGLE - POLICE CAR
ML

OFFICER PONTE
What a waste.

ANGLE - CORNER
Sweet Dick, ML and Coconut Sid stare right back at the cops.

ANGLE POLICE CAR
ML
It drives off.

ANGLE - CORNER SWEET DICK WILLIE

COCONUT SID
As I was saying before we were so rudely interrupted by the finest.

SWEET DICK WILLIE
That's my word.

ML
What was you saying?

69

Coconut Sid blanks.

> **SWEET DICK WILLIE**
> Motherfucker wasn't saying shit.

> **ML**
> Look at that.

> **COCONUT SID**
> Look at what?

ML points across the street to the Korean fruit and vegetable stand.

> **ML**
> It's a fucking shame.

> **SWEET DICK WILLIE**
> What is?

> **ML**
> Sweet Dick Willie.

> **SWEET DICK WILLIE**
> That's my name.

ML
Do I have to spell it out.

(COCONUT SID)
Make it plain.

ML
Ok, but listen up. I'm gonna break it down.

SWEET DICK WILLIE
We're listening. Let it be broke.

CLOSE ML

ML
Look at those Korean motherfuckers across the street, I betcha they haven't been a year off da mother-fucking boat before they opened up their own place

CLOSE-COCONUT SID

(COCONUT SID)
It's been about a year.

CLOSE ML

ML
 motherfucking
A motherfucking year off the boat and got a good business in our neighborhood occupying a building that had been boarded up for longer than I care to remember and I've been here a long time.

CLOSE SWEET DICK WILLIE

SWEET DICK WILLIE
It has been a long time.

CLOSE ML

ML me
Now for the life of I haven't been able to figger this out. Either dem Koreans are geniuses or we Blacks are dumb.

This is truly a stupyfying question and all three are silent. What is the answer?

COCONUT SID
It's gotta be cuz we're Black.
No other explanation, nobody
don't want the Black man to
be about shit.

SWEET DICK WILLIE
Old excuse.

ML
I'll be one happy fool to see
us have our own business right
here. Yes sir, I'd be the first
in line to spend the little money
I got.

Sweet Dick Willie gets up from his folding chair

SWEET DICK WILLIE
It's Miller Time. Let me go give
these Koreans some more business.

ML
It's a motherfucking shame.

EXT. STOOP-DAY

Da Mayor sits on his stoop and a kid, EDDIE runs by.

 DA MAYOR
Sonny! Sonny!

Eddie stops.

 DA MAYOR
Son, what's your name?

 EDDIE
Eddie Lovell.

 DA MAYOR
How old are you?

 EDDIE
Seven.

 DA MAYOR
What makes Sammy run?

 EDDIE
My name is Eddie.

DA MAYOR
What makes Sammy run?

EDDIE
I said my name is Eddie. Eddie Lovell.

DA MAYOR
Eddie, I want you to go to the corner store. How much will it cost me?

EDDIE
How do I know how much it's gonna cost, if I don't know what I'm buying.

DA MAYOR
Eddie, you're too smart for your own good, listen to me. How much do you want to run an errand for Da Mayor.

EDDIE
Fifty cents.

DA MAYOR

71

INT. SAL'S FAMOUS PIZZERIA - DAY

ANGLE PAY PHONE ON WALL

Mookie is on the phone.

> MOOKIE
> I know I haven't seen you in four days, I'm a working man.

> TINA (OS) (VO)
> I work too, but I still make time.

> MOOKIE
> Tina, what do you want me to do?

> TINA (OS)
> I want you to spend some time with me. I want you to try and make this relationship work. If not I'd rather not be bothered.

> MOOKIE
> Alright. Alright. I'll be over there sometime today.

13

TINA (OS)
When?

MOOKIE
Before I get off work.

TINA (OS)
Bring some Ice Cream, I'm burning up...
Do you love me?

MOOKIE
Do you want to know I love you?

CLOSE- SAL

SAL
Mookie get offa da phone.

CLOSE-MOOKIE

MOOKIE
Be off in a second, Tina, I
dedicated a record on Mister
Senor Love Daddy's show to you.

TINA (OS)
Big deal.

CLOSE-SAL

SAL
Mookie! How is anybody gonna call in?

CLOSE MOOKIE

MOOKIE
Big deal? ~~It means I care.~~ If that's not LOVE, I don't know what is.

CLOSE PINO

PINO
You deaf or what?

CLOSE MOOKIE

MOOKIE
Gotta go. See ya soon.

He hangs up.

MOOKIE
Everybody happy now.

The phone rings right away and Pino picks it up.

ANGLE-PINO

PINO
Sali's Famous Pizzeria, yeah, 2 large
pizzas, pepperoni and anchovies
hold on... See Pop, Mookie fucking
talking on the phone and people
are trying to call in orders. He's
making us lose business.

CLOSE-SAL

SAL
Mookie, you're fucking up.

CLOSE PINO

PINO
Twenty minutes.

He hangs up the phone.

PINO
How come you niggers are so stupid?

CLOSE MOOKIE

MOOKIE
If you see a nigger here kick
his ass.

75

CLOSE PINO

>PINO
> Fuck you and stay off the phone.

CLOSE VITO

>VITO
>Forget it Mookie.

ANGLE PIZZERIA

>MOOKIE
>Who's your favorite basketball player?

>PINO
>Magic Johnson.

>MOOKIE
>And not Larry Bird? Who's your favorite movie star?

>PINO
>Eddie Murphy.

Mookie is smiling now.

MOOKIE
Last question. Who's your favorite rock star?

Pino doesn't answer because he sees the trap he's already fallen into.

MOOKIE
Barry Manilow.

Mookie and Vito laugh.

MOOKIE
Pino, no joke. C'mon answer.

VITO
It's Prince. He's a Prince freak.

MOOKIE
Sounds funny to me. As much as you say nigger this and nigger that, all your favorite people are "niggers".

PINO
It's different, Magic, Eddie, Prince are not niggers

PINO [CONT'D]
but not really Black. They're more than Black. It's different.

With each additional word Pino is hanging himself even further.

MOOKIE
Pino I think secretly that you wish you were Black. That's what I think. Vito, what do you say?

PINO
Y'know I've been listening and reading 'bout Farakhan, ya didn't know that did you?

MOOKIE
I didn't know you could read.

PINO
Fuck you. Anyway Minister Farakhan always talks about the "so called day" when the Black man will rise. "We will one day rule the earth as we did in our glorious past."

PINO (CONT'D)
You really believe that shit.

MOOKIE
It's evita-bla.

PINO
Keep dreaming.

MOOKIE
Fuck you, your pizzeria and Frank Sinatra too.

PINO
Well fuck you too and fuck Michael Jackson.

(CUT TO)

RACIAL SLUR MONTAGE

The following will be a quick* MONTAGE of racist slurs, with different ethnic groups pointing the finger at each other. Each person looks directly into the camera.
*cutting

CLOSE - MOOKIE

MOOKIE
Dago, Wop, Garlic breath, Pizza slinging, Spaghetti bending, Vic Damone, Perry Como, Luciano Pavarotti, Sole Mio non-singing Motherfucker.

CUT TO

CLOSE - PINO

PINO
You gold teeth, gold chain wearing, fried chicken and biscuit eatin', monkey, ape, baboon, big thigh, fast running, high jumping, spear chucking, spade — moulan yan.

CUT TO

CLOSE - STEVIE

STEVIE
You slant eyed, me no speak American, own every fruit and vegetable stand in New York, Reverend Moon, Summer Olympics 88',

STEVIE (CONT'D)
Korean kick boxing bastard.

(CUT TO)

CLOSE OFFICER LONG

OFFICER LONG
Goya bean eating, 15 in a car,
30, in ~~cream~~ an apartment,
pointed shoes, red wearing, medo medo
Puerto Rican cocksucker.

(CUT TO)

CLOSE KOREAN CLERK

KOREAN CLERK
It's cheap, I got a good price
for you, Mayor Koch. How I'm doing,"
Chocolate eggcream drinking B'Nai
B'rith asshole.

(CUT TO)

18

CLOSE - MISTER SENOR LOVE DADDY

He screams like a banshee.

 MISTER SENOR LOVE DADDY
 Aaaaaah. I'm paid stupid dollar
 to make females scream and holla'

CUT TO

CLOSE - WHITE HOT SUN

INT. SAL'S FAMOUS PIZZERIA - DAY

Mookie picks up his two pizzas for delivery.

 MOOKIE
 Sal, can you do me a favor?

 SAL
 Depends.

 MOOKIE
 Can you pay me now?

 SAL

MOOKIE
Sal, just this once, do me that solid.

SAL
You know you don't get paid till we close tonight. We're still open.

MOOKIE
I would like to get paid now.

SAL
Tonight.

Mookie leaves. Money.

EXT. STREET - DAY

Mookie walks down the block. The streets are filled with kids playing. We see stoop ball, double dutch, hand games, bike riding, skate boarding, etc.

ANGLE - MOOKIE

Radio Raheem approaches Mookie.

MOOKIE
Whaddup Money?

RADIO RAHEEM
I was going to buy a slice.

MOOKIE
I'll be back after I make this delivery.

RADIO RAHEEM
On the rebound.

MOOKIE
Later Money.

INT. SAL'S PIZZERIA - DAY

Radio Raheem enters Sal's with music blaring.

RADIO RAHEEM
Two slices.

SAL
No service till you turn dat shit off.

RADIO RAHEEM
Two slices.

PINO
Turn it off.

SAL
Mister Radio Raheem I can't ever hear myself think. You are disturbing me and you are disturbing my customers.

Sal grabs his Mickey Mantle bat from underneath the counter. Everyone, Sal, Vito, Pino, Radio Raheem and the customers are poised for something to jump off, STATIC.

(CLOSE RADIO RAHEEM

He smiles and turns off the BEAT.

RADIO RAHEEM
Two slices.

(CLOSE SAL)
Ode

Sal puts Mickey Mantle back into it's place.

SAL
When will come in Sal's no music, No

INT TENEMENT HALLWAY - DAY

Mookie hands the pizzas over and takes the money, and counts it.

 MOOKIE
Thanks.

EXT. STREET - DAY

Mookie walks, says hello to the people he knows.

EXT. STOOP - DAY

Mookie runs up stoop.

INT. MOOKIE'S APT - DAY

We hear a key in the door, the lock turns and Mookie enters.

 MOOKIE
Jade.

 JADE (OS)
I'm in here.

INT. JADE'S BEDROOM-DAY

Jade sits in a chair directly in front of an air conditioner going full blast.

JADE
How come you're not at work?

MOOKIE
I'm at work.

JADE
Is this another one of your patented two hour lunches?

MOOKIE
I'm sticky and sweaty, just came home to take a quick shower.

JADE
Sal's gonna be mad.

MOOKIE
Later for Sal. Sometimes I think you're more concerned with dear than me.

JADE
I think no such a thing. Sal pays you, you should work.

MOOKIE
Slavery days are over. My name ain't Kunte Kinte. Sis, I don't want to argue. Let me be.

JADE
Mookie, I just don't want you to lose the one job you got that's all. I'm carrying you as it is. Just do your job.

MOOKIE
Don't worry 'bout me. I'll always get paid.

JADE
It's ~~too late to think~~ Take your shower.

INT. SHOWER DAY

Mookie turns on the shower and screams, the water is ICE COLD.

EXT. MOTHER SISTER'S STOOP - DAY

Mother Sister sits in her window looking out at the block.

EXT. DA MAYOR'S STOOP - DAY

Da Mayor has fallen asleep sitting on his stoop. His hands, loosely, hold a brown paper bag that is tightly twisted around a beer can.

EXT. CORNER - DAY

Sweet Dick, ML and (coconut) Sid each hold an umbrella for protection from the HOT and HARSH rays.

EXT. FIRE ESCAPE - DAY

Ahmad, Punchie, Ice and Ella sit on a fire escape, trying to keep still, trying to find a cool spot in the shade. No one says a word.

INT. SAL'S FAMOUS PIZZERIA - DAY

Sal takes a seat at one of the tables.

SAL
I'm beat.

Pino sits down next to his father.

PINO
Pop, I think we should sell this place, get outta here while we're still ahead... and alive.

SAL
Since when did you know what's best for us?

PINO
Couldn't we sell this and open up a new one in our own ~~pizzeria~~ neighborhood?

SAL
Too many pizzerias already there.

PINO
Then we could try something else.

SAL
We don't know nuthin else.

PINO
I'm sick of niggers, it's a bad neighborhood. I don't like being around them, they're animals.

VITO
Some are OK.

PINO
My friends laugh at me all the time, laugh right in my face, tell me go feed the moolan yans.

SAL
Do your friends put money in your pocket? Pay your rent? Food on ya plate.

Pino is quiet.

SAL
I didn't think so.

16

PINO
Pop, what else can I say? I don't wanna be here, they don't want us here. We should stay in our own neighborhood, stay in Bensonhurst.

SAL
So what if this a Black neighborhood, so what if we're a minority. I've never had no trouble with dese people, don't want none either, so don't start none. This is America. Sal's Famous Pizzeria is here for good. You think you know it all, well you don't, I'm your father, you better remember that.

INT. BATHROOM - DAY

Mookie pulls the shower curtain back and steps out.

INT. MOOKIE'S ROOM - DAY

Mookie sits on his bed, still wet and dials a number.

(CLOSE MOOKIE)

MOOKIE
Hello Sal's Pizza. Have penis, will travel.

TINA (OS) (VO)
Mookie, you are not well. When are you coming over?

MOOKIE
I'm at the crib now but as soon as I can slip away from Sal's I'll be there.

TINA (OS)
Don't forget the ice cream, Häagen-Dazs. Also Breyers

MOOKIE
What flavor?

TINA (OS)
What flavor?

93

 MOOKIE
Butter Pecan. Butter Pecan.

 TINA (OS)
You don't remember anything

 MOOKIE
Tina, just take your vitamins.

 TINA (OS)
No need to. There will be none
of that.

 MOOKIE
We'll talk about it when I get
there. Later.

Mookie hangs up the phone just as Jade knocks on his door.

ANGLE - JADE

 JADE
Hurry up and get dressed.

 MOOKIE
I'm coming.

JADE
I'm going with you to Sal's. ~~jhhh hhhh~~
~~hhh hhhhh hhhhhhhh~~

EXT. WE-LOVE RADIO - DAY

Buggin' Out waves at Mister Senor Love Daddy as he walks by the storefront

INT. SAL'S FAMOUS PIZZERIA - DAY

Buggin' Out sticks his head in and yells.

BUGGIN' OUT
Sal, we're gonna boycott ya fat ass.

Before Sal and his two sons can answer Buggin' Out is gone.

EXT. STREET - DAY

Buggin' Out has one foot up on a fire hydrant and tries to clean his soiled AIR JORDAN.

ANGLE: JADE and MOOKIE

Jade and Mookie walk in to Blaine Q+

BUGGIN' OUT
It's so nice to see a family hanging out together.

MOOKIE
We're not hanging out. I'm being escorted back to work.

JADE
That's not even true. I just want a slice

BUGGIN' OUT
Jade, you didn't know this but I'm organizing a boycott of Sal's Famous Pizzeria.

JADE
What did he do this time?

BUGGIN' OUT
Y'know all those pictures he has hanging on the wall of fame.

JADE
Yeah.

BUGGIN' OUT
A we
Have you noticed something about them?

JADE
No.

Mookie interjects.

MOOKIE
Yo, I'm gone.

JADE
I'll seeya there.

BUGGIN' OUT
Peace

Mookie leaves.

BUGGIN' OUT
Every single one of those pictures is somebody Italian.

JADE
And?

BUGGIN' OUT
And I, we want some Black people up.

JADE
Did you ask Sal?

BUGGIN' OUT
Yeah I asked him. I don't want nobody in there, nobody spending good money in Sal's. He should get no mo' money from the community till he puts some black faces up on that motherfucking wall.

Jade looks at Buggin' Out like "are you serious?"

JADE
Buggin' Out I don't mean to be disrespectful but you can really direct your energies in a more useful way.

BUGGIN' OUT
So in other words you are not down.

JADE
I'm down, but for worthwhile cause

BUGGIN' OUT
Jade, I still love you.

JADE
I still love you too.

INT. SAL'S FAMOUS PIZZERIA - DAY

SAL
Mookie, you are pushing it. You're really pushing it. I'm not paying you good money to fucking jerk me around.

Mookie has nothing to say.

SAL
You're gonna be in the shed with the rest of your buddies.

PINO
'Bout time Pop.

ANGLE DOOR

Jade enters and Sal looks up. He stops blasting Mookie and a very noticable change comes over him.

SAL
Jade, we've been wondering when you would pay us a visit.

JADE
Hi Sal, Pino, Vito.

VITO
What's happening Jade?

JADE
Nuthin' really. How are you treating my brother?

SAL
The Mook? Great. Mookie's a good kid.

PINO
Pop, stop lying

SAL
Shaddup, Jade, what can I fix you?

JADE
What's good?

SAL
Everything, but for you, I'm gonna make up something special. Take a seat, there, that's a clean table.

Sal moves behind the counter and goes to work. Pino and Mookie look at each other in agreement, neither likes what he has seen. This happens to Sal everytime Jade is in the place.

ANGLE TABLE

Vito sits down with Jade.

JADE
You still letting Pino push you around?

VITO
Who told you that? He doesn't push me.

|101|

VITO (CONT'D)
who told you, Mookie tell you that? I hold my own.

JADE
Forget about it Vito. Forget I brought it up.

VITO
Pino picks on me but I don't let him push me around.

JADE
Alright already.

EXT. ROOFTOP - DUSK

The once white hot sun is now turning into a golden orange glaze as it begins to set. Ahmad, Cee, Punchie and Ella dance on the roof around a box that is tuned into WE LOVE. Each one is trying to come up with some new moves, a new dance and a name for it.

EXT. STREET - DUSK

Radio Raheem is walking down the block and there is something wrong, something is not quite right. AHA! His music is not LOUD, the RAP SONG begins to drag and finally stops all together.

CLOSE- RADIO RAHEEM

He looks at his box and presses the battery level indicator.

CLOSE- BATTERY LEVEL INDICATOR

The needle doesn't move. His batteries have had it.

INT. FRUIT-N-VEG DELIGHT- DAY

CLOSE- RADIO RAHEEM

RADIO RAHEEM
20 "D" Duracells.

CLOSE- KOREAN CLERK

KOREAN CLERK
20 "C" Duracells.

103

CLOSE- RADIO RAHEEM

> RADIO RAHEEM
> D not C.

CLOSE KOREAN CLERK

> KOREAN CLERK
> C Duracell.

CLOSE- RADIO RAHEEM

> RADIO RAHEEM
> D! D! D! You dumb motherfucker. Learn how to speak english first. D.

Radio Raheem points to the D batteries behind the counter.

CLOSE - KOREAN CLERK

> KOREAN CLERK
> How many you say?

CLOSE- RADIO RAHEEM

RADIO RAHEEM
20! MOTHERFUCKER! 20!

CLOSE- KOREAN CLERK

KOREAN CLERK
Motherfucker you.

Radio Raheem has to laugh at that one.

RADIO RAHEEM
Motherfucker you. You're alright. You're alright. Just gimme my 20 Duracells please.

EXT FRUIT-N-VEG DELIGHT

Da Mayor is looking at a bunch of cut flowers when Radio Raheem comes out with batteries in hand finally.

EXT MOTHER SISTER'S STOOP-DAY

ANGLE WINDOW

Mother Sister is sitting in her window as usual.

ANGLE STOOP

Da Mayor walks up the stoop with a bunch of fresh cut flowers in a discarded wine bottle for a vase.

ANGLE DA MAYOR

Da Mayor holds them out for Mother Sister who does not acknowledge him at all.

 DA MAYOR
 I'd thought you might like these....
 I guess not.

Da Mayor takes a seat on the stoop and puts the flowers to his face.

 DA MAYOR
 Ain't nuthin' like the smell of
 fresh flowers. Don't you agree
 Miss Mother Sister?

Mother Sister does not answer. He puts the flowers down.

 DA MAYOR
 Summertime, all you can smell

DA MAYOR [CONT'D]
is the garbage. Stink overpowers
everything, especially soft sweet
smells like flowers.

He looks up at Mother Sister who immediately turns away.

DA MAYOR
If you don't mind I'm gonna set
right here, catch a breeze or
two then be on my way.

Da Mayor looks up at the setting sun.

DA MAYOR
Thank the Lord, the sun is going
down, it's hot as blazes.

CLOSE-SUN

The sun is a orange and purple glaze.

EXT. STREET-DUSK

Radio Raheem is back in action. He's alive, he's bad and he
out his 20 "D" Duracell batteries, his BOX IS KICKING

107

ANGLE CORNER

Radio Raheem bops by Coconut Sid, ML and Sweet Dick Willie.

CLOSE- COCONUT SID, ML and SWEET DICK WILLIE

All three shake their heads in bewilderment as Radio Raheem goes by.

 ML
 What can you say?

 COCONUT SID
 I don't know how he does it.

Sweet Dick Willie gets up from his chair and goes to the corner, zips down his pants and urinates.

 SWEET DICK WILLIE
 ML?

 ML
 What?

 SWEET DICK WILLIE
 This Bud's for you.

Sweet Dick Willie and Coconut Sid laugh.

ML
That's OK. At least my Moms didn't name me Sweet Dick Willie.

Sweet Dick Willie zips up his pants and returns to his seat.

SWEET DICK WILLIE
Why you gotta talk 'bout my Moms?

ML
Nobody talkin' bout ya Moms.

SWEET DICK WILLIE
I didn't say nobody, I said you.

ML
Sweet Dick, I didn't mean it like that.

SWEET DICK WILLIE
Yes you did

COCONUT SID
Squash it.

109

ML
I just wanted to know who named you Sweet Dick Willie?

SWEET DICK WILLIE
It's just a name

COCONUT SID
And what does ML stand for? Martin Luther?

ML
No. ML stands for ML. That's it

SWEET DICK WILLIE
Naw, that's some stupid shit.

ML
Niggers kill me, always holdin' onto, talkin' 'bout their dicks.

COCONUT SID
I don't know 'bout you but it's too hot to fuck

SWEET DICK WILLIE
Never too hot, never too cold
for fucking. Which reminds me,
somebody's daughter is in trouble.

EXT. STREET - DUSK

An old Puerto Rican man rings a bell as he pushes his
cart on wheels. On the side of it is hand lettered
HELADO DE COCO, and a big block of ice rests on
top surrounded by different colored bottles of flavors.

ANGLE - CART

A group of kids eagerly wait for the ices. The
man scrapes the block of ice, puts the shavings
in a paper cup and drowns it with syrup.

ANGLE - DA MAYOR

Da Mayor is walking down the street.

ANGLE MISTER SOFTEE TRUCK

We hear the familiar tune from the Mister Softee truck
as it comes down the street.

ANGLE EDDIE LEVEL Lovell

Eddie, the young kid who earlier ran an errand for Da Mayor looks up from the sidewalk where he's playing and runs out into the street in pursuit of Mister Softee

EDDIE
Ice Cream. Ice Cream.

Eddie is running in pursuit of the truck unaware of the oncoming speeding car in the opposite direction.

ANGLE DA MAYOR

Da Mayor sees the speeding car bearing down on Eddie.

ANGLE STREET

Da Mayor runs across the street and knocks Eddie down out of the way of the car. Both are ~~on down~~, thrown, just being hit by the reckless driver.

CLOSE- EDDIE and DA MAYOR

Eddie is crying as Da Mayor picks him up.

DA MAYOR
Doctor, you know better to run out in the street... Stop crying son.

ANGLE STREET

A crowd gathers.

DA MAYOR
Doctor, there's nothing to cry about. You're OK.

A woman in her 20's, LOUISE, Eddie's mother breaks through the crowd and hugs her baby.

LOUISE
What's wrong?

EDDIE
Mayor knocked me down.

LOUISE
You should be ashamed of yourself.

DA MAYOR
Mon, the boy is just scared to death.

113

DA MAYOR (CONT'D)
What actually happened is that I was minding my business when I saw your son about to be run over, I ran into the street to save him and I had to knock him down to keep the both of us from getting hit.

The crowd agrees that's the way it happened, and Louise stands up.

LOUISE
Eddie, is that the truth?

Eddie is quiet.

LOUISE
Eddie, you hear me talkin' to you?

Eddie is still mum.

LOUISE
I'm talkin to you boy.

DA MAYOR
Miss, the boy is fine.

LOUISE
And when your father comes home, he's gonna wear ya little narrow behind out too.

Eddie runs away

LOUISE
Get up stairs now

WHOP!

EDDIE
Mommy! Mommy! I'm sorry, I'm sorry

WHAP!

LOUISE
What did I tell you 'bout playing in the street?

WHOP!

LOUISE
What did I tell you 'bout lying?

WHAP! Louise hits him on DA BUTT. Eddie starts to dance as his mother hits hard, she's heavy handed

|115|

DA MAYOR
You didn't have to hit yar son, he was scared to death as it was.

LOUISE
I appreciate you helping my ~~son~~ Eddie. I truly do but I'll have nobody question how I raise him, not even his father.

DA MAYOR
Ya're right.

Louise goes away, probably to give her son another "whooping." Da Mayor tips his hat to her.

INT. SAL'S FAMOUS PIZZERIA - DUSK

Sal sits at a table talking to Jade as she finishes her "special" slice.

JADE
Sal, that was delicious.

SAL
Anytime.

117

Vito, Pino and Mookie look on watching Sal have the time of his life.

JADE
Thanks.

Jade gets up and Mookie helps her.

MOOKIE
I'll see you out.

JADE
Seeya around.

SAL
Don't wait too long to come back.

EXT. SAL'S FAMOUS PIZZERIA - DUSK

Mookie takes Jade by the hand and pulls her out of view from Sal.

ANGLE MOOKIE and JADE

MOOKIE
Jade, I don't want you coming in here no mo'.

JADE
Stop tripping.

MOOKIE
No, you're tripping. Don't come in Sal's. Alright, read my lips.

JADE
What are you so worked up about?

MOOKIE
Over Sal, the way he talks and the way he looks at you.

JADE
He's just being nice.

MOOKIE
Nice!

JADE
He's completely innocent.

MOOKIE
Innocent!

JADE (CONT'D)
— I'm didn't stutter.

MOOKIE
You should see the way he looks at you. All Sal wants to do is hide da salami.

JADE
You are too crude.

MOOKIE
I might be but you're not welcome here.

JADE
I only hope — I'm tired of stopping to play big brother. I'm a grown woman. You gotta lotta nerve, Mookie, you can hardly pay your rent and you're gonna tell me what to do. (come off it)

MOOKIE
One has nuthin' to do with the other.

JADE
Oh it doesn't huh! You,gd your little

JADE (CONT'D)
250 dollars a week plus tips....

MOOKIE
I'm getting paid...

JADE
...peanuts.

MOOKIE
Pretty soon I'll be making a more

JADE
I truly hope so. I'm tired of supporting a grown man.

INT. CONTROL BOOTH - DUSK

CLOSE MISTER SEÑOR LOVE DADDY

MISTER SEÑOR LOVE DADDY
As the evening slowly falls upon us living here in Brooklyn, New York this is ya Love Daddy rappin' to ya. Right now we're gonna open up the Love Lines.

MISTER SENOR LOVE DADDY [CONT'D]
Hello, you're on Love Daddy's Love Line.
No names please. Let's keep it anonymous.

FEMALE VOICE #1 (VO)
Hi, Mister Senor Love Daddy. I'd
kiss your feet every morning that's
how much I love you.

MISTER SENOR LOVE DADDY
How nice of you.

FEMALE VOICE #2 (VO)
I think you have the sexiest voice
in the world. All you have to do
is talk.

MISTER SENOR LOVE DADDY
Love Line, you're on.

FEMALE VOICE #3 (VO)
You give me fever.

She moans.

MISTER SENOR LOVE DADDY
She's feeling it.

|21|

 FEMALE VOICE #4 (VO)
 Love Daddy I'd work in Mickey D's 24,7
 and 365 just to call you my own. Give
 you all my money honey

 MISTER SEÑOR LOVE DADDY
 That was the last call for tonight on
 Mister Señor Love Daddy's Love Line. I
 love you. Ya I love.

EXT. MOTHER SISTER'S STOOP - NIGHT

Da Mayor is walking by Mother Sister in her
window when she calls him.

CLOSE MOTHER SISTER

 MOTHER SISTER
 Mister Mayor, I saw what you did.

ANGLE DA MAYOR

 ~~DA MAYOR~~

Da Mayor stops and looks at her. A smile comes
to his face, after 18 years has he finally broken
down her defenses?

CLOSE MOTHER SISTER

MOTHER SISTER
That was a foolish act but it was brave. That chile owes you his life.

(CLOSE DA MAYOR)

DA MAYOR
I wasn't trying to be a hero. I saw what was about to happen and I reacted, didn't even think. If I did I might not have done it in second thought. Da Mayor is an old man, haven't run that fast in years.

Da Mayor is warming up now.

DA MAYOR
Maybe I should be heroic more often.

CLOSE MOTHER SISTER

MOTHER SISTER
Maybe you shouldn't. Don't get happy. This changes nothing between you and me. You did a good thing and Mother Sister wanted to thank you for it.

ANGLE: STOOP

DA MAYOR
I thank you.

MOTHER SISTER
You are welcome.

Da Mayor tips his hat.

INT. SAL'S FAMOUS PIZZERIA - NIGHT

Mookie enters.

MOOKIE
Sal I don't care if you fire me this exact minute, leave my sister alone.

INT. HALLWAY - NIGHT

Mookie rings the bell and a "FINE," sister answers the door.

SAL
Mookie, I don't know what you're talking about, plus I don't want to hear it.

MOOKIE
Sal, just do me a favor, leave Jade alone.

SAL
Here, you gotta delivery.

Mookie takes the pie and looks at the address.

MOOKIE
Is this the right name and address?

SAL
Yeah, do you know 'em?

MOOKIE
No, just checking.

[125]

> MOOKIE
> Delivery from Sal's Famous Pizzaria

> TINA
> What took you so long? Is it hot?

> MOOKIE
> Hot. Hot.

> TINA
> Come in then.

INT. TINA'S APARTMENT-NIGHT

Tina watches Mookie watch her. When she's through watching she takes the pizza from his hands and puts it on the floor. Mookie grabs her and starts to kiss. Tina is Mookie's woman, the one he's been on the phone with earlier. We've heard the voice and now see the person.

> MOOKIE
> Tina, you are _too_ slick.

> TINA
> How else was I going to get you here.

TINA (CONT'D)
I haven't seen you in a week either.

MOOKIE
I've been working hard, getting paid.

TINA
Where's the Ice Cream? The Haagen-Dazs Butter Pecan?

MOOKIE
Sh*t! I forgot.

TINA
Your memory is really getting bad.

MOOKIE
I just forgot.

TINA
And I really wanted some Ice Cream too.

MOOKIE
I can run out and get it.

TINA
No! No! You won't come back either.

MOOKIE
I can't be staying long anyway.

TINA
How long then?

MOOKIE
Long enough for us to do the nasty.

TINA
That's out. No! It's too hot! You think I'm gonna let you get some, put on your clothes then run outta here and see you again in who knows when.

MOOKIE
A quickie is good every once in a blue moon.

TINA
You a blue moon fool

MOOKIE
Then we'll do something else.

TINA
What else?

MOOKIE
Trust me.

Mookie pushes Tina back into her bedroom.

INT. BEDROOM. NIGHT

Mookie sits. Tina lays down on her futon bed, turns off the lights and turns on WE LOVE RADIO as Mister Señor Love Daddy serenades them with slow jams.

MOOKIE
I'm gonna take off ya clothes.

TINA
Mookie, I told you already it's too hot to make love.

MOOKIE
I heard you the first time.

 MOOKIE [CONT'D]
 This is..., something else.

He laughs his sinister laugh.

ANGLE- MOOKIE and TINA

Mookie unsnaps her bra, then pulls her panties off.
Tina is naked.

 MOOKIE
 Tina, you're sweating.

 TINA
 Of course I'm sweating, ~~xxxxxxxx~~.
 I'm burning up. It's hot, moron.

 MOOKIE
 Lie down, please.

He gets up.

INT. KITCHEN- NIGHT

Mookie opens the freezer door and takes out two ice trays.

INT. BEDROOM-NIGHT

Mookie sits down on the bed with a bowl filled with ice cubes.

CLOSE TINA'S FOREHEAD

Mookie rubs an ice cube on her forehead.

TINA (VO)
It's cold. It's high.

MOOKIE
It's 'pose to be cold.

CLOSE TINA'S NECK

Mookie rubs an ice cube on her neck.

CLOSE TINA'S LIPS

Mookie rubs an ice cube on her full moist lips, then puts it in her mouth.

MISTER SEÑOR LOVE DADDY (VO)
Yes children, this is the Cool Out Corner. We're slowing it down for all the lovers.

131

MISTER SEÑOR LOVE DADDY (CONT'D)
in the house. I'll be giving you all the
help you need, musically that is.

CLOSE: TINA'S THIGHS

He rubs an ice cube up and down her thighs.

MOOKIE (VO)
Thank God for thighs.

CLOSE: TINA'S BUTTOCKS

He rubs an ice cube on her round, firm buttocks.

MOOKIE (VO)
Thank God for buttocks.

CLOSE: TINA'S BREAST

He rubs an ice cube on her breast.

MOOKIE (VO)
Thank God for the right nipple...
Thank God for the left nipple...

Both Tina and Mookie are dying. Mookie now has an ice cube on the left and right nipples and we see before our very own eyes both get swollen, red and erect.

TINA (VO)
Feels good.

MOOKIE (VO)
Yes, yes, Lord. Isn't this better than Haagen-Dazs Butter Pecan Ice Cream.

CLOSE TINA'S MOUTH

Mookie kisses her.

MOOKIE
I'll be back tonight to finish.

INT SAL'S FAMOUS PIZZERIA-NIGHT

Officers Ponte and Long are awaiting their orders.

SAL
It's almost ready.

133

OFFICER LONG
What time you closing tonight?

SAL
Ten.

Sal goes over to the oven, takes out their food and wraps it up.

SAL
Here you go.

OFFICER PONTE
What do we owe you?

SAL
Nine, fifty.

OFFICER PONTE
Here, keep the change.

SAL
Thanks. Enjoy.

OFFICER LONG
Vino, Pino, seeya later.

INT. SIGN ROOM - NIGHT

The Officers leave just as Mookie enters. Pulls Vito into the back.

MOOKIE
Sal, if you want me to deliver any faster get me a jet rocket or something cuz I can't run with pizzas, all the cheese ends up on one side.

SAL
I didn't say nuthin', You must have a guilty conscious, What are you guilty of?

MOOKIE
I'm not guilty of nuthin.

SAL
You must be guilty of something or you would have never come in saying the things you said.

MOOKIE
C'mon Sal.

SAL
Where we goin'?

[135]

While Sal laughs at his corny joke Pino pulls Vito into the back.

INT. STOREROOM - NIGHT

PINO

Vito, I want you to listen to me. I'm your brother. I may smack you around once in awhile, boss you around but I'm still your brother.

VITO

I know this.

PINO

I love you.

VITO

I'm listening

PINO

Good. I want you to listen.

VITO

Jesus Christ on the cross, I said I'm listening.

PINO
Good Vito, you trust that Mookie too much.
So does Pop.

VITO
Mookie's OK.

PINO
You listening to me?

VITO
Stop busting my balls. I said Jim
listening 10 fucking times already.

PINO
Mookie is not be trusted. No madda
, you can be trusted. The first time
you turn your back, boom, a knife
right here.

Pino gestures.

PINO
In the back.

VITO
How do you know this?

PINO
I know.

VITO
You really think so?

PINO
I know so. He, them, they're not to be trusted.

VITO
So what do you want me to do?

PINO
Be on guard. Mookie has Pop conned already, so <u>we</u> have to look out for him.

VITO
I like Mookie alot.

PINO
And that's exactly what I'm talkin' 'bout.

HOT CITY NIGHT MONTAGE

THE BLOCK. We've seen it at daytime but now we see it at night. Even though the WHITE HOT SUN is gone, nonetheless the heat is still stifling. And in a peculiar funny sort of way it's worse. Ya expect it to be hot during the light of day when the sun is beating down on the cement and tar but at night it should be considerably cooler, well not tonight, IT'S HOT.

All the residents of THE BLOCK: The Corner Men, Mother Sister, Da Mayor, Jade, etc, all the people we've seen throughout the day are now coping with the night time heat, plus it's HUMID AS SHIT. Everyone is outside, sitting on stoops, on cars and you know the kids are playing running up and down the block. Now it's THE HOTTEST NIGHT OF THE YEAR.

SAL(OS)
Vito! Pino! Let's go.

PINO
Be right there Pop. Listen to what I said.

VITO
I listened.

EXT. STREET - NIGHT

Buggin' Out sits down on a car next to Radio Raheem, as usual his BOX IS BLASTING.

BUGGIN' OUT
How you be?

RADIO RAHEEM
I be. I'm living large.

BUGGIN' OUT
Is that the only tape you got.

RADIO RAHEEM
You don't like Public Enemy. It's the dope shit.

BUGGIN' OUT
I like em but you don't play anything else

RADIO RAHEEM
I don't like anything else.

BUGGIN' OUT
(Check this out, Y'know Sal's.

RADIO RAHEEM
Yeah, I know dat motherfucker.

BUGGIN' OUT
I'm trying to organize a boycott of
Sal's joint. Ya see what I'm saying?

RADIO RAHEEM
I almost had to yoke him this afternoon.
Tell me, tell me to turn my music down. Didn't even say please.
Who the fuck he think he is? Don Corleone —?
and shit

BUGGIN' OUT
He makes all his money off us black people
and I don't see nuthin but Italians up
in that, Sylvester Stallone and motherfuckers
Ya see what I'm saying homeboy?

RADIO RAHEEM
Talk to me.

[4]

BUGGIN' OUT
We shouldn't buy a single slice, spend a single penny in that motherfucker till some people of color are put up in there.

RADIO RAHEEM
I'm down.

BUGGIN' OUT
You got my back.

RADIO RAHEEM
Ya back is got.

BUGGIN' OUT
My brother.

INT. SAL'S PIZZERIA - NIGHT

Vito, Pino and Mookie are cleaning up.

MOOKIE
Sal, it's almost ~~now~~, quitting time so please start counting my pay. I gotta get paid.

Sal is looking into the cash register.

 SAL
 We did good business today. We got a good
 thing going. Nothing like a family in business
 working together. One day the both of you
 will take over ... and Mookie there will
 always be a place for you at Sal's Famous
 Pizzeria. Y'know it should be Sal's and Sons
 Famous Pizzeria

ANGLE: VITO, PINO and MOOKIE

All three look at each other. The horror is on their faces,
with the prospect of working, slaving in Sal's and Sons
Famous Pizzeria, trapped for the rest of their lives. Is this
their future? It's a frightening thought.

ANGLE DOOR

Ahmad, Cee, Punchie and Ella enter.

 SAL
 We're about to close.

AHMAD
Just far slices, regular slices. Please

SAL
OK, but that's it. It's been a long day.

Mookie goes over to the table where Ahmad, Cee, Punchie and Ella sit.

MOOKIE
Look, I want you to eat your slices then outta here. No playing around.

AHMAD
You got it.

MOOKIE
Good. No joke. We all wanna go home.

OH NO! We hear the DUM-DUM-DUM of Radio Raheem's Box. As everyone turns their heads to the door Buggin' Out and Radio Raheem are inside already. We have never heard the RAP MUSIC as loud as it is now. You have to scream to be heard and that's what they do.

SAL
What did I tell ya 'bout dat noise.

BUGGIN' OUT
What did I tell ya 'bout dem pictures.

SAL
Whaddafuck! Are you deaf?

BUGGIN' OUT
No are you? We want some Black people up on the wall of fame.

SAL
Turn that JUNGLEMUSIC off. We ain't in Africa.

Ahmad, Cee, Punchie and Ella start to dance while Mookie takes a seat, the non-partial observer that he is.

BUGGIN' OUT
Why it gotta be about Jungle Music and Africa?

SAL
It's about turning that shit off and

[115]

146

SAL (CONT'D)
getting the fuck outta my shop.

PINO
Radio Raheem.

RADIO RAHEEM
Fuck you.

SAL
What ever happened to nice music with words you can understand?

RADIO RAHEEM
This is music. My music.

VITO
We're closed.

BUGGIN' OUT
You're closed alright, till you get some Black people up on that wall.

Sal grabs his Mickey Mantle bat from underneath the counter and brings it down on Radio Raheem's box, again and again and again. The music stops.

CLOSE - RADIO RAHEEM'S BOX

Radio Raheem's pride and joy is smashed to smithereens. Mmm
It's going to the junk yard quick.

ANGLE PIZZERIA

There is an eerie quiet as everyone is frozen, surprised by the suddenness of Sal's action, the swings of his Mickey Mantle bat. All look at Radio Raheem and realize what is about to happen.

ANGLE. RADIO RAHEEM

Radio Raheem screams, he goes crazy.

RADIO RAHEEM
My music!

Radio Raheem picks Sal up from behind the counter and starts to choke his ass. Radio Raheems prized possession—his box, the only thing he owed of value—his box, the one thing that gave him any sense of worth, his box, has been smashed to bits.) Radio Raheem like the large majority of Black youth is the victim of materialism and a misplaced sense of values.)

147

now he doesn't give a fuck anymore. He's gonna make Sal pay with his life.

Vito and Pino jump on Radio Raheem who only tightens his grip around Sal's neck, Buggin' Out tries to help his friend. Mookie just stands and watches as Ahmad, Cee, Punchie and Ella cheerlead.

EXT. SAL'S FAMOUS PIZZERIA-NIGHT

The tangled mass of choking, biting, kicking, screaming of confusion flies through the door of Sal's out onto the sidewalk.

CLOSE- EDDIE

The kid yells.

 EDDIE
 Fight! Fight!

CUT TO

CLOSE DA MAYOR

He looks up.

CUT TO

CLOSE MOTHER SISTER (OR)

She looks up

CUT TO

CLOSE - SWEET DICK WILLIE

He also looks up.

ANGLE STREET

The people on THE BLOCK run to Sal's Famous Pizzeria to see the "STATIC".

ANGLE SAL'S FAMOUS PIZZERIA

Radio Raheem, Buggin Out, Sal, Vito and Pino are still entangled, rolling around on the sidewalk but now before an entertained crowd of onlookers.

ANG'S DA MAYOR

DA MAYOR
Break it up. This is crazy.

150

The fight continues. Da Mayor is smart enough not to get in the middle of this WAR, when we hear SIRENS, somebody has called DA COPS.

ANGLE STREET

The cop cars come right through the crowd, almost running over some people. The Cops get out with nightsticks and guns drawn. We recognize two of the faces, Officers Long and Ponte. Anytime there is a skirmish between a black man and a white man you can bet the house on who the cops are gonna go for. You know the deal! Buggin' Out is pulled off first, then Vito and Pino but Radio Raheem is a crazed man. It takes all 6 Cops to pull him off Sal who is red as a beet from being choked.

ANGLE-COPS

Handcuffs are put on Buggin' Out as he watches the other put a choke hold on Radio Raheem to restrain him.

ANGLE RADIO RAHEEM

He's still struggling, then he just stops, his body goes limp and he falls to the sidewalk like a fifty pound bag of Idaho potatoes.

ANGLE STREET

Officers Long and Ponte kick him.

OFFICER LONG
Get up! Get up!

Radio Raheem just lies there like a bump on a log.

ANGLE (CROWD)

The crowd stares at Radio Raheem's still body. He's unconscious or dead.

CLOSE OFFICER LONG

OFFICER LONG
Quit faking.

ANGLE STREET

The Officers all look at each other. They know exactly what they've done. THE INFAMOUS MICHAEL STEWART CHOKE HOLD

OFFICER PONTE
Let's get him outta here.

51

The Officers pick up Radio Raheem's limp body and throw him into the back seat. Buggin' Out is pushed into another car. The cops cars speed off, in their haste to beat it, they have left a crowd. It's at this point the crowd becomes an angry MOB.

ANGLE MOB

The Mob looks at...

ANGLE MOB POV

Sal still on the sidewalk being helped to his feet by Vito and Pino who are in bad shape themselves.

ANGLE MOB

The mood/tone of the MOB is getting ugly. Once again they have seen one of their own killed before their eyes at the hands of the cops. We hear the murmurs of the folks go through the crowd.

THEY KILLED HIM
THEY KILLED RADIO RAHEEM
IT'S MURDER
DID IT AGAIN

|153|

JUST LIKE THEY DID MICHAEL STEWART
MURDER
ELEANOR BUMPURS
MURDER
IT'S NOT SAFE
NOT EVEN IN OUR OWN NEIGHBORHOOD
IT'S NOT SAFE
NEVER WAS
NEVER WILL BE

The cops in their haste to get Radio Raheem out of there have left an angry mob of Black folks first with a defenseless Sal, Vito and Pino, this now well.

The MOB looks at them.
WON'T STAND FOR IT
THE LAST TIME
FUCKIN' COPS
THE LAST TIME
IT'S PLAIN AS DAY
DIDN'T HAVE TO KILL THE BOY

HIGH ANGLE-

Mookie looks at the crowd and notices he's on the wrong, he side leaves the street Sal and his two sons.

ANGLE STREET

Da Mayor walks in front of the crowd.

 DA MAYOR
Good people, let's all go home. Somebody's gonna get hurt.

 CROWD (OS)
Yeah, you!

 DA MAYOR
If we don't stop this now, we'll all regret it. Sal and his two boys had nothing to do with what the police did.

 CROWD (OS)
Get out of the way old man.

 CROWD (OS)
You're a Tom anyway.

 DA MAYOR
Let em' be.

ANGLE STREET, PIZZERIA NIGHT.

Mookie picks up a garbage can and dumps it out into the street. He walks through the crowd, up to Da Mayor, Sal, Vito and Pino.

CLOSE MOOKIE

He screams

MOOKIE
Howard Beach!

SLO-MOTION

Mookie hurls the garbage can through the plate glass window of Sal's famous Pizzeria. "THAT'S IT, ALL HELL BREAKS LOOSE." The dam has been unplugged, broke. The rage of a people has been unleashed, a fury. A lone garbage can thrown through the air has spurred a tidal wave of frustration.

ANGLE STREET

Da Mayor pushes Sal, Vito and Pino out of the way as the MOB storms into Sal's famous Pizzeria.

INT. SAL'S FAMOUS PIZZERIA - NIGHT

The people rush into Sal's Famous Pizzeria tearing it up.

CLOSE CASH REGISTER

The cash register is opened, we only see coins Sal has the paper.

EXT. DA MAYOR'S STOOP - NIGHT

Da Mayor leads Sal, Vito and Pino back to his stoop where they watch in horror.

 SAL
 There it goes. Why?

 DA MAYOR
 You was there. First White folks
 they saw. You was there.

 PINO
 Fuckin' niggers.

INT. SAL'S FAMOUS PIZZERIA - NIGHT

Someone lights a match. WHOOOSH!

EXT. SAL'S FAMOUS PIZZERIA - NIGHT

Sal's Famous Pizzeria is going up in flames and now it's a carnaval.

MOTHER SISTER
Burn it down. Burn it down.

One might have thought that the elders who through the years have been broken down, whipped, their spirits crushed, beat into submission would be docile, strictly on lookers, that's not the case except for Da Mayor. The rest of the elders are right up in it with the young people.

INT. SAL'S FAMOUS PIZZERIA - NIGHT

CLOSE - PHOTOS ON WALL OF FAME

The photos of famous Italian Americans are burning.

EXT. FRUIT-N-VEG DELIGHT - NIGHT

The mob now moves across the street in front of the Korean fruit and vegetable stand. Sweet Dick Willie, (coconut) Sid and ML stand at the head of the mob.

 ML
 It's your turn.

CLOSE - KOREAN CLERK

He's scared to death, as the MOB is poised to tear his place up too. The clerk wildly swings a broom to hold them off.

pg 80
 KOREAN CLERK
 Me no White. Me no White.
 Me Black. Me Black.
 Me Black.

CLOSE ML

 ML
 Me Black, Me Black.

The Mob starts to laugh, they feel for him

ANGLE MOB

 SWEET DICK WILLIE
 Korea Man is OK. Let's leave him alone.

ML
Him no White, Him No White.

(COCONUT SID)
Him Black, Him Black.

ANGLE DA MAYOR'S STOOP

Sal, Vito and Pino look on as Sal's Famous Pizzeria goes up in smoke.

DISSOLVE TO

(LOSE VITO

DISSOLVE TO

(LOSE PINO

DISSOLVE TO

(LOSE SAL

ANGLE STREET

Jade is running through the MOB, looking for her brother.

JADE
Mookie! Mookie!

ANGLE MOOKIE

Mookie is running around with the rest of the MOB

ANGLE STREET

The wail of Fire Trucks and police sirens is now added to the night.

ANGLE SAL'S FAMOUS PIZZERIA

The ~~tired~~ MOB moves back to in front of Sal's as the Fire Trucks and Police in full riot gear pull up in the street behind them.

POLICE LOUDSPEAKER (VO)
Please disperse.
Please disperse.

The Firemen rush to hook up their hoses, ~~and~~ the Police force themselve between the crowd and the burning Sal's Famous Pizzeria.

POLICE LOUDSPEAKER (VO)
Please disperse!
Please disperse!

ANGLE- SAL'S FAMOUS PIZZERIA

The MOB doesn't listen, they will not be moved. The MOB will not be moved until they see Sal's Famous Pizzeria burn to the ground.

The firemen douse the pizzeria, trying desperately to stop the fire from spreading into the adjoining buildings.

POLICE LOUDSPEAKER (VO)
People, we're giving you one more warning.
Please go back home.

(CLOSE MOOKIE

MOOKIE
This is our home.

(CLOSE MOTHER SISTER

MOTHER SISTER
This is our neighborhood.

[162]

ANGLE: MOB

It will will take force to move this mass of people.

> POLICE LOUDSPEAKER (VO)
> You've had your warning!

POW!

The hoses thare turned on the MOB.
WE SEE Mookie, Mother Sister, Sweet Dick Willie, ML, Coconut Sid Jade, Ahmad, Cee, Punchie and Ella, etc go down before the powerful blast of the FIRE HOSES.
NOW WE'VE COME FULL CIRCLE WE'RE BACK TO MONTGOMERY OR BIRMINGHAM, ALABAMA. THE ONLY THING MISSING IS SHERIFF BULL CONNOR AND THE GERMAN SHEPARDS.

It would take force to move them and that's exactly what the MOB got. People are trying to hold onto each other, cars, railings, anything to keep from being swept away.

ANGLE- DA MAYOR'S STOOP

Da Mayor, Sal, Vito and Pino watch in disbelief. It's UNBELIEVABLE what is happening before their eyes.

CUT TO:

THEIR POV

People are screaming, kids and women are not being spared from the brute force of the fire hose either.

EXT. WE LOVE STOREFRONT - NIGHT

WE SEE the reflection of the fire in the storefront window as Mister Senor Love Daddy looks on.

ANGLE JADE and MOTHER SISTER

Jade and Mother Sister try to hold onto a street lamp as a gush of water hits them, their grip loosens, the water is too powerful and they slide away down the block.

INT. SAL'S FAMOUS PIZZERIA - NIGHT

CLOSE-PHOTOS

Some burnt photos on the floor.

CLOSE - MICKEY MANTLE BAT

CLOSE RADIO RAHEEM'S BOX

Radio Raheem's box has melted into a black mass of goo.

CLOSER· RADIO RAHEEM'S BOX

As we move in tighter on the melted box we begin to hear THE RAP SONG that we've heard throughout. All other sound drops out as THE RAP SONG gets louder and louder until it gets deafening. Then we

CUT TO BLACK

THE MORNING AFTER

FADE IN

EXT. STREET - DAY

THE CAMERA from HIGH ABOVE cranes down on THE BLOCK. The sidewalk is desserted, broken glass is everywhere and it looks exactly as how one expect it to look, the morning after an UPRISING.
THE CAMERA now moves in on the WE LOVE Storefront where MISTER SENOR LOVE DADDY is in his familiar place behind the mike.

MISTER SEÑOR LOVE DADDY
My People. My People.
What can I say?
Say what I can.
I saw it but I didn't believe it
I didn't believe it what I saw.
Are we gonna live together?
Together are we gonna live?
This is ya Mister Señor Love Daddy
here on WE LOVE RADIO 108 FM
on your dial.

CLOSE MISTER SEÑOR LOVE DADDY

MISTER SEÑOR LOVE DADDY
Today's weather

He yells.

MISTER SEÑOR LOVE DADDY
HOT!

CLOSER MISTER SEÑOR LOVE DADDY

He screams.

166

MISTER SEÑOR' LOVE DADDY
WAKE UP!

CUT TO

INT. TINA'S BEDROOM - DAY

Mookie jumps out of her bed; Tina sleeps by his side.

MISTER SEÑOR LOVE DADDY (OS)
WAKE UP!

MOOKIE
Fuck! My Money!

EXT. SAL'S FAMOUS PIZZERIA - DAY

Mookie walks up to Sal's Famous Pizzeria as it still smolders in the morning light. Sal emerges from the wreckage, he looks like he might have slept there.

SAL
Whatdafuck do ya want?

MOOKIE
I wants my money. I wants to get paid.

Sal looks at Mookie in disbelief.

SAL
Mookie, I always liked you, not the smartest kid but you're honest. Don't make me dislike you.

MOOKIE
Sal, I want my money

SAL
Don't even ask about your money. You money wouldn't even pay for that window you smashed

MOOKIE
C'mon Sal

SAL
You niggers are crazy... Mook, this isn't the time.

MOOKIE
Fuck Dat. The time is fuckin now. Y'know I'm sorry 'bout Sal's famous pizzeria b+I gotta live too. I gotta get paid.

SAL
We both do.

MOOKIE
We all know ya're gonna get over with the insurance money <u>anyway!</u> Ya know da deal.

SAL
Do we now?

MOOKIE
Quit bullshitting

SAL
You don't know shit about shit.

MOOKIE
I know I wants to get my money.

Sal has had it.

SAL
How much? How much do I owe you?

MOOKIE

My salary, Two fifty.

Sal pulls at a wad and quickly peels off hundred dollar bills.

SAL

One, Two, Three, Four, Five

Sal throws the "C" notes at Mookie, they hit him in the chest and fall to the sidewalk.

SAL

Are you happy now? That's five fucking hundred dollars. You just got paid Mookie you are a rich man, now ya life is set, ya'll never have another worry, a care in the world. Mookie, ya wealthy, a fuckin' Rockefeller.

Mookie is stunned by Sal's outburst. He picks up the bills.

SAL

Ya got paid, so leave me the fuck alone.

SAL
It's suppose to be even hotter today.

MOOKIE
You gonna open up another Sal's Famous Pizzeria?

SAL
No. What are you gonna do?

MOOKIE
Make dat money.

SAL
Radio Raheem?

Mookie shakes his head.

MOOKIE
The Cops.

SAL
Yeah!... I'm goin' to the beach for the first day in 15 years. Gonna take the day off and go to the beach.

MOOKIE
I can dig it. It's gonna be NOT as a motherfucker.

SAL
Y'know what Mookie?

MOOKIE
What Sal?

SAL
Things have changed.

MOOKIE
How's dat?

SAL
I think you Blacks might be wising up.

MOOKIE
Yeah? Tell me.

SAL
Twenty years ago you Blacks would have burned down your own buildings.

172

Mookie thinks about it, looks at the 2 "C" notes still smiling up at him. He quickly scoops them up.

<div style="text-align:center">

MOOKIE
Maybe we are a little smarter.

</div>

HIGH ANGLE STREET

As Mookie turns and walks away, Sal goes back into Sal's Famous Pizzeria to salvage what is salvageable and THE BLOCK begins to AWAKE from it's slumber, ready to deal once again with the heat of THE HOTTEST DAY OF THE YEAR

FADE OUT

ROLL CREDITS

Crew shot. *Do the Right Thing* was shot in the summer of 1988.

FILM CREDITS CAST & CREW

CAST

	
Sal	Danny Aiello
Da Mayor	Ossie Davis
Mother Sister	Ruby Dee
Vito	Richard Edson
Buggin' Out	Giancarlo Esposito
Mookie	Spike Lee
Radio Raheem	Bill Nunn
Pino	John Turturro
ML	Paul Benjamin
Coconut Sid	Frankie Faison
Sweet Dick Willie	Robin Harris
Jade	Joie Lee
Officer Ponte	Miguel Sandoval
Officer Long	Rick Aiello
Clifton	John Savage
Mister Señor Love Daddy	Sam Jackson
Tina	Rosie Perez
Smiley	Roger Guenveur Smith
Ahmad	Steve White
Cee	Martin Lawrence
Punchy	Leonard Thomas
Ella	Christa Rivers
Charlie	Frank Vincent
Stevie	Luis Ramos
Eddie	Richard Habersham
Louise	Gwen McGee
Sonny	Steve Park
Kim	Ginny Yang
Korean Child	Sherwin Park
Puerto Rican Icee Man	Shawn Elliott
Carmen	Diva Osorio
Stevie's Friends	Chris Delaney
	Angel Ramirez
	Sixto Ramos
	Nelson Vasquez
Hector	Travell Lee Toulson
Sergeant	Joel Nagle
Plain Clothes Detective	David E. Weinberg
Double Dutch Girls	Yattee Brown
	Mecca Brunson
	Shawn Stainback
	Soquana Wallace
Stunt Double (Sal)	Danny Aiello III
Stunt Driver	Mharaka Washington
Stunt Players	Gary Frith
	Andy Duppin
	Rashon Khan
	Erik Koniger
	Malcolm Livingston
	David S. Lomax
	Dominic Marcus
	Eric A. Payne
	Roy Thomas
	Tom Wright

FILMMAKERS

	
Produced, Written and Directed by	Spike Lee
Co-Producer	Monty Ross
Line Producer	Jon Kilik
Photographed by	Ernest Dickerson
Editor	Barry Alexander Brown
Original Music Score	Bill Lee
Production Design	Wynn Thomas
Casting	Robi Reed
Costumes	Ruth Carter
Sound Design	Skip Lievsay
Production Supervisor	Preston Holmes
1st Assistant Director	Randy Fletcher
2nd Assistant Director	Nandi Bowe
2nd 2nd Assistant Director	Chris Lopez
Location Manager	Brent Owens
Unit Manager	R.W. Dixon
Production Office Coordinator	Lillian Pyles
Asst. Production Office Coord.	Robin Downes
40 Acres Production Coord.	Susan D. Fowler
40 Acres Production Assistant	Audra C. Smith
Production Comptroller	Robert Nickson
Auditor	Holly Chase
Assistant Auditor	Eric Oden
Script Supervisor	Joe Gonzalez
Camera Operator	John Newby
1st Assistant Camera	Jonathan Burkhart
2nd Assistant Camera	Darnell Martin
Additional Camera Operators	Frank Prinzi
	George Pattison
Additional Camera Assistants	Robert Gorelick
	Paul S. Reuter
	Stuart Allen
	Frank Stettner
Louma Crane Technician	Andy Schmetterling
Sound Recordist	Abdul Malik Abbott
Boom Man	Charles Hunt
Cablemen-Production Assts.	David Lee
	Michael Green
	Dennis Bradford
Still Photography	Pam Stephens
Assistant Art Directors	Jeff Balsmeyer
	Jeffrey L. Glave
Art Department Coordinator	Joyce Kubalak
Storyboard Artist	Patricia Bases
Chargeman	Lawrence Casey
2nd Scenic Artist	Jeff Miller
Scenic Artists	Octavio Molina
	Mark Selemon
Property Master	Marc Henry Johnson
1st Assistant Props	Kevin Ladson
2nd Assistant Props	Andy Lassman
3rd Assistant Props	Scott Rosenstock
Additional Assistant Props	Keith Wall
Leadman	Steve Rosse
Key Set Dresser	Jon Rudo
Set Decorator	Anthony Baldasare
Assistant Set Decorator	Michael Lee Benson
Set Dressers	James Bilz
	Thomas Hudson Reeve
	Rosalie Russino
Shop Person	Sherman Benjamin
Production Assistant—Shop	Martin Bernstein
Construction Coordinator	James Bonice
Construction Grips	David Bromberg
	Jonathan Graham
	Rich Kerekes
	Charles Marroquin
	Monique Mitchell
	Carl Peterson
	Carl Prinzi
	Bryan Unger
Production Asst.—Construction	Robert Woods, Jr.
Key Set Builder	Ken Nelson

	
Carpenters	Rodney Clark, Dominic Ferrar, Harold Horn, Timothy Main, Chris Miller, Twad Schuetrum, Robert Ippolito, Paul Wachter, Rex North, Rodney Bauer, John Archibald, Erich Augenstein, Donald Bailer, Roger Kimpton, Marcus Turner, Charles Houston, Val DeSalvo, Sergei Mihajlov, John O'Malley, Derrick Still, James Boorman, Christopher Vanzant, Addison Cook, Juan Lopez, Beverly C. Jones, Tula Goenka, Leander Sales, Philip Stockton, Jeff Stern, Brunilda Torres, Alex Steyermark, Gail Showalter, Rudy Gaskins, Gene Gearty, Tony Martinez, Bruce Pross, Stuart Stanley, James Flatto, Marissa Littlefield, Nic Ratner, Nzingha Clarke, William Docker, Marko A. Costanzo, Tom Fleischman
Key Grip	Mixed at ... Sound One Studios
Best Boy	Dailies Projection ... Boston Light and Sound
Dolly Grip	Projectionist (Dailies) ... Michael Gaynor
3rd Grip	Dolby Stereo Consultant ... Mike DiCosimo
Additional Grips	Music Copyist ... James "Jabbo" Ware
Gaffer	Piano Tuner ... Rosie Perez
Best Boy	"Fight the Power" Choreography ... Alexander Ostrovsky
3rd Electrics	Special Effects ... Otis Sallid
Generator Operator	Assistant Effects ... Steve Kirshoff
Electrics	... John N. Berry
Electric Trainees	... Wilfred Caban
Grip Trainee	... Paul Collangello
Production Assistant—Electric	... Dave Fletcher
Assistant Editor	... Bill Harrison
Apprentice Editor	... Don Hewitt
Production Assistants—Wardrobe	William Van Der Putten
Wardrobe Seamstress	... Dennis Zack
Assistant Costume Designer	... Karen Perry
Casting Assistant	... Jennifer Ruscoe
Extra Casting	... Valerie A. Gladstone
Additional Makeup	... Michele Boissiere
Makeup	... Millicent Shelton
Hair	... Larry Cherry
Stunt Coordinator Assistants	... Matiki Anoff
Stunt Coordinator	... Marianna Najjar
Production Asst.—Casting	... Andrea Reed
Teamster Captain	Francine Renee Lawrence
Drivers	... Sarah Hyde-Hamlet, Tracy Vilar, Eddie Smith, Chantal Collins, Jim Leavey, Willi Gaskins, Clifford Johnson, Sullie Jordan, Brian Maxwell, Martin Whitfield, Carlos Williams, Kenny Buford, Spencer Charles, Eric Daniel, Michael Ellis, Eddie Joe, Stephanie Jones
Production Assistants—Set	
Assistant Sound Editors	
Foley Editor	
Sound Editors	
Dialogue Editor	
Supervising Dialogue Editor	
Apprentice Editor	
Assistant Editor	
Music Editor	
ADR Editor	
Foley Editor	
Apprentice Sound Editors	
Foley Artist	
Re-Recording Mixer	
Interns	... Richard Beaumont, Kai Bowe, Dawn Cain, Fritz Celestin, Melissa A. Clark, Arlene Donnelly, Juliette Harris, Ernie Mapp, Mitchell Marchand, Jacki Newson, Traci Proctor, Sara Renaud, Carolyn Rouse, Astrid Roy, Sharoya N. Smalls, Alan C. Smith, Susan Stuart, Karen Taylor, Jean Warner, Latanya White, Gail White, Monique Williams
Production Assistants-Office	
Emergency Medical Services	On Location Medical, Inc.
Legal Services	Frankfurt, Garbus, Klein and Selz
Completion Guarantee	The Completion Bond Company
Publicity	Tobin and Associates
Unit Publicist	Sam Mattingly
Caterers	T&A Caterers
	Central Falls Caterers
Product Placement	Unique Product Placement
Product Placement Coordinator	Norm Marshall & Associates, Inc.
Craft Services	Avril Lacour-Hartnagel
Camera Equipment	Cheryl Ann Scott
Sound Equipment	Technological Cinevideo Services, Inc.
Negative Matching	Audio Services
	Noëlle Penraat

Color Timers Bob Hagans
Opticals . John Nicolard
. Select Effects
Photo Research .
The Schomburg Center for Research in Black Culture
New York Public Library

Malcom X/Martin Luther King, Jr.
photo courtesy of World Wide Photos/Peggy Farrell

Main and End Titles Designed and Produced by
BALSMEYER & EVERETT, INC.

DO THE RIGHT THING Logo by
ART SIMS/11:24 DESIGN & ADVERTISING

Music Score Recorded at RCA STUDIOS, N.Y.
Color by DU ART LABORATORIES, INC.
Prints by DELUXE®

THE MUSIC

FIGHT THE POWER
Music and Lyrics by Carlton Ridenhour, Hank Shocklee
Eric Sadler and Keith Shocklee
Performed by PUBLIC ENEMY
Def American Songs, Inc. (BMI)
Courtesy of Def Jam/CBS Records

DON'T SHOOT ME
Music and Lyrics by Spike Lee, Mervyn Warren,
Claude McKnight and David Thomas
Performed by TAKE 6
Spikey-Poo Songs, Inc. (ASCAP)
Dee Mee Music/Mervyn Warren Music/Claude Vee Music (BMI)
Courtesy of Reprise/Warner Brothers Records

CAN'T STAND IT
Music and Lyrics by David Hines
Performed by STEEL PULSE
Pulse Music, Ltd. (P.R.S.)
Courtesy of MCA Records/Loot Music

TU Y YO
Music and Lyrics by Rubén Blades
Performed by RUBÉN BLADES
R.B. Productions, Inc. (ASCAP)
Courtesy of Elektra Records

WHY DON'T WE TRY
Music and Lyrics by Raymond Jones,
Larry DeCarmine, Vincent Morris
Performed by KEITH JOHN
Jerrelle Music Publishing (ASCAP)
Zubaidah Music, Inc./Unicity Music Publishing (ASCAP)
Hey Nineteen Music (ASCAP)
Courtesy of Black Bull Productions

HARD TO SAY
Music and Lyrics by Raymond Jones
Performed by LORI PERRY and GERALD ALSTON
Zubaidah Music, Inc. (ASCAP)
Gerald Alston courtesy of Motown Records, LP/Taj Records
Lori Perry courtesy of MCA Records

PARTY HEARTY
Music and Lyrics by William "Ju Ju" House and Kent Wood
Performed by EU
Ju House Music (ASCAP), Syce-M-Up Music (ASCAP)
Courtesy of Virgin Records

PROVE TO ME
Music and Lyrics by Raymond Jones and Sami McKinney
Performed by PERRI
Zubaidah Music, Inc. (ASCAP)
Unicity Music, Avid One Music (ASCAP)
Courtesy of Zebra/MCA Records

FEEL SO GOOD
Music and Lyrics by
Sami McKinney, Lori Perry and Michael O'Hara
Performed by PERRI
O'Hara Music/Texas City Music (BMI)
Avid One Music (ASCAP)
MCA Publishing/Perrylane Music (BMI)
Courtesy of Zebra/MCA Records

MY FANTASY
Music and Lyrics by Teddy Riley and Gene Griffin
Performed by GUY
Cal-Gene Music, Inc. (BMI)/Don Ril Music (ASCAP)
Virgin Songs, Inc. (BMI)
Courtesy of MCA Records

NEVER EXPLAIN LOVE
Music and Lyrics by Raymond Jones and Cathy Block
Performed by AL JARREAU
Building Block Music (BMI)
Zubaidah Music Inc./Unicity Music Publishing (ASCAP)
Al Jarreau courtesy of Warner Brothers Records/WEA Inter'l., Inc.

WE LOVE RADIO JINGLES
Performed by TAKE 6
Courtesy of Reprise/Warner Brothers Records

LIFT EVERY VOICE AND SING
Music and Lyrics by
James Weldon Johnson and John Rosemond Johnson

THE NATURAL SPIRITUAL ORCHESTRA

Conductor
William J.E. Lee

Featuring
Branford Marsalis – Tenor and Soprano Saxophone

Terence Blanchard-Trumpet
Marlon Jordan-Trumpet
Donald Harris-Alto Saxophone
Jeff "Train" Watts-Drums
Robert Hurst-Bass
Kenny Barron-Piano
James Williams-Piano

VIOLINS
Stanley G. Hunte-Contractor
Alen W. Sanford-Concert Master
Elliot Rosoff
Kenneth Gordon

John Pintavalle
Gerald Tarack
Charles Libove
Louann Montesi
Paul Peabody
Lewis Eley
Regis Iandiorio
Sandra Billingslea
Cecelia A. Hobbs
Marion J. Pinheiro
Richard Henrickson
Joseph Malin
Lesa Terry
Laura J. Smith
Diane Monroe
Alvin E. Rodgers
Elena Barere
Patmore Lewis
Gregory Komar
Winterton Garvey

VIOLAS
Alfred V. Brown
Harry Zaratzian
Barry Finclair
Maxine Roach
John R. Dexter
Lois E. Martin
Maureen Gallagher
Juliette Hassner

CELLOS
Frederick Zlotkin
Mark Orrin Shuman
Bruce Rogers
Melissa Meel
Eileen M. Folsom
Zela Terry
Carol Buck
Astrid Schween

BASS
Michael M. Fleming
Rufus Reid

Quotation by Malcolm X used by permission of Dr. Betty Shabazz

Quotation by Dr. Martin Luther King, Jr. used by permission of Mrs. Coretta Scott King

SPECIAL THANKS TO

Explosives Unit-New York City Fire Department
Orangetown Fire Company Number 1, South Nyack, NY
John Wilson
Rush
New York City Board of Education and District 16
Public School 308
Antioch Baptist Church
Bed-Stuy Community Board #3
New York City Mayor's Office for Film, Theatre and Broadcasting

THANKS ALSO TO

Brooklyn Beer
Canal Jeans
Elan Jewelry
El Diario/La Prensa
Ellis Collection
Essence Magazine
Gitano
Johnson Publications
Levi Strauss & Co.
Miller Beer Company
Mr. Softee, Inc.
Nike
New York Daily News
New York Newsday
New York Post
New York Times Company
Old English
Pepsi-Cola
Ray-Ban/Bausch & Lomb
Radio WJIT
Willi Wear
Xenobia

Shot on location in Bedford-Stuyvesant in the Republic of Brooklyn, New York

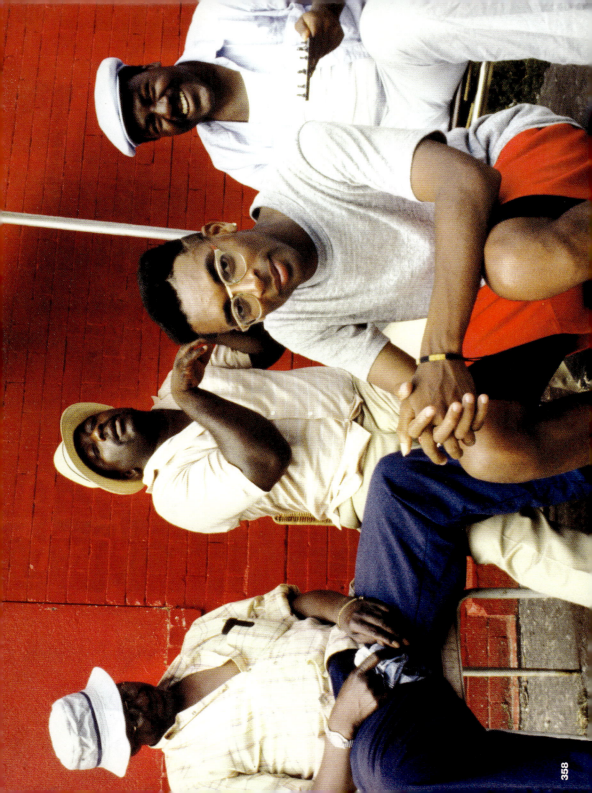

SPIKE LEE DO THE RIGHT THING

BY SPIKE LEE AND JASON MATLOFF

EDITED BY STEVE CRIST

Photographs by David Lee
Interviews © 2010 Jason Matloff
Design: Carrie Worthen and Ben Pope, Thirdthing
Archivist/Scanning: Eden Marie Picazo, 40 Acres
Copy Editor: Sara DeGonia
Production: Reid Embrey and Virginia Conesa

Special, Special Thanks to:
Tonya, Satchel, and Jackson.
Daddy loves y'all.

Special Thanks to:
David Lee
Jimmy Horowitz
Jason Lampkin
Art Sims

Jason Matloff Acknowledgments: I would like to thank Tim Swanson, former movie editor at the *Los Angeles Times*, for his support; Howard Karren, for his invaluable input; my wife, Joelle, for her patience and understanding, despite the many times I watched the same scenes over and over again; and Spike Lee, for making such an amazing and important movie.

Portions of these interviews first appeared in the *Los Angeles Times*, May 24, 2009, and are reprinted here with permission.

Photographs and stills from *Do the Right Thing* courtesy Universal Studios Licensing, Inc. All Rights Reserved.

Library of Congress Control Number: 2010910783
ISBN: 978-1-62326042-2

© 2010 AMMO Books, LLC. All Rights Reserved. No part of this book may be reproduced by any means, in any media, electronic or mechanical, including motion picture film, video, photocopy, recording, or any other information storage retrieval system without prior permission in writing from AMMO Books, LLC.

Printed in China

For more information on AMMO Books, please visit www.ammobooks.com